Practising with Deleuze

Practising with Deleuze

Design, Dance, Art, Writing, Philosophy

Suzie Attiwill, Terri Bird,
Andrea Eckersley, Antonia Pont,
Jon Roffe and Philipa Rothfield

Edinburgh University Press is one of the leading university presses in the UK. We publish academic books and journals in our selected subject areas across the humanities and social sciences, combining cutting-edge scholarship with high editorial and production values to produce academic works of lasting importance. For more information visit our website: edinburghuniversitypress.com

© Suzie Attiwill, Terri Bird, Andrea Eckersley, Antonia Pont, Jon Roffe and Philipa Rothfield, 2017

Introduction © Gregory Flaxman, 2017

Edinburgh University Press Ltd
The Tun - Holyrood Road, 12(2f) Jackson's Entry, Edinburgh EH8 8PJ

Typeset in 11/13 Bembo by
IDSUK (DataConnection) Ltd, and
printed and bound in Great Britain by
CPI Group (UK) Ltd, Croydon CR0 4YY

A CIP record for this book is available from the British Library

ISBN 978 1 4744 2934 4 (hardback)
ISBN 978 1 4744 2936 8 (webready PDF)
ISBN 978 1 4744 2935 1 (paperback)
ISBN 978 1 4744 2937 5 (epub)

The right of Suzie Attiwill, Terri Bird, Andrea Eckersley, Antonia Pont, Jon Roffe and Philipa Rothfield to be identified as the authors of this work has been asserted in accordance with the Copyright, Designs and Patents Act 1988, and the Copyright and Related Rights Regulations 2003 (SI No. 2498).

Contents

List of Figures	vi
Acknowledgements	viii
Notes on Co-Authors	ix
1. Introduction: Deleuze: In Practice *Gregory Flaxman*	1
2. Philosophising Practice *Antonia Pont*	16
3. Forming *Terri Bird*	49
4. Framing – ?interior *Suzie Attiwill*	87
5. Experience and its Others *Philipa Rothfield*	120
6. Encountering Surfaces, Encountering Spaces, Encountering Painting *Andrea Eckersley*	162
7. Practising Philosophy *Jon Roffe*	183
Bibliography	199
Index	213

List of Figures

3.1 Public Share, clay collection site at Wiri, Well-Connected Alliance worksite – Wednesday, 26 November 2014. Photographer: Public Share. 69

3.2 *Smoko (Part 1)*, Morning tea break, Performing Mobilities Assembly, Federation Hall, University of Melbourne – Saturday, 10 October 2015. Photographer: Public Share. 71

3.3 *Smoko (Part 2)*, Well-Connected Alliance, Wiri site tearooms – Monday, 13 June 2016. Photographer: Public Share. 71

5.1 Trisha Brown Dance Company, Melbourne, 2014. Photographer: Ron Fung. 126

5.2 Trisha Brown Dance Company, Melbourne, 2014. Photographer: Ron Fung. 133

5.3 Deborah Hay, Learning Curve, Dancehouse, Melbourne, 2014. Photographer: Gregory Lorenzetti. 145

5.4 Dance Exchange, Australia (director: Russell Dumas). Dancers: Jonathon Sinatra, Nicole Jenvey. Photographer: Russell Dumas. 146

6.1 Andrea Eckersley, *Surface event #1*, 2014. Oil, acrylic, enamel, gesso and painted wood panel on wall. Dimensions variable. 168

6.2 Andrea Eckersley, *Surface event #3*, 2014. Oil, acrylic, gesso, gouache, wax, gloss and sanded back sections on wall. Dimensions variable. 172

6.3 Andrea Eckersley, *Depth is as good as range*, 2014. Acrylic, gesso, gouache and sanded back sections on wall. Dimensions variable. 173

Acknowledgements

This book developed out of a series of seminars initiated by Terri Bird and held in 2014 at West Space, an artist-led organisation in Melbourne. These seminars, 'Practising: A series of seminars exploring the writing of Deleuze', aimed to unpack some of the key ideas in the writings of Gilles Deleuze, and those written together with Félix Guattari, from the perspective of contemporary creative practices. Each seminar was a dialogue between a creative practitioner and Jon Roffe, focused on a particular aspect of practice: forming, framing, experiencing, encountering, practising. Each practitioner approached the topic from the perspective of their specific field: Terri Bird – sculpture, Suzie Attiwill – interior design, Philipa Rothfield – dance, Andrea Eckersley – painting, and Antonia Pont – creative writing.

We would like to thank West Space for making the gallery available, for hosting and facilitating these seminars. In addition we'd like to acknowledge the significant role of the Melbourne School of Continental Philosophy. The creative practitioners met while attending various courses given by Jon Roffe, on the philosophy of Deleuze, over the past ten years or so at the MSCP. The MSCP continues to make a major contribution to supporting a broad engagement with the work of a wide range of philosophers through its programme of seminars, courses and events.

We would also like to gratefully thank Gregory Flaxman for his remarkable Introduction, which frames and illuminates the discussions of practising that come after it so well, and Haydie Gooder for the excellent Index (both of which were produced under draconian time constraints).

The publication of this volume was supported by The School of Humanities and Languages at the University of New South Wales.

Notes on Co-Authors

Suzie Attiwill is Associate Professor, Interior Design and Deputy Dean of learning and teaching in the School of Architecture and Design, RMIT University, Melbourne, Australia. Since 1991, her practice has involved exhibition design, curatorial work, writing and teaching. Projects pose questions of interior and interiority in relation to contemporary conditions of living, inhabitation, subjectivity, pedagogy and praxis. Her creative practice research is conducted through a practice of designing with a curatorial inflection attending to arrangements (and rearrangements) of spatial, temporal and material relations. Previous roles include Artistic Director, Craft Victoria; Chair, West Space Artist-Led Initiative; Chair, IDEA (Interior Design/Interior Architecture Educators Association); and Executive Editor, *IDEA Journal*.

Terri Bird is an artist, primarily practising with the collaborative group Open Spatial Workshop, which includes Bianca Hester and Scott Mitchell. They were winners of the inaugural Melbourne Prize for Urban Sculpture in 2005, instigated the west Brunswick Sculpture Triennial in 2009, and exhibited 'Converging in Time' at MUMA in 2017. She is a senior lecturer in the Fine Art Department at Monash University, and completed her PhD in the Centre for Comparative Literature and Cultural Studies at Monash University in 2007.

Andrea Eckersley is a lecturer in Fashion Design at RMIT University. She was awarded a PhD in Fine Arts (Painting) from Monash University in 2016. Primarily interested in the way the body interacts with abstract shapes, Andrea's work investigates the material aspects of painting with a particular focus on its surface. Andrea is the art editor at the *Deleuze Studies* journal and exhibits regularly in Australia.

Antonia Pont is a poet, yoga practitioner and scholar. After early training in dance and gymnastics, she began studies in yoga and Zen that have been ongoing since 1995. She is Senior Lecturer in Writing and Literature at Deakin University, Australia. In 2009 she established the Australian school of Vijnana Yoga, where she teaches and practises.

Philipa Rothfield is Adjunct Professor in Philosophy of the Body and Dance at the University of Southern Denmark. She is also an honorary staff member in Philosophy and Politics at La Trobe University. She has been dancing, on and off, for thirty-odd years, occasionally performing, mainly rolling around the studio floor. Her mentors and teachers include Margaret Lasica (dir. Modern Dance Ensemble), Russell Dumas (dir. Dance Exchange) and Alice Cummins (dir. Footfall). She also reviews dance for *RealTime* magazine and is Creative Advisor for Dancehouse, Australia. She is co-editor, with Thomas F. DeFrantz, of *Choreography and Corporeality: Relay in Motion* (Palgrave Macmillan 2016).

Jon Roffe is Vice-Chancellor's Postdoctoral Fellow at the University of New South Wales. The editor of a number of books on recent and contemporary French philosophy, he is the author of *Badiou's Deleuze* (Edinburgh University Press 2012), *Abstract Market Theory* (Palgrave 2015), *Gilles Deleuze's Empiricism and Subjectivity* (Edinburgh University Press 2016), and *Lacan Deleuze Badiou* (Edinburgh University Press 2015) with A. J. Bartlett and Justin Clemens. Jon is also the author of the collection of aphorisms *Muttering for the Sake of Stars* (Surpllus 2012).

1

Introduction: Deleuze: In Practice

Gregory Flaxman

We do not listen closely enough to what painters have to say.

Gilles Deleuze[1]

One

Over the course of forty-plus years, Gilles Deleuze was never at a loss to articulate the aims and aspirations, principles and predilections of philosophy. Still, perhaps no definition today is as familiar, or as universally acclaimed, as 'the creation of concepts'. So ubiquitous is the definition, so casual is the conceit, that we run the risk of reducing its profound task to glib abstraction. Ironically, we're apt to mistake the audacity of Deleuze's declaration for a bromide, the kind of thing one says (out of fatigue, or boredom, or exasperation) to lay thought to rest. Given as much, if we return to the creation of concepts, there can be no other reason than to exhume Deleuze's spirit of radical constructivism – the doing, thinking and living from which concepts are *fabricated*. But how?

Between philosophy and the creation of concepts, Deleuze insists on a dimension of 'practice' where (or when) the objective and object converge. 'For many people', he admits, 'philosophy is something which is not "made", but is pre-existent, ready-made in a prefabricated sky.'[2] To the contrary, Deleuze avows that 'philosophical theory is itself a practice, just as much as its object. It is

no more abstract than its object. It is a practice of concepts.'[3] Not only is philosophy a practice, something always 'made', but the practice of philosophy entails 'making' concepts: in other words, practice consists in the exercise of living thought without which philosophy would be inert and concepts still-born. But what does it really mean to say that philosophy creates concepts *in practice*? If philosophy is the 'practice of creating concepts', what is the concept of practice? Is it a first concept, a transcendental concept? Should we understand practice architectonically, as the principle of foundation? Institutionally, as the provenance of the discipline? Legislatively, as the proper avocation of what is called philosophy? Dialectically, as the synthesis of will and idea? Methodologically, as a procedure for critique or interpretation? Politically, as the expression of a materialist and revolutionary line in Marx and Marxism?

The sense and value of practice could be cashed out in any of these registers, but in this introduction I want to trace a philosophical genealogy of the concept within which to locate Deleuze's practice of concepts and concept of practice. My hope, in so doing, is to provide the context for *Practising with Deleuze*, since the title of the book is also its intervention, its undertaking and its risk. This volume brings together six essays, all but one written by artists whose aim is to think, work and practise *with* Deleuze. But if the contributors – a poet (Antonia Pont), a painter (Andrea Eckersley), an installation artist (Terri Bird), an interior designer (Suzie Attiwill), a dancer (Philipa Rothfield) and a philosopher (Jon Roffe) – engage the philosopher's practice, *Practising with Deleuze* concerns a great deal more than influence or appropriation. At its heart, this book revolves around the shared belief that, between the plane of philosophy and the place of art, a kind of collaboration – or, better still, collusion – can take shape. If philosophers can address works of art, why shouldn't artists address works of philosophy? My contention, per Deleuze, is that this eventuality is not only possible, nor even desirable, but absolutely *vital*. Surely this is why Deleuze relies so heavily on the insights of artists: novelists, poets, painters, filmmakers and composers are capable of disclosing a kind of practice, at once method and experience, in which philosophical practice means to create new concepts.

Two

Taken in its noun form, 'practice' derives from the ancient Greek *praxis* (πρᾶξις). The latter, broadly denoting action or activity, corresponds to the verb *prassô* (πράσσω) – to pass over, to cross to the end – from which it seems to have acquired related senses: to complete, accomplish, act or do. Indeed, *praxis* belonged to an important 'word family' – including *prattein* (acting, especially good action: *eu prattein*), *praktikos* (fit for action; practical, effective), and *praktos* (done; to be done) – that emerged alongside the closely related branch of *pragma* (deed, act; thing done; affair), *pragmatikos* (fit for business, relating to fact, systematic), *pragmateuomai* (to transact business).

The constituents of this family were already established in Homeric Greek (e.g. *prêxis* (πρῆξῖς)), but the conceptualisation of *praxis* developed thereafter, in Attic Greek. The dialect of the classical Athens, Attic was the language of the great tragedians, historians and of course philosophers. Thus, in the Attic formality of Plato's Academy and, especially, Aristotle's Lyceum, *praxis* became the subject of analysis, classification and specification. Aristotle did not define *praxis* as much as he redefined the sense and sphere, extent and limits of the term. Broadly construed, he distinguished this sphere of human activity – derived from decision, undertaken by will, and enacted in relation to a community – from two other, namely *theoria* (theory) and *poiēsis* (skilful manufacture). Among the three spheres, *praxis* concerns our relation to other people and, thence, the *polis* itself. Indeed, *praxis* describes a domain of active human life to which politics belongs, but Aristotle's innovation lies, ultimately, in making this the locus of ethics. By displacing it from the *Eideitic* heights of Platonism, and releasing it from the confines of intellection, Aristotle refitted morality to the measure of human action. Hence, the opening lines of the *Nicomachean Ethics* invoke *praxis* (and its variants) to describe 'good living and good acting' (*to d' eu zên kai to eu prattein*) (1.1, 1095a19), 'men of culture and men of action' (*hoi de charientes kai praktikoi*) (1.3, 1095b22), and 'acting in accord with justice' (*to dikaiopragein*) (1.8, 1099a19).[4]

Inasmuch as Aristotle profoundly shapes our sense of practice, however, the legacy of the classical concept relied on subsequent

circumstances that we cannot afford to ignore. The dissemination of *praxis* was deeply indebted to the efflorescence of *hē koinē diálektos* – literally, 'the common dialect' – that consolidated Attic Greek in a common idiom. Although the *koinē* had been evolving for decades, especially in Athens, this transformation might have come to little had not the Macedonians adopted it. With Alexander's conquests, the Macedonian (or Hellenic) empire advanced the *koinē* into three continents, and for centuries thereafter this so-called Alexandrian dialect served as the lingua franca for large swaths of the Mediterranean and Middle East. Even as it was replaced by Medieval Greek or displaced altogether, *koinē* Greek inflected a great many Indo-European languages. *Praxis* is a case in point: one finds derivatives of the Greek etymon in all Romance languages, many Slavic languages and Baltic languages, and a number of Germanic languages, as well as Albanian and even Armenian (a separate branch of the Indo-European).[5]

The majority of these languages, including those that concern us here (principally German, French and English), did not acquire the etymon directly from Greek but, rather, by way of Latin, where the term enjoyed a peculiar existence. Along with certain of its variants, *Praxis* was appropriated into Latin as a 'cognate', that is, a word borrowed from another language but subject to the orthographic changes of the host (hence, *practica, practicare* and later *practicus*). At the same time, however, Latin adopted the transliterated Greek word *praxis* without changes. In other words, *praxis* existed in Latin alongside its own Latin adaptation for centuries: the words are twins, but we can't be sure whether they're identical or fraternal. They were often interchanged, sometimes mistaken, and yet there was no shortage of discourses, avocations and occasions, and circumstances that appear to have been associated with one or the other. The question is not 'what is *praxis*?' but, rather, 'why is this a *praxis* and not that?'

Among the languages that adapted the etymon from Latin, many resumed, *mutatis mutandis*, the aforementioned dualism, in some cases hanging on to it for several centuries before its dissolution. In Middle and early modern French, for instance, *praxis* had been reserved for specialised, often technical endeavours (science, medicine, law, etc.), but eventually the word began

to disappear, giving rise to the expansion of the Francophonised *pratique/pratiquer*. Likewise, as Raymond Williams explains, *praxis* 'has been used in English since the sixteenth century to express the practice or exercise of an art or an idea, a set of examples for practice, and accepted practice. In none of these is it quite separate from practice.'[6] By the early twentieth century, *praxis* had become very nearly archaic, and the occasional invocation of the word tended to be specific, technical or scientific. Take the translation of *The Psychopathology of Everyday Life*, where Freud embarks on an analysis of *Fehlleistung*, an action whose explicit intent is displaced by another, unconscious aim.[7] Of course, the most famous example of this 'faulty function' is the slip of the tongue (*das Versprechen*) or so-called 'Freudian slip' (*freudsche Fehlleistung*), but this is only one instance of a broader phenomenon that includes things not only misspoken, but also miswritten, misread, forgotten, lost and botched. The translators of Freud's Standard Editions (James Strachey et al.) struggled to find an English equivalent for *Fehlleistung*, finally settling on '*parapraxis*' to describe the unwitting 'success' of an unconscious action alongside its conscious failure.

Notwithstanding the criticism surrounding this translation – that it's clumsy, stilted, pseudo-scientific – we cannot comprehend the motivations outside of the philology of *Praxis* itself. As we know, the word had gradually disappeared from English, as well as most Indo-European languages, by the twentieth century. As a result, one naturally assumes that the origins of the *parapraxis* were Greek. Though technically true, it's hard to imagine that this neologism would have been offered up had not *Praxis* itself been so ubiquitous in German. In the early twentieth century, the word circulates more widely than ever before, and one need only consult Freud to find innumerable references to '*psychoanalytischen Praxis*'.

Three

Among the languages that resumed the dualism we discover in Latin, only German preserved *Praxis* and pressed its distinction into philosophical service. On the one hand, German adapted the Latin *practicare*, thereby giving rise to Kant's familiar nomenclature

(*der Praktik, praktisieren*). On the other hand, German also appropriated the transliterated Greek (*Praxis*) we associate with Marx and the development of revolutionary action. The problem does not consist in the agony of choosing one philosophical path or the other but in recognising the linguistic resources on which German thought was able to draw. After all, how can we understand the enduring existence of *Praxis* here and almost nowhere else? In the first place, we would call it a 'loanword' – a word adopted from one language to another without translation. Thus, unlike the adapted *Praktik*, the adopted *Praxis* enters German as a foreign word. Still, one would be hard-pressed to consider it as such: despite its peculiar (and peculiarly intransigent) form, *Praxis* exists 'as a virtually German word'.[8] What, then, is it?

In Early New High German and then High German, *Praxis* covered much of the same semantic terrain associated with *Praktik*. Often enough, the terms were substituted for each other, though not entirely without consequences. *Praxis* was often coloured by the suggestion of technical professions qua skills (the term was explicitly identified for some time with surgeons). The different valences of the two terms are borne out in Kant's philosophical lexicon. In the *Critique of Practical Reason* and throughout his oeuvre, Kant speaks of '*das Praktische*' – with one exception. In 'On the common saying: this may be true in theory but it does not apply in practice' (1793), both the title and the essay itself conspicuously adopt the language of *Praxis*. It's been said that, in the context of his critique of institutional tradition and political wisdom, Kant co-opts 'the word *Praxis* and the "commonplace" that is attached to it by the very writers he is criticizing (the "popular" philosophers and the jurists and theorists of government of the Enlightenment)'.[9] Ultimately, though, Kant's attempt to borrow the cruder, more common and more technical *Praxis* in the interests of practical reason only serves to underscore their disparity.

Surely Kant's reference helps to explain why the young Hegelians and then the young Marx seized on *Praxis* in earnest. In the *Economic and Philosophic Manuscripts of 1844*, Marx stresses the significance of *Praxis* in contradistinction to previous materialisms, all of which struck him as fugitive idealisms. A year later,

in the opening sentences of 'Theses on Feuerbach' (1845), Marx laid bare the concept and mystification of *Praxis*:

> The main defect of all hitherto-existing materialism – that of Feuerbach included – is that the Object [*der Gegenstand*], actuality, sensuousness, are conceived only in the form of the object [*Objekts*], or intuition [*Anschauung*]; but not as human sensuous activity, practice [*Praxis*], not subjectively. Hence it happened that the active side, in opposition to materialism, was developed by idealism – but only abstractly, since, of course, idealism does not know real, sensuous activity as such.[10]

Above all, Marx's critique consists in showing that previous materialisms reduce 'the Object [*der Gegenstand*], actuality, sensuousness' to the 'form of the object [*Objekts*], or intuition [*Anschauung*]'. Behind Feuerbach, then, it's impossible not to see the looming figure of Kant. In so many words, Marx's contention is that, despite the significance Kant attributes to practical reason as the groundwork of morals and the domain of ethics, he dilutes practice of its very substance, 'human sensuous activity'. In the process, Marx returns the question of *praxis* to the place from which it has been exiled – not Kant's second *Critique* (when it's already too late, the propaedeutic framework having already been decided), but his first *Critique*. For Kant, of course, the 'form of the object' (object = x) is contingent upon the forms of space and time within which all sensible experience is given. In the *Critique of Pure Reason* Kant reserves the term *Anschauung* to describe the peculiar faculty of 'intuition' whereby experience operates upon our minds and we upon it. In other words, intuition comprises the condition for being sensibly affected as well as the conditioned state of being affected.[11]

For Marx, by contrast, the mystery of *Anschauung* reflects the mystification of 'the Object [*der Gegenstand*], actuality, sensuousness': extracted from subjective *Praxis*, it has become the enigmatic object of speculation, theorisation and metaphysical riddling. The irony in all of this, as Marx suggests in the 1844 *Manuscripts*, is that '[t]he

solution to the theoretical riddles is the task of practice [*Aufgabe der Praxis*]'.¹² Marx's solution, magnified by Engels, inspired a lineage (or, perhaps, several) within Marxism – one thinks of Lenin, Plekhanov, Goldmann, Gramsci and the Frankfurt School – that made *Praxis* an expression of method, resistance, political and economic struggle, and revolutionary action. *Pace* Marx, philosophy itself consists in 'the philosophy of *praxis*'.¹³ My point, however, is that this eventuality was conditioned, to no small extent, by the existence in German of the loanword *Praxis* alongside the cognate *Praktik*. The opportunity to lay claim to *Praxis* was contingent on both the word's familiarity and, to a certain extent, its redundancy. The latter made it possible to leverage *Praxis*, as if it were a kind of nominal pleonasm, 'a virtually German word' with an entirely German counterpart, in order to recover a Greek sense of the political.

Four

Whatever we choose to call them, these conditions did not obtain in French or English; as we've seen, *praxis* gradually disappears from common usage, becoming specialised and very nearly archaic. There could be no better proof of this comparative linguistic difference than the fact that the reappearance of *praxis*, in English and French, is due more than anything to the translation of Marx in the twentieth century! Indeed, lexicographers attribute the resurrection of the word to the new editions of Marx's early works, in French and English, and the corresponding reception – predominantly the 1930s and the 1960s.

This relatively recent resurrection of *praxis* ought to compel us to grapple with the longstanding lineage of 'practice' that comes out of Medieval Latin. The latter exported *practicare* to Old French, whereupon it evolved into the Middle French verb (*pratiser, practiser*), and finally settled into the familiar verb (*practiquer, pratiquer*) and its noun form (*practique, pratique*). The subsequent emergence of the etymon in English reflects debts to both Latin and, perhaps even more significantly, Middle French, from which *practice, practise, practic* and *practicale* were derived in the fourteenth and fifteenth centuries. Moreover, this aggregative lineage may well explain why the English 'practice' has acquired its wide variety of

shades and meanings. At any rate, while we cannot hope to parse all its idiomatic valences, we can roughly historicise a number of its trajectories. Chronologically, uses of 'practice' (n.) in the early fifteenth century concern particular professions, especially the practice of medicine and law, as well as their premises. Soon enough, the term came to be defined in opposition to purely speculative endeavours or, alternatively, to entail the application of speculative ideas/ideals; in both cases, practice was distinguished from theory, and so it came to suggest performance, accomplishment, achievement, working, operation and realisation. Nevertheless, from the end of the fifteenth century, 'practice' began to acquire a second and altogether more abstract definition, namely repeated behaviour, conventional exercise or habitual action – often with an eye to learning, improving or preparing. Thus, alongside the practice of law and medicine, with which we began, one soon came to speak of, say, 'legal practices'. Even as bureaucratic procedures of law were enacted in the present, 'practice' came to reflect the rote experience of the pro forma and the establishment of well-hewn customs.

The intimations of this dichotomy are borne out when we consider the development of 'practise' as a verb, especially inasmuch as it acquired both intransitive and transitive usages.[14] The transitive has traditionally been the more common of the two, and in relation to the first appearance of 'practice' (n.) the corresponding verb initially means to be engaged in law or medicine (or some other such profession or occupation). Along these lines, to practise came to mean: to exercise one's skill in a trade, skill or art; to observe (a duty) or perform (a rite); and to carry out the teachings of a religion, adhere to a faith or follow a custom. At the same time, an intransitive use of the verb developed whereby to practise meant to repeatedly perform (an activity) or regularly exercise (a skill) in order to improve, maintain or ready oneself. This corresponds to the second sense of practice (n.), for the intransitive verb introduces us into activities and exercises that are recurrent, habitual, often continuous, and ultimately drawn out into a kind of convention. Taken to semantic extremes, 'practice' seems to comprise nearly opposed perspectives. On the one hand, it pertains to the material reality of our existence and the

will to alter it, as opposed to the logic and abstraction of theory. Hence, we say 'practise what you preach' because practice denotes the field of real experience in which one's morals, so easily maintained under ideal (or hypothetical) circumstances, actually count. But on the other hand, it seems to consist in a kind of preparation, such that a musician practises with an eye to a recital or an athlete in advance of a game. Thus, we say 'practice makes perfect' because this exercise is prefatory – in other words, because practice is not the real thing.

Notwithstanding the plurivalences of the English word, this feature of 'practice' is by no means unique to English: it exists in German (*Praktik, praktizieren*) and French (*pratique, pratiquer*), as it did in Medieval Latin (*practica, praticare*) and ancient Greek (*praxis, prassein/prattein*). What do these examples share? The Greek export finds a home in Latin, French, German and English to the extent that it is assimilated to the conventions of the host – spelling, pluralisation (of the noun), conjugation (of the verb), pronunciation and so on. Only under these conditions does the whole word family emerge, like an archipelago, in the sea of signification (*practic, practising, practitioner, practised, practical, practicable, practicalise, practicality, practically*, etc.). By contrast, when Latin, German, French and English adopt the transliterated Greek *praxis*, the noun stands alone, a solitary lexical island. There are no other parts of speech – unless, of course, we recourse to versions of 'practice'. Of course, we'd have to admit that this feels like bad faith: having chosen *praxis* to begin with, why would one opt to vehicularise it by dint of 'practice' except inasmuch as there is no other option, no verb with which to activate *praxis*?

This point must not be underestimated in light of Deleuze's own practice. Consider once more how we characterised the definition of philosophy: that which we practise, and the practice of creating concepts. Rhetorically, there can be no question of our encompassing both aspects of this task, much less others, by dint of *praxis*. One could say that, in order to create concepts, Deleuze dispenses with the concrete and limited language of *praxis* to embrace the relatively limitless, if ambiguous, opportunities opened up by practice, understood here to be a family of words. Practice provides the flexibility to adapt, to invoke different shades

of the noun, to enact different modes of the verb, to encompass both the rigours of practising and the reality of practice.

Five

Deleuze rarely speaks of *praxis*. Predictably, the term appears several times in his most manifestly Marxist work, *Anti-Oedipus* (though this is also likely to be the intervention of Félix Guattari, the book's co-author, who was a great deal fonder of the term). More telling are Deleuze's comments in 'Intellectuals and power', a widely anthologised discussion with Michel Foucault from 1971. In conversation, both thinkers dwell on the fate of the intellectual and the recognition that older modes of intellectualism – monastic, juridical, literary-humanistic – are no longer adequate to the challenges of contemporary society.

Interestingly, far from disclosing even the least bit of nostalgia for the demise of those modes, both philosophers take this eventuality to be an opportunity. As if to speak for both of them, Deleuze remarks: 'Maybe it's because for us the relationships between theory and *praxis* are being lived in a new way.' Thus, where formerly *praxis* was typically taken to mean the application of or inspiration for theory, Deleuze insists that the relation between theory and *praxis* is invariably 'fragmentary', inevitably 'local' and ultimately exigent: 'A theory cannot be developed without encountering a wall, and a *praxis* is needed to break through.'[15] In light of Foucault's work, which never ceases to ask '[w]ho speaks and who acts' (DI 207), Deleuze's point is that, rather than oppose theory and *praxis*, both terms ought to be posed against the spectre of representation with which they are reified and ossified. 'There is no more representation. There is only action, the action of theory, the action of praxis, in the relations of relays and networks' (DI 207), Deleuze writes. 'So it is that theory does not express, translate, or apply a praxis.' Foucault agrees: 'it is a praxis – but local and regional, as you say: non-totalizing. A struggle against power, a struggle to bring power to light and open it up wherever it is most invisible and insidious' (DI 207–8). What concerns me here is Deleuze's response: 'Yes, that's what a theory is, exactly like a tool box' (DI 208). Of course,

this avowal (frequently repeated thereafter) has attracted a great deal of critical attention and debate, but when we understand it in the context of this conversation, the 'tool box' acquires a different sense: not a metaphor plucked from the ether but a material and machinic extension of *praxis*.

Notably, Deleuze returns to the concept in his book on Foucault,[16] but far from confirming the previous conversation, the commentary seems to mark the divergence between the two philosophers: unlike Foucault, whose work is aligned with *praxis*, Deleuze himself all but abandons the term. Does he still belong to the inclusive 'us' for whom 'the relationships between theory and *praxis* are being lived in a new way'? More to the point, why does he regard philosophy (and his own work as a philosopher) as practice and not *praxis*? These are questions that return us to Marx and, thence, to Aristotle, and it's in this context that Deleuze's preference for practice takes shape.

In Marx's recuperation, *Praxis* took aim at the transcendental tradition of philosophy (i.e. German Idealism) on the basis of a recourse to a Greek term and, in particular, an Aristotelian concept. This was not without problems. For all its advantages, *praxis* entangled Marx in the complications of Aristotle's system. In the latter, the very nature of *praxis* was, to no small degree, defined in opposition to *theoria*. For Marx this was naturally the opportunity to lay claim to action and to render it the instrument with which to pursue communal and political concerns. In any case, this materialist sense of *praxis* demanded a particular approach and entailed significant costs. Because activity is apportioned among three *epistemoi*, *praxis* is distinguished from *theoria* as well as *poiēsis*; in affirming it, inverting its relation to *theoria*, Marx tacitly renounces *poiēsis*. Here's the problem: for Aristotle, *poiēsis* concerns what is made – an object, product or state that is achieved – whereas *praxis* is actually understood on the basis of the activity itself. The end of *praxis* is the energising of the one acting or doing, and while this ought not to be diminished, it's hard to imagine a Marxist practice that does not, finally, take account of material ends. Of course, Marx surely believed that, in contrast to *theoria*, the immanent political claims of *praxis* suited his project, but we might say that if Deleuze speaks of practice this is precisely because *praxis* implicitly

divorced materialism from the productive undertaking of *poiēsis*. The point is not that one is more important than the other but that, in practice, we ought to realise both the action and the object – even (or especially) if that object is a concept. Simply put, the creation of concepts is a work of art, which Deleuze's practice unashamedly embraces.

Six

But if Deleuze's philosophy bears witness to a longstanding philosophical engagement with artistic practice, this book concerns the reverse, namely the artistic engagement with philosophical practice. These engagements yield not only ideas with which to return to art but, also, the inspiration to experiment philosophically, to bring art to bear on concepts, to think with Deleuze. Careful though he was to distinguish the creations of philosophy (concepts) from those of the arts (broadly, percepts and affects), he thrills at the prospect of 'interference', when and where the practices of philosophy and art enjoy a kind of proximity. At these frontiers, distinctions are swallowed by 'zone[s] of indiscernibility'[17] – and inasmuch as he gravitates to those zones, it's surely because they confirm the creative and thoroughly syncretic practice of philosophy. Practice, he says, 'must be judged in the light of the other practices with which it interferes'.[18]

I do not know whether artists today are on the whole more interested in philosophy than before, but I think it's fair to say that, where and when this is the case, Deleuze's influence and appeal are undeniable.[19] Personally, I know of no other philosopher or thinker who assumes so prominent a place or inspires as much enthusiasm in the intellectual life of artists. In this regard, it's worth recalling Deleuze's discussion, in *Practical Philosophy*, of the exceptional circumstances whereby artists – non-philosophers – are influenced and inspired by Spinoza.

> Writers, poets, musicians, filmmakers – painters too, even chance readers – may find that they are Spinozists; indeed, such a thing is more likely for them than for professional philosophers. It is a matter of one's practical conception

of the 'plan.' It is not that one may be a Spinozist without knowing it. Rather, there is a strange privilege that Spinoza enjoys, something that seems to have been accomplished by him and no one else. He is a philosopher who commands an extraordinary conceptual apparatus, one that is highly developed, systematic, and scholarly; and yet he is the quintessential object of an immediate, unprepared encounter, such that a nonphilosopher, or even someone without any formal education, can receive a sudden illumination from him, a 'flash.' Then it is as if one discovers that one is a Spinozist; one arrives in the middle of Spinoza, one is sucked up, drawn into the system or the composition ... the affective reading, without an idea of the whole, where one is carried along or set down, put in motion or at rest, shaken or calmed according to the velocity of this or that part. Who is a Spinozist?[20]

Could the same not be said for Deleuze himself? Today, he has come to occupy a similar position with respect to artists, and for somewhat similar reasons. One does not set out to be a Deleuzian any more than one sets out to be a Spinozist (notwithstanding the conventions of academic philosophy, which promotes them, these affiliations are absurd!). Rather, the point is the philosopher becomes the object of an 'unprepared encounter' that grips the artist, and then 'it is as if one discovers that one is' a Deleuzian.

Notes

1. Deleuze, *Francis Bacon: The Logic of Sensation*, p. 81.
2. Deleuze, *Cinema 2: The Time-Image*, p. 280.
3. Ibid.
4. Aristotle, *Nicomachean Ethics*. This is an abbreviated version of a list taken from Cassin et al., *Dictionary of Untranslatables*, p. 820.
5. Among other sources on the subject, see Clackson, *Indo-European Linguistics*, and Benveniste, *Dictionary of Indo-European Concepts and Society*.
6. Williams, *Keywords: A Vocabulary of Culture and Society*, p. 268. Though there were occasions when *praxis* was rigorously understood as a 'systematic exercise in an understood and organized skill', Williams

admits that this wasn't 'predominant in the English development. As late as 1800 Coleridge used the wider sense: "in theory false, and pernicious in praxis"' (ibid.).
7. Freud, *The Psychopathology of Everyday Life*, pp. 71–114; see also Laplanche and Pontalis, *The Language of Psycho-Analysis*.
8. Cassin et al., *Dictionary of Untranslatables*, p. 823.
9. Ibid., p. 824.
10. Marx and Engels, *The German Ideology, Including Theses on Feuerbach*, p. 569. Note that I have modified the translation, which renders *Anschauung* as 'contemplation', with 'intuition', now the standard translation vis-à-vis Kant.
11. Above all, see the exposition of the 'Transcendental Aesthetic' in Kant, *Critique of Pure Reason*.
12. Marx and Engels, *Economic and Philosophic Manuscripts of 1844 and the Communist Manifesto*, p. 122.
13. Gramsci, *Selections from the Prison Notebooks*, p. 381ff.
14. Notably, the *OED* draws on a single dated source – the *Rolls of Parliament* 1439 IV. 158/1 – to provide examples for both forms.
15. Deleuze, 'Intellectuals and power', in *Desert Islands and Other Texts*, p. 206. Here and throughout this chapter, this title is referred to as DI.
16. See Deleuze, *Foucault*, p. 27: 'Foucault is not content to say that we must rethink certain notions; he does not even say it; he just does it, and in this way proposes new coordinates for praxis.' On the same page, he adds: 'The stakes of Foucault's book lie in a different theory, a different praxis of struggle, a different set of strategies.'
17. Deleuze and Guattari, *What Is Philosophy?*, p. 25ff.
18. Deleuze, *Cinema 2*, p. 280.
19. Among the more notable instances, consider Elmgreen and Dragset's 2015 exhibition 'Aéroport Mille Plateaux'; see Flaxman, 'People, places, things'.
20. Deleuze, *Spinoza: Practical Philosophy*, p. 129.

Gregory Flaxman is the director of Global Cinema Studies at the University of North Carolina, Chapel Hill. He is the author of *Gilles Deleuze and the Fabulation of Philosophy* (Minnesota 2011) and the co-author (with Robert Sinnerbrink and Lisa Trahair) of a forthcoming book on cinematic thinking from Edinburgh University Press.

2
Philosophising Practice

Antonia Pont

> Discipline, when it is not the learning of a skill, is an enraged impatience about people's salutary unwillingness to comply.
> Adam Phillips, *One Way and Another*

Practice and those labelled practitioners tend to be associated with a certain idea of discipline. Practitioners can be people on whom others (non-practitioners?) regularly project the quality of *being*-disciplined, thereby activating a raft of assumptions to flesh out popular conceptions of this term.

At the same time, practitioners can be people who mistake their own activity for discipline at one level, but who – if they are consistent and serious – might over time find themselves confronted by a methodological or experiential undermining of received ideas about this.

I propose that practising can be understood as (constituting) a context in which ideas about intention, activity, action, desire and 'discipline' are tested, unsettled and clarified. This chapter argues that this mode of doing – as an articulate and articulable body of lived knowledge – can be joyously accompanied by Deleuzian conceptual rigour and inventiveness. The latter provides a precise vocabulary for the robust and established methodologies of the former, to which the enthusiastic engagement with Deleuze's oeuvre by arts practitioners in general might attest.

But even if one were to indulge some version of the notion that *practising involves being very disciplined*, what, we could ask, might

be uncovered about discipline, as well as its associated notions of intention, acting, agency and so on, over the course of a sincere and sustained engagement with practising per se via any of its various modes? Hiking, cooking, painting, dancing, singing, listening, reading, prayer, life-drawing, golf, swimming, gardening, movement practices, cleaning, sculpture, meditating, drawing, climbing and sewing are all examples of structured behaviours with the potential to operate as practising.

Phillips's quote confronts us with two readings of what discipline might be. His binary invites us to disambiguate it, to be precise about what we mean in order to clarify what we might, in the absence of rigour or lucid curiosity, have assumed.

One way to enter into some of the preoccupations of this volume is to ask, equipped with Phillips's provocation, *in what ways would practising be, or not be, about discipline?* If indeed it is about discipline, then what ilk of the latter might this be? What does practising, in other words, help us to understand better about actions, intention, agency, capacity and change?

I'd propose that practice, as many meet and live it, has unproblematically much to do with the first limb of Phillips's definition. It is – among other things – a skill that one learns. Arguably, however, it has less to do with the second limb of his definition.

I will invite the reader to approach practising as having a wholly subtractive relationship with both impatience and compliance. A subtractive relation, if we follow Badiou on the notion, involves a negation that isn't destructive, or rather the term 'subtraction' can be another way of saying that there is an absence of any relation whatsoever, an avoidance of reliance on the logic of the other's terms.[1] So, practice is not busy with opposing or refusing impatience or compliance; it's simply that it will happen to have no relation with them or how they operate.

This is not to say, within the laboratory of practising, that the practitioner will never encounter the atmospheres of both compliance and impatience. Rather, practising is not an operation dependent on, or fostered by, these modes or moods.

Instead of compliance and impatience being conditions for practice-as-discipline – as regularly assumed in lay contexts – the

story we can tell, thanks to Deleuze, is a radically different and more interesting one. To repurpose a phrase used by Deleuze in relation to the Eternal Return (which will become relevant later in this chapter), I'd argue that practising 'repudiates [compliance and impatience] and expels them with all its centrifugal force' (DR 113).[2]

If subjectivity too, in a usual sense and as a kind of habit ('the habit of saying "I"'[3]), is disrupted, ignored, transformed, complicated or simply left behind by what practice brings into play, we see the way in which it must also unravel the terms on which compliance relies – *what or who would be compliant with what or whom?*

Practising might be a context in which operations of compliance may come to light and which – precisely in order to enable this – does not set forth on the basis of compliance, thus rendering obsolete a certain inflection of disciplined-ness.

Rather than being subjects who have learned compliance, and who would mobilise it to maintain or foster a given order, practitioners stage encounters with their own tendencies to comply or to resist complying (often the same thing) and gradually, surreptitiously, may come to *un*learn these. Along the way, they may gain insight into the adequacy or otherwise of compliance as a descriptor for how action or, better said, *movement* obtains.

Practice, as practitioners often come to experience, can tend to interrupt received conceptions concerning the subject as discrete and primary. On the other hand, the strangeness of practising pertains to its parallel tendency to foster stability or emergent *stabilities*. Practitioners seem to have a certain structural integrity that accompanies them, or which seems to be conjured in their vicinity – a kind of atmospheric wake. This atmosphere has little to do with the practitioner-as-subject, but instead reflects an alignment with, or participation in, processes proper to practising and its associated ontological entanglements.

Relevant to this, in his 1968 work *Difference and Repetition*[4] Deleuze goes very far in displacing the notion of identity as primary, and of identity-thinking or the dogmatic image of thought. We can appreciate that Deleuze's project in this work is at once painstakingly philosophical and political in its motivations. Echoing what Wendy Brown notes in her book *States of Injury* (1995),

a certain formation of the individual – and I read this tendency as including a reliance on identity for thought – facilitates the conditions for the control and domination of this same entity (conditions under which the term 'compliance' might be relevant). Brown writes:

> These [highly individuated, self-interested subjects produced by liberal cultures and capitalist political economies] turn out to be the subjects quintessentially susceptible to disciplinary power: their individuation and false autonomy is also their vulnerability.[5]

Brown spots an operation inherent to a certain conception of subjectivity – namely that it does not become more robust as a result of its self-interest and individuation. Instead, so-conceived and constituted, it is in fact rendered and produced as increasingly vulnerable (or more unstable).

Brown, here too, employs the term 'disciplinary', inflecting it negatively as that which might come to bear on assemblages, shaping and restricting their trajectories and becoming, in networks of relations that perhaps don't produce very much joy.

While practice does not reinforce identity (or the subjectivity noted by Brown), it does not forgo a certain mode of stability, otherwise conceived. In practice, something (or some*how*) remains stable. Perhaps we could say more accurately that in practice stability itself is invented, a new expression of stability obtains, or perhaps the conditions for it. It is a stability consisting neither of achieving alignment with the dominant, existing sociopolitical order, nor of the practitioner-as-discrete-subject consolidating notions of their own autonomy.

As a mode that may relieve us of the business of ramifying identity, practice, again rather strangely, does not dilute the possibility or importance of responsibility. It arguably reframes it, in a way more aligned with this term's etymology than with its looser, and morally tinged, associations of blame and duty. The practitioner becomes a site where responsiveness is more, rather than less, likely. The practitioner is responsible insofar as she is aware of, or embedded within, networks in which she participates and

reacts, in which she is *affected*. From one perspective, she has arguably harmonised forces 'within' herself, so as to be capable of a response from a specific, but non-static, site within a field. This response is not sheer reaction, or when it is reactive it is an *acted* reactivity.[6] Practice then invites the arising – or coming out of solution – of new stabilities, wholly real perspectives that can coalesce and dissolve again, thereby enabling capacities for responsiveness, or responsibility. These are not reliant on existing codes and loyalties (hence are subtractively engaged with such codes) while at the same time do not by default (or compulsively) dispute them. In a kind of post-adolescent position, practitioners would be theys (*pl.*) who are invested neither in the undermining of dominant orders (as objectified project – rendering them dependent on what they dispute), nor in maintaining a static position or making incremental gains within a sedimented order.[7]

(When Deleuze and Guattari speak of the nomadic (DR 46), we can read into this mode of distribution allowance for the rhythms of slowing, or dwelling for a time. The nomadic is that which fills *itself* into space, rather than being distributed within it. Being 'without property', it might also not preclude the varying modes of sojourn and waiting, alongside a plethora of other rhythms, other inclinations in space and timing.)

To return to Phillips's equation, although practising can be difficult, it is not fostered by impatience. It comprises encounters with force and between forces, but does not obtain *through* the forcing on the part of a so-called discrete subject. Non-compliant, yet not gauchely mutinous at a gross level, the practitioner arguably cultivates a precise and emergent relation with reactivity itself. By including reactivity in its ambit, what we deem here 'practising' enacts a turning – a minor, almost non-existent, reinflection – of this very mode, coming closer to the mechanics that underpin action and change in a given state of affairs.

Deleuze, as we will see throughout this volume, contributes enormously to the thinking of *how change happens*. Via his exhaustive ontological inquiry, he invents, investigates and thinks *becoming* – the ways of change. He also invents (or repurposes existing) vocabularies to open this mode to articulation and greater precision.

In order to do this in his company, his reader/practitioner must go very far, or very deep, and make looser any received and easy assumptions of how life is, and what its processes entail. Practitioners, I'd contend (and as we see throughout the chapters in this volume), are those who have always been in this laboratory – over the course of millennia – but who, not necessarily being philosophers, and perhaps cautious regarding orthodoxies in thought, have on the whole abstained from speaking about these matters. Without precise vocabulary and a multiplicity of deft, conceptual machines – both of which I'd claim Deleuze provides – *saying* practising can be either a mediocre, over-simplified business or disconcertingly esoteric.

In this sense, we could say that through his discipline of philosophy (in the sense of a learned set of skills) Deleuze has incidentally (or otherwise) *un*muted practising. By querying how change happens – politically, larvally, socially, amorously, molecularly, aesthetically – he intersects with the secret, tenacious, and often unacknowledged, preoccupation of practice, which – whether it knows it or not – operates in a sibling laboratory, staging gorgeous and terrifying accidents, courting intensities, and not-precluding joyous collisions.

If practice, in any sense, bears a relation to discipline, then we can only agree to Phillips's initial definition: that it pertains to the learning of a skill or skills. Practice, then, is also a kind of learning, and, in this way, a mode of invention. It would require at the very least – like learning, which as adults we can forget – a tolerance for lost-ness and not-knowing. As well as a *getting*-lost, practice would invite or court a *becoming*-lost, a setting out into lost-ness – a skill for embarking with this strange intention. Aaron Ridley speaks to this lost-ness in his noting that, for Nietzsche, if freedom for all of us consists in a willing of the laws that constrain us, art distinguishes itself further insofar as, for artists, such laws 'defy all formulation through concepts'.[8] For art practice particularly, as this volume will attest, practising involves a lost-ness that can be unpacked in one way by appreciating it as *willing oneself to be constrained by that which is unformulatable in advance*. It turns out that by willing constraint, one strangely slips its bindings.

This, again, confounds any knee-jerk definition of discipline. Furthermore, Phillips's binary calls attention to another, more insidious coupling nested inside the first. In this one, the pole corresponding to an impatient and compliant version of discipline conjures its assumed and unexamined opposite. It is the naturalness or presumed self-evidence of this second term that practising, I'd argue, unsettles, undermines, even nonsensifies. When we use the term 'discipline' in that second rage-flavoured way, we almost invariably, in the very same manoeuvre, affirm the validity or usefulness of that category, quality, temperament, known as laziness.

To align oneself with the enraged mode of discipline involves, as I see it, a concealed but robust (and defensive) belief that humans are lazy, or that laziness is *primary* and must be overcome. Laziness, here, carries a clearly pejorative inflection. This easy pairing, which precludes multiplicities that escape its structuring (*what isn't disciplined is probably lazy*), aligns with the position that says: by default we are at risk of falling out of desire, and must strap ourselves into its seat, hence the necessity of a certain inflection of discipline. (To invoke such discipline, however, I'd argue, further lessens the likelihood of desire's surfacing, of movement obtaining. We have all experienced the drop out of one's own enthusiasm after the institution of a pious, imposed programme.)

We can challenge this anxious suspicion that we are indolent creatures with the other possibility that we might, in fact, be unable to avoid desire's roaring, tireless surf. This recalls for me Deleuze and Guattari's observation concerning William Turner:

> Looking at his paintings, one understands what it means to scale the wall, and yet to remain behind; to cause flows to pass through, without knowing any longer whether they are carrying us elsewhere or flowing back over us already.[9]

They speak here about art in order to intimate the nature of desire's flows – its lava rivers, its storms, insidious trickles, and coy delayings.

'To be lazy' – by now clearly a dubious concept – would rely on the existence of a subject who can motivate, or fail to motivate, itself *as* subject. Laziness, then, as a concept, can only hold with the persistence of a certain understanding of subjectivity. It is this particular subjectivity that both Deleuze and practising-as-mode invite us to lose our taste for.

As we'll see in Philipa Rothfield's chapter on Deleuze's Nietzsche and dance, Deleuze has been crucial in the lineage of thought that unsettles entrenched assumptions regarding human agency, as well as the phenomenological preoccupation with experience as necessarily being that of the experience-of-a-subject. This is one example of the ways in which Deleuze's contributions to thought have made possible a philosophising of practice which – I'd contend – was simply not feasible before his conceptual labours.

Deleuze prepares thought for an articulation of how practice works and what practice does – this is not insignificant for art, for politics and for daily life. The repercussions, the reverberations, of this contribution in philosophy (whether taken up, integrated, modified, extended or distorted by readers and philosophers proper) are not appearing to settle any time soon.

Labelling ourselves lazy, and our seemingly unflagging belief in its concept, might on the other hand be an impatient response in the face of curiosity as to why – and bafflement or despair as to why not – activity, movement or change happens. As Rothfield notes, one of Nietzsche's questions in *Daybreak*, and an enduring question for any philosophy, is: *how is it that human action comes about?*[10] And indeed, even beyond the category of the human, *what is the how of movement? of* real *change?* has global implications, in this moment, that are clearly not insignificant. Dance, as a practice, offers one refined context for pursuing this inquiry. Similarly, practising per se, as a register or mode that Deleuze assists us to think, is the field in which we can rigorously ask about, and invent, ways of (and into) action, becoming and change.

Let's risk a preliminary definition, then, that practising (at one of its registers) is a particular *mode* of doing, which at the

same time constitutes an effective affective laboratory – a suitably artificial and contrived context – for learning doing, the hows of action, and for courting transformations or newness. Practising, in this way, would not be normal or natural, while at the same time more common than assumed, and partaking of the universal.

Practice does not pursue a *return* to any state or existing thing, but rather sets out – with no thought of origins or catalogued destinations. This is where it intersects with an intentionality that may mirror Deleuze's expressivist kind rather than a voluntarist one.[11] In its setting out to unknown destinations, however, practice also invariably goes via the strange portal of repetition. Its (approach to) intention would appear to follow certain contours of ontological insight, which it does not – necessarily and of itself – make explicit.

A Zen practitioner (with over thirty-five years' consistent practice) once mused to me that people tend to begin practising because they want to fix their 'problems', but they only continue if they become interested in what constitutes the nature of problems per se.

Practising can be considered a mode of close reading of doing and action, and of what enables them. It speaks to Phillips's discipline-as-learning, since to practise is to cultivate a capacity for a very precise kind of action, and to seek to explore, or to be willing to find oneself encountering, action's character proper. No matter the shape of practising – whether one throws pots, plays an instrument, rows (or, or, or . . .) – a practitioner also always comes to accompany the very way change and movement unfold. She may come to cultivate a capacity for courting intensities – a rare learning – or, better said, to abstain from smothering the latter's moments of inception.

To risk a cliché: practising is learning not to get in the way. Or, it involves the 'discipline', if you like, of non-obstruction, that passes via an exquisite relationship to obstructions.

Shortly I will turn to two central concepts or operations signalled in the title of Deleuze's 1968 work *Difference and Repetition*. There could be no other two operations that speak more explicitly to how practice works in its closest mechanisms.

Difference and Repetition was published for the first time in a year now marked as revolutionary in France and across the globe. At a time when change was seeping, pressing, or exploding up through the cracks in the dominant order, and creative and parodic – that is, repetition-based – forms of resistance were proliferating, Deleuze published a work that offered a coherent, systematic ontological scaffolding on which one could potentially hang rigorous accounts of how what was going on was linked to what is always also going on. *Difference and Repetition* is less of an explicitly political work than, say, *Anti-Oedipus* and *A Thousand Plateaus*; however, it offers a conceptual vocabulary and vision, as an essential and *generative* work for what was to come after, and a clear lexicon for that which subtends the political.

Difference-in-itself

The book has five main chapters, of which the first two are salient for our purposes: Chapter 1, 'Difference in itself', and Chapter 2, 'Repetition for itself'. Already in the Introduction, Deleuze is frank about what's at stake:

> It is rather a question of knowing what it means to 'produce movement', to repeat or to obtain repetition. (DR 12)

He links movement *with* repetition, rather than – perhaps more predictably – linking repetition with stuckness or movement's faltering. In order that a reader/practitioner be able to appreciate the nuance of this, Deleuze will have to take us via a long detour into the history of philosophy and the status and conceptualisation of what has been called difference. Difference, he will point out, has never really had its own concept. There have been many examples of *conceptual differences*, but no rigorous *concept of difference* (in itself) (DR 40). We read, in a passage concerning difference in Aristotle, about where this emphasis took root, in a 'propitious moment':

> This is the sleight of hand involved in the propitious moment (and perhaps everything else follows: the subordination of difference to opposition, to analogy, and to

resemblance, all the aspects of mediation). Difference then can be no more than a predicate in the comprehension of a concept. (DR 40–1)

From then onwards, difference is confined to being a predicate only (something we can say about something else, not its own thing). Although remaining an unruly one, it is subjected to a kind of domestication. The differences for Aristotle – specific and generic – will distinguish things, operate between them, and set the limits of categories (think: taxonomic ranks). Given two things, it will be on the basis of their opposition, their comparability, or their similarity, that we could countenance thinking difference between them. Why does it matter that difference is subordinated in this way? Deleuze explains that, when we think difference like this, thought remains caught in a mode that is representational: '[g]eneric and specific differences are tied together by their complicity in representation' (DR 43).

Difference, as predicate, is relegated to this status within the register of representation. Put somewhat simply, this would be the register within which we can perceive things as legible, already existent within orders and categories, self-evident – comparable, similar or opposed, and definitely *identified*. As Terri Bird notes in her chapter, however, 'artists engage with force relations in processes that render sensory or perceptible the imperceptible'.[12] Art is not, for Deleuze, about representation. The tricky part of the register pertaining to representation is that it always comes to seem foundational, substantial, 'natural'. For this conjuring to obtain, it is necessary for thought to be restricted to a notion of difference that is mere *conceptual difference*, and for it thereby to be deprived of its own concept.

Deleuze's project in this chapter is to trace a philosophy of difference and with that the possibility of a concept of difference (in itself). There has always been this other difference, occluded but nevertheless insistent – often monstrous, and cursed (DR 37) – and which, in that 'propitious moment' in Aristotelian philosophy, in a kind of ambiguity or via 'a fracture introduced into thought' (DR 41), which Deleuze pinpoints therein, glimmered for a moment before being

again subordinated, mediated in that Aristotelian atmosphere. This unmediated difference, this difference as a concept in itself, will be that on the basis of which 'things' or individuated and identifiable entities might be generated, eventually to be shown *to be different from* each other. Of analogy's problem – as it relates to specific and generic difference – Deleuze notes:

> [I]t must essentially relate being to particular existents, but at the same time it cannot say what constitutes their individuality. (DR 47)

What does constitute their individuality? Not what *thing*, but rather what *operation* or series of operations, concatenations, scores of larval movements and interactions? Beyond analogy, and 'circulating and communicating underneath matters and forms' (DR 48), is the answer: another, secret difference. This *productive* difference is an entirely positive concept. It is not dependent, and does not logically arise after forms and matters. It can be read as a verb, rather than a thing. Difference is an operation, something-happening, logically prior to 'things' at all. We read his description of it as

> that which acts ... as a transcendental principle: as a plastic, anarchic and nomadic principle, contemporaneous with the process of individuation, no less capable of dissolving and destroying individuals than of constituting them temporarily; intrinsic modalities of being, passing from one 'individual' to another ... (DR 47–8)

Practice, I'd like to contend, and in a meta-sense of this mode of doing, is almost sheer methodology, as the lived and quotidian staging of encounters with difference-in-itself. Its point is to welcome these – monstrously, humorously! Of course, practice always goes (and interminably) via all other kinds of differences. When we practise, we also slog or skid our way through habitual registers. Practice reinflects what habit makes possible – that is, continuity in a living present – but it extends and diversifies

what habit establishes by also *not*-precluding the other modes of time. Practitioners become connoisseurs of the most minute and nuanced differences, with the latter's particular ilk corresponding to the chosen modality of practising. The yogi notices differences in distributions of weight through the palms of the hands. A golfer notes a slight variation in the arc travelled by the club in the swing. A ceramicist clocks the tiny difference in rhythm each time the clay hits the wheel. Imperceptible to a non-practitioner of that mode (the golfer may or may not be able to spot or comprehend the rhythmic change of the ceramicist's wheel . . .), these differences for the practitioner are never incidental, but they are also neither pursued nor evaded. An equanimity – to borrow a term from another tradition – is cultivated in relation to conceptual differences, lived and cascading differences-between. The practitioner comes to know them very well, and learns not to be too busy with them. Conceptual difference, after all, is not his preoccupation. Difference-in-itself is what secretly motivates the engagement.

Via the inherent wandering that constitutes practice – within each and every iteration of practising – fine and precise mechanisms that constitute the hows of practising work to not-preclude encounters with, or intimations of, that other difference. This *other* difference, despite representation's 'shackles' (DR 38), simmers beneath this register. Representation occludes its workings but cannot arrest them, since representation itself is generated out of its swarm.

Practitioners, whether they've read Aristotle or not, whether they knowingly subscribe to tidier notions of difference, have also been buffeted by the squall of difference-in-itself. It might be why practitioners go back for more – back to the choreographies of repetition (about which we'll say more) – and the minutiae that matter but also *mustn't* matter too much.

We can sidle up to the atmosphere, and thereby towards the concept, of this other kind of difference via particular operations in art – where we see an inquiry into a relation with the indeterminate that is characteristic of practice more broadly. Approaching it from this angle, Deleuze explains:

> Nor is it certain that it is only the sleep of reason which gives rise to monsters: it is also the vigil, the insomnia of thought, since thought is that moment in which determination makes itself one, by virtue of *maintaining* a unilateral and *precise* relation to the indeterminate. (DR 37, emphases added)

If we hold off, momentarily, from reading 'monsters' as merely negative, and instead read this term as that which is not legible in the register of representation, as that which evades the latter's categories and existing taxonomies, then monstrosity arguably also has something to do with the new and with futurity. This might be why our dreams include both latent, recognisable content (our episodes recycled, handled again) and our unshaped and illegible desires, teeming forth in strange containers and muffled languages. Practice, due to its necessarily iterative rhythms, often lulls us, and dreams us – tending to marry an insomnia or alertness with something indistinct and emergent. In my experience of practising, one roams among the three modes or syntheses of time (as Deleuze has clarified them; see Chapter 2 of *Difference and Repetition*): the living present, the pure past and the empty form of the future, which the Eternal Return helps us to think (DR 91ff).

In the quotation above, a strange intention is at work: that of maintaining a relation to the indeterminate, one that is unilateral and precise. Let me offer an example from the practice of *asana* (postures) in yoga. To an outside eye, yoga postures would seem to be some kind of exercise in putting the body into curious shapes, probably with the aim of getting stronger, more flexible, or cultivating balance. For the serious practitioner, who inhabits these poses *as invitations*, something else entirely is also going on. By moving very slowly, and attempting a vigil of alertness, or attention – a shifting distribution throughout the felt body – what is at stake concerns the attempt to perceive *what is not there*, or that which *doesn't appear*.

To perceive that which is not represented is a strange intention. Or, to redeploy Terri Bird's musings on the matter, *to render perceptible*

forces that lie beyond perception and to capture, in what is given, the forces that are not given.

The riddle of practising *asana* is that the transition from not being able to 'do' the pose to being able to 'do' it will reliably go via an encounter with nothingness, or with the indeterminate. The strangeness of yoga practice is this setting out to look for the silent space, the blank/*blanc*, for that which is not able to be catalogued (and thereby not able technically to be even felt at first).

The reason, perhaps, why the body cannot find its way into a particular pose might involve material capacity (muscles, bones, flesh, confidence), but also a relation to the pure and empty form of the future for which there is yet no cartography – a future in which an entirely new and as yet uninvented 'body' will become that particular pose. The practitioner will not travel across this gulf, will not be brought along. 'She' does not exist as a typical subject, and as the sum of umpteen relations and encounters – assemblages, if you like – coalescing and disappearing in each instant, is unrelated to whomever (or whatever constellation of forces) was *there* before. The practitioner, in this way, can have no enduring identity, in any rigorous sense. Their personal belief in their own identity, however, may be thinned out to varying degrees, depending on their capacity to reflect on what is happening in practising.

Again we recall Deleuze's formulation: *maintaining a relation with the indeterminate.*

This notion of the indeterminate gestures towards the terrain of difference-in-itself. The usual differences through which one trawls as a practitioner, and by and with which one may become unduly distracted and preoccupied (*maybe I'll just move my shoulder a little like this; maybe I'll just wriggle things this way; maybe I'll use more force and that will do it . . .*), are merely gross content among which one may happen upon intimations of another movement or deeper operation. The above formulation, which hints at the potential of maintaining a relation with the indeterminate, is not foreign to those familiar with the atmospheres and strange intentions involved in practice.

We can conclude at this point that practitioners are difference-workers, in both senses of this term. They are constantly shuffling and sifting through what we might call difference*s* (n.) – between

this pathway and this other pathway, between this amount of pressure, or that shade of colour, or that positioning – but thereby they also have a direct but mostly unuttered immersion or fluency in, or acquaintance with, difference-in-itself.

Practitioners, I've always privately mused, are at an unfair advantage when it comes to reading and finding their way with this book of Deleuze's. This advantage, of course, is also enjoyed by philosophers, since philosophy, as we'll read in the final chapter of this book, is itself a mode of practising. Reading, writing, thinking, and inventing and articulating concepts are some of the structural modes of those who practise in this modality.

In the third section below, we look to the focus of the second chapter of *Difference and Repetition*, 'Repetition for itself'. Before we do, I want to make a further detour via our earlier binary of discipline and laziness – to return to it, but differently.

Active laziness or the criterion of relaxation

If a discipline/laziness binary operates unchallenged, we might find ourselves wedged and deprived of movement, flipping between the poles of pleased-with-oneself discipline (read: economic productivity, tractable psychology, pious busy-ness) and its dreaded spouse, laziness (read: reluctance, lethargy and pathologised psychologies). Wedding oneself to either pole will conjure (eventually or inevitably) its opposite. Practice works into the imprecision of this insidious logic, slipping its noose by taking up its 'negative' pole and enacting it actively.[13]

As I've written elsewhere,[14] an indispensable criterion for doing-inflected-as-practice is relaxation. It is the third moment of four that constitute practising. Relaxation disturbs the logics at play in the discipline/laziness pair, reframing the second term by unsettling the way it can be mobilised within habits of thought and their representational spinoffs.

Relaxation, when it is not ghettoised within New Age or corporate vocabulary, is a strategy for approaching the conundrums of how movement obtains, and one that does not preclude transformation and which can also cultivate new modes of stability. There are vast numbers of philosophical writings within Taoism,

as well as other traditions that we do not have space to inventory here, except to say that Deleuze's work brings certain schools of thought back around to these lineages – to notions such as *Wu Wei*, for example, which can be translated as 'action-not-exist', as opposed to non-doing, or abstaining from action. The latter renderings in the English are too oppositional, missing the litheness of the Taoist and Deleuzian offerings.

To leave unexamined the ubiquitous concept of discipline as compliant action, or as complying with oneself or some super-ego – as opposed to the entirely different matter of willing, or 'becoming what one is'[15] – is both imprecise and also debilitating.

Bowden's noting that, on the issue of agency, Deleuze might be best described as expressivist[16] suggests that intention and action do not exist in a sequential or chronological relation, or even in a logical one where intention is taken as the condition for 'real' action. Rather, actions are the expression of intention. In other words, *what* we do brings to light what *is/was* intended.[17]

Practising, I'd contend, is the space in which research into these questions is experientially undertaken, where the practitioner plays with the logical orders of intending and doing, becoming acquainted with their characters – rigorously and intimately. In my experience, practising tends to confirm that what we like to call discipline is primarily a learning – a profound learning about the nature of actions, events, intentions and sense. One can only assume that Phillips himself, in his own practice of intense listening that we dub psychoanalysis, came to *learn* this, hence his statement. (There is a further way in which practice might welcome rigorously a tag of discipline, which we'll touch on in the final section below.)

Working with student-practitioners, I use the suggestion of 'elegant laziness' as a way for them to approach various movements and transitions. (This recalls Nietzsche's emphasis on what he names 'style'[18] insofar as style/elegance operates as a kind of enabling constraint. It turns the limitations of any set of circumstances into its strength.)

The oxymoron in this instruction – elegance/laziness – is intentional, seeking via ideokinesis to unbind approaches to

movement that are trapped within the polarisation of striving/ forcing *or* collapse/resignation. Unravelling this insistence in newer practitioners – *only/either* forcing *or* collapsing – requires much stamina and subtle working. The insistence is not only at the level of received ideas (as if one could just put these down and pick up a new idea). It would seem to have come to structure the body's very capacity, to have circumscribed it. Discipline/ laziness is a misconceptual structuring that, recalling Deleuze's Spinoza, quite simply produces less joy and diminishes that of which a body is capable.[19] Noting that practice has the potential to weaken the former's hold, we can begin to appreciate one example of how practice works to enable bodies. This enabling would not stem from any discrete skill sets that practice appears to cultivate. Instead, yogis can do more in the world because they understand *what doing is* and have curiosity rather than resentment for *how movement obtains*, not because they can stand on their head, or drop into a back bend from standing.

Miraculous repetition

A simple way to explain what is at stake in *Difference and Repetition*, and, I'd wager, what is at stake – throughout a life, urgently and profoundly – for each of us, is whether there is a register other than the register of perpetual change and modification, something other than generality. This question arguably frames our most persistent longings (political, amorous, artistic and so on) whether we grasp it as such or not. In relation to generality, the mode in which we typically exist, Deleuze writes: 'The exchange or substitution of particulars defines our conduct in relation to generality' (DR 1). In quotidian life, our time is *constituted* by exchanges and substitution of particulars. *This type of food by this more recommended type of food. That reading material by this more strategic or rigorous reading material. That suburb. This more clement job. That partner. This life-attitude. That more complete belief system. This inside pet.* The cascading of generalities and their incessant replacement by others – similar, opposite, modified, 'improved' – as well as our exchanging of current generalities for anticipated ones *just up ahead* marks the flavour of a life in our particular sociopolitical moment. It may,

however, also just be the familiar taste of any *now*, of what Deleuze calls our 'lived, or living, present' (DR 91): habitual time.

The substitution game, the exchange of one thing/person/place for another, is also a way we know that intensity can be avoided. Through it, we can objectify, while adroitly fending off, the contours of any unknowable future.

In order to be able to think a register that isn't generality, we will have to go to the very operations that constitute or synthesise time, those which give 'us' time, but which also thrust us, in the moment of time's usual constitution, into the dual orders of habit and memory, and their incumbent activation of representational modes.

Deleuze dedicates the first chapter of *Difference and Repetition* to outlining the difference between the difference we have been able to think, and with which usual thought is cosily at ease – *conceptual difference* – and the other kind of difference. The first is what I sometimes call 'difference-between', and it governs the relationships between nouns. The other difference – difference-in-itself – coincides with the very operation that founds nominality.

If we wish to move out of generality, then the question is an operational one: *how?* If you want to make a train move using steam, then you need to understand the principles of thermodynamics. To understand how to get out of generality, how to move differently in an ontological and existential sense, then you need to get very accurate about the mechanisms constituting this same generality. This is what I read Deleuze to be emphasising when he writes: 'it is rather a matter of knowing what it means to "produce movement", to repeat or to obtain repetition' (DR 12).

Movement happens, so he seems to be implying here, not through resisting or overcoming repetition, but in conjunction with it, or on the condition of its operating. Repetition is not movement's obstacle, but rather the key to its rare register.

Repetition, as it turns out, is the shape in which difference first appears. Difference-in-itself has no bulk, no there-ness. It is only accessible by dint of repetition's operation. Repetition

almost retroactively implies difference-in-itself, constituting the first change of which we can say 'there has been a difference'. Before the 'shape' that we call repetition, there was only 'perfect independence on the part of each presentation' (DR 90) – outside time, logically prior to any time.

Hume sets out the way to first think this, and Bergson extends it. We recall that 'the rule of discontinuity or instantaneity ... tells us that one instance does not appear unless the other has disappeared' (DR 90). And Deleuze reminds us: 'a succession of instants does not constitute time any more than it causes it to disappear; it indicates only its constantly aborted moment of birth' (DR 91).

For time to synthesise, we will need a contraction, a way for the wake of these instances to linger, for their impact to register somehow and conjure time's originary continuity. Deleuze calls this operation (which is not really a thing, or a place) the imagination, and we can think of it as akin to the ability of a lake's surface to hold a trace of the boat's propeller that moved through. The water here is the *operation* that allows for the bringing into appearance of the sheer, disappearing moments of a movement, and acts as the medium for its trace. This first trace, this contracted series of moments, which otherwise was disappearing technically without existence (difference's *in*-itself), constitutes the living present. Formed on the basis of a contraction-operation dubbed the imagination, it is the 'water' of our example as an original subjectivity that is strictly passive.

Deleuze writes:

> Time is constituted only in the originary synthesis which operates on the *repetition* of instants. This synthesis contracts the successive independent instants into one another, thereby constituting the lived, or living, present. (DR 91, emphasis added)

We see here how repetition fits in. If the cascading instants *are* repetitions (as the quotation suggests), there is however no basis on which one could claim they are the same (and therefore repeating).

Deleuze says that this is why the in-itself of repetition isn't thinkable. It has no yardstick at this register. What the succession of instants *do* do, however, is change something in the 'mind' or medium that retains the succession, as a *contracted synthesis* of instants. A change is introduced into the 'mind', this change is the first difference, and *the form of the first difference* is repetition. This will be repetition-*for*-itself. It is not difference at the level of substance, but the first difference as a structural operation.

Is it not wonderful – the first appearance of difference turns out to be that particular form/structure that we call repetition! Difference initially arises as formal, not as nominal (or more precisely as a designation of relations between 'things') at all. Hence, we find that there is a difference prior to the differences-between.

We read again, and hopefully with increasing insight:

> Does not the paradox of repetition lie in the fact that one can speak of repetition only by virtue of the change or difference that it introduces into the mind which contemplates it? By virtue of a difference that the mind *draws from* repetition? (DR 90, emphasis original)

The inextricable link between difference and repetition begins to dawn on the reader by now, and this brings us around to generality.

When time synthesises in the contraction of the living, habitual present, the order of generality is woken. In the mode of the 'first passive synthesis' – as Deleuze names this mode of time – the immediate past of retention (that is part of the living present's mode) is one of particularity, the particularity of instants, and the immediate future of anticipation is one of *generality*. The arrow of time moves from particularities to generalities, and our synthesised continuity chugs interminably along.

But the shape of our longing (and terror) is not for the generalities of our anticipations (and, at the next level, predictions), but rather for the singularities that hurl us into uncharted futures – pure empty futures – where it is a matter of the universal rather than the general, the singular rather than streams of particulars. And this begins to make sense of Deleuze's startling claim on the volume's opening page:

> To repeat is to behave in a certain manner, but in relation to something unique or singular which has no equal or equivalent. (DR 1)

Repetition here pertains to behaviour. *To repeat is to behave* . . . Practice involves getting involved with behaviours that are set up for, which intend to lure or court, a certain kind of repetition. The mode of practice is the container within which repetitions of all kinds, and at various registers, will be set going.

This brings us around to representation. Deleuze has a problem with it, and his reader slowly comes to see why. Curiously, however, representation is also one moment in repetition's repertoire. We read:

> The constitution of repetition already implies three instances: the in-itself which causes it to disappear as it appears, leaving it unthinkable; the for-itself of the passive synthesis; and, grounded upon the latter, the reflected representation of a 'for-us' in the active syntheses. (DR 92)

The active syntheses include those of understanding and memory, for example. Representation is a register *grounded upon* the passive syntheses that subtend it. It is one of repetition's modes, but a later mode, which hides that which enables it, while also cutting 'us' off from the generativity and changeability of repetition-for-itself as portal for difference-in-itself.

How, then, would someone mired in generality's element go about loosening the weave of its atmosphere? Representation (as repetition in a third instance) constitutes our appearing world. It amounts arguably to all that *exists* (depending on one's use of this term), but not to all that is real. Repetition-for-itself is real, but it doesn't appear. To this end, Deleuze has some interesting things to say about action. I will quote him at length:

> It is easy to multiply reasons which make habit independent of repetition: to act is never to repeat, whether it be an action in process or an action already completed. As we have seen, action has, rather, the particular as its variable and

generality as its element. However, while generality may well be quite different from repetition, it nevertheless refers to repetition as the hidden basis on which it is constructed. Action is constituted . . . only by contraction of elements of repetition. This contraction, however, takes place not in the action itself, but in a contemplative self which doubles the agent. . . . [C]ontemplation never appears at any moment during the action – since it is always hidden, and since it 'does' nothing . . . (DR 96)

One way to aphorise what practising is is to describe it as 'the art of doing nothing' (and indeed descriptions of this kind litter the literature of various traditions). This only superficially esoteric attitude becomes transparent when we go via Deleuze's work on the syntheses that subtend action. If the register of representation has become 'shackling', then practitioners have always known that the best way to welcome newness, change and the possibility of a future – which would not just be a generalisation of the current present – is to hone the craft of doing nothing, slipping below the threshold of action, above which we are ontologically excluded from the register at which repetition-for-itself operates and where difference is available and teeming. (We can note here that most of what we would typically deem 'doing nothing' in fact, or under the surface, involves dense doings – resistances, refusals, stealth manoeuvrings and so on. For this reason, the very precise and laborious 'doing nothing' of practice has little in common with quietism.)

We can see more easily how Nietzsche fits in here. Nietzsche, as Ridley notes, grasps that to be free is to do as one intends. The activation of this logic involves saying: *well, then, intend whatever it is that you do.* (Artists, more than anyone, know this.) To intend what you do is to skim all amending, modifying, regretting – actions over and above the bare minimum – off the top of what is happening. This gets the practitioner close to doing *nothing*. When one rides, as such, the limit function towards nothingness, the likelihood of action falling away and a coinciding with the register of repetition-for-itself becomes stronger.

The established practitioner has lived this as plausible, even self-evident, whether or not she has precise words for it. When not mired in hubris and misinformed ambition that tends to sneak action back in, she is consistently involved in a doing that invites a *becoming herself*. Such a mode would consist in inhabiting without reserve, without remainder, therefore *utterly*, the precise conditions into which one has been thrust: one's body and its hindrances; one's daily world, its obligations and interruptions; one's triggers and anxieties; one's character, and so on. The Nietzschean inheritance in Deleuze is clear, and practice enacts its singular strangeness alongside it, with startling alignments.

I read Deleuze's take on the Eternal Return to be an ontological, not merely ethical or moral one. Even if Nietzsche's contribution is intended as a thought-experiment (which it also *is*), Deleuze takes its mechanism much further, and practice – I'd affirm – plays out its ontological gravity in quotidian spaces and schedules.

Die Ewige Wiederkehr des Gleichen, as name for an 'attitude', a test, a threshold, draws on an ontological hunch about the relation we must adopt with the world if we are *not going to hinder or stymy* the world's (as *our* world's) becoming. The world does not need us to become itself. This is not its existential problem. We, however, as humans, may interact less or more artfully with the conditions in which we find ourselves. Certain capacities we have can rebound on us, insofar as we fail to take up joyously the constraints *that we are*. The Eternal Return plays out via the machine of repetition – a repetition, as Deleuze will emphasise, that is only miraculously obtained, so rare are the instances of our relaxing enough to *repeat* what we are. Relaxing, for the purpose of practitioners, can be summarised as *doing only what is necessary in any given context*, or matching effort to necessity in each singular case. As the yogis know, this dropping of effort constitutes a very strange kind of effort.[20] Relaxation during high jump is not comparable to relaxation in the bath. We see here that Deleuze's rejection of identity-thinking proves crucial. Comparison operates within representational thought, and this instance of repetition does not partake of the identical, the comparable, the similar or the opposite.

Repetition here means another mistake, again without wincing, joyous and wholly intended. It means not hankering for another version of myself, of my life, of you, us, or this broken, dithering 'now'.

Repetition in practice plays itself out by dint of the first of practising's criteria, namely the settling on *a set of structured behaviours able to be repeated*. The practitioner innovates via a *giving up of* innovation in the meta-structure of its modality. The ceramicist embraces the discipline (here's that word again, but now in a third inflection) offered by the *form* of her practice. They both repeat within the episode of a single session of practising, as well as repeating episodes of practising – every day, every week and so on.

There is a form and it admits of repetition, and within this repetition the so-called subject is carried along – forgotten, absented, transformed – since unmoored from the tethers of identity, comparison and negation which ensure a continuity as entity within habit's laws.

In this way, practice is both of the register of habit (and its time, the living present)[21] and then in rare moments – that seem outside time, because in fact subtracted from our usual continuities – gives on to the empty form of the future. There will have been a *coinciding*, and in this absence of excess and remainder, which involves repetition as miracle, there is a break with existing conditions.

Another, less dramatic but equally compelling, way to approach this emphasises the ethical richness latent in Deleuze's offering. This timbre of reading comes through in James Williams's framing of what it means to repeat:

> There is a way of repeating *well* [for Deleuze] with respect to the pure differences that give life its intensity.[22]

If life is intense, and constantly in flux, its constant streams of differences-between placing pressure on our continuity as entities, then we must ask the perennial philosophical question *how to live*, or, by extension, *how to invent the life one has (which doesn't yet exist)*. Williams evokes the idea of 'repeating well', a way of being in this world responsibly, responsively, and I'd add nimbly, which means ontologically informed.

So-called artistic practice might be a slice of a wider and often more muted engagement that unfolds across a vast range of modalities. I would call this approach to doing, intention, action, creativity and being alive *practising*. In its so-called 'artistic' modalities it can produce artefacts, but it can also operate quietly, producing less explicit outcomes – verbal or processual outcomes (almost nothing[23]) – which nevertheless reverberate through our worlds, contributing to the qualities of the atmospheres we inhabit, as well as care-taking and inventing new stabilities, those which can welcome and shelter the desires and differences that we are.

Notes

1. Badiou, 'Destruction, negation, subtraction – on Pier Paolo Pasolini'.
2. Deleuze, *Difference and Repetition*, 2004 edition, p. 113. Here and throughout this chapter, this title is referred to as DR.
3. Deleuze and Guattari, *A Thousand Plateaus*, p. 3.
4. See Chapter 3 of Deleuze, *Difference and Repetition*: 'The image of thought'.
5. Brown, *States of Injury*, p. 19.
6. On this point, see Chapter 5 of this volume, 'Experience and its others'.
7. On this point, see Brown, *States of Injury*, p. 25: 'Freedom of the kind that seeks to set the terms of social existence requires inventive and careful use of power rather than rebellion against authority; it is sober, exhausting, and without parents.'
8. Ridley, 'Nietzsche on art and freedom', p. 212.
9. Deleuze and Guattari, *Anti-Oedipus*, p. 132.
10. Nietzsche, *Daybreak*, p. 116.
11. See Bowden, 'Human and nonhuman agency in Deleuze', p. 72.
12. See the opening of Chapter 3, 'Forming', in this volume.
13. See Chapter 5 of this volume, 'Experience and its others'.
14. See Pont, 'An exemplary operation: Shikantaza and articulating practice via Deleuze'.
15. See Ridley, 'Nietzsche on art and freedom', p. 216.
16. See Bowden, 'Human and nonhuman agency in Deleuze'.
17. Ridley also makes this point; see 'Nietzsche on art and freedom', p. 216.
18. See ibid., pp. 210–11.

19. See Deleuze, *Spinoza: Practical Philosophy*, pp. 48–51, as cited in Bowden, 'Human and nonhuman agency in Deleuze', p. 61.
20. See Vācaspatimiśra, *The Yoga System of Patanjali*, p. 192.
21. For more on habit, see Grosz, 'Habit today: Ravaisson, Bergson, Deleuze and us'.
22. Williams, *Gilles Deleuze's* Difference and Repetition, p. 92, emphasis added.
23. This reading casts in a different light the quote (recalled from Rilke's *Florenzer Tagebuch*): 'Die Religion ist die Kunst der Nichtsschaffenden' (Religion is the art of the Do-Nothings). As a result, I read it to be *also* saying: *Religion is the art of the Nothing-Makers.*

Forming
Form in Platonism and Aristotle

According to a common reading of Plato, a Form (*eidos*) is an ideal, self-identical *type*, eternal and unchanging.

Examples: Piety (*Euthyphro*), Love (*Symposium*), Justice (*Republic*).

A just person or act *participates* in the Form of Justice. More broadly, the material world is constituted in relation to the Ideas that it participates in.

Crux of the issue: what is participation?

Forming
Form in Platonism and Aristotle

This is also the crux of Aristotle's critique: forms cannot exist on their own terms, outside of the material world that they structure.

Aristotle's view: *hylomorphism*, from *hule* (matter) and *morphé* (form).

For Aristotle, form is immanent to matter. A house is not an assembly of random pieces, but formed matter.

But to substitute white for red bricks, wood for stone, makes no difference to the form.

There remains a hierarchy of form over matter -> Forming is imposition of essential form on inessential matter.

Forming
Form in Platonism and Aristotle

Note the implication for the classical view of the artist: artist as analogue of God, giving meaningful form to dead matter.

Example: classical vision of the sculptor.

Here as elsewhere, Deleuze is a severe critic of Aristotelianism.

His essential if implicit resource here: Raymond Ruyer (who replaces *form* with *formation*) and Gilbert Simondon (who replaces *form* and *formation* with continual *modulation*).

Forming

Forming in Deleuze: first comment

Art is a creative project in the fullest sense.

It does not involve the imposition of an existing model on to dead matter, but the transformation of a dynamic material reality.

The relationship between philosophy and art is analogous: philosophy does not reveal Beauty and Truth, which are then taken up by the artist.

Not only is philosophy itself creative in this full sense, it unfolds at the same level as art. They *run interference* for each other.

> It is at the level of interference of many practices that things happen, beings, images, concepts, all kinds of events. (Deleuze, *Cinema 2: The Time-Image*, p. 280)

Forming

Forming in Deleuze: second comment

Deleuze therefore advances a different conception of matter = dynamic flows that do not necessarily bear any relationship to form.

So: matter is not dead homogenous 'stuff', but a plurality of these movements, characterised by differing degrees of intensity.

It is 'a powerful non-organic life', made up of 'unformed, unstable matters, by flows in all directions, by free intensities or nomadic singularities, by mad or transitory particles' (Deleuze and Guattari, *A Thousand Plateaus*, p. 40).

Substance = formed matter. But not all matter is formed = stabilised, organised, slowed down, fixed.

Example of an electrical circuit board, which is

> not made up simply of formed substances (aluminium, plastic, electric wire, etc.) or organising forms (program, prototypes, etc.) but of a composite of unformed matters exhibiting only degrees of intensity (resistance, conductivity, heating, stretching, speed or delay . . .) (Deleuze and Guattari, *A Thousand Plateaus*, p. 511)

Forming

Forming in Deleuze: third comment

From the point of view of fixed substances (i.e. formed matter) and our habituated experience of the world which turns around these substances, unformed matters constitute troubling encounters.

Example: the depth we encounter in the experience of vertigo.

But also: artworks. The goal of art is to render these dynamisms, to engender direct encounters with them.

> In art, and in painting as in music, it is not a matter of reproducing or inventing forms, but capturing forces. For this reason no art is figurative [i.e. representational]. Paul Klee's famous formula – 'Not to render the visible, but to render visible' – means nothing else. The task of painting is defined as the attempt to render visible forces that are not themselves visible. Likewise, music attempts to render sonorous forces that are not themselves sonorous. That much is clear. (Deleuze, *Francis Bacon: The Logic of Sensation*, p. 56)

3

Forming

Terri Bird

Forms of capture

The many and varied practices of art engage in multiple processes of forming, involving conceptual, material, bodily, temporal and spatial procedures. In *What Is Philosophy?* Gilles Deleuze and Félix Guattari insist 'composition is the sole definition of art', stating 'what is not composed is not a work of art' (WP 191).[1] They task artists with producing compounds of sensation that render sensory heterogeneous aggregates, or assemblages of affects and intensities extracted from forces lying at the limits of sensibility. The aim of art they describe is to render perceptible forces that lie beyond perception and to capture, in what is given, the forces that are not given. An exploration of composition as forming in this chapter will emphasise processes of capture orientated around practices using sculptural methodologies.

These practices produce materialisations experienced as spatial and temporal encounters, which engage materiality, corporeality, spatiality and temporality in procedures that artists such as Lynda Benglis and Richard Serra experimented with in the late 1960s and early 1970s. For example, Benglis exploited the inherent qualities of materials to take their own form in process-oriented approaches that required the production of the work in the place of its display. This is evident in works such as *Brunhilde* (1970), where she propped distorted sheets of chicken wire, covered with plastic, as temporary armatures for her polyurethane pours. This process produced airborne projections cantilevered from the

gallery walls.² Serra's *Verb List* (1967–8) catalogues actions for material manipulations that foreground making through experimentation. Serra explored this potential by emphasising material procedures in the production of works such as *Splash Piece: Casting* (1969–71), created by using the joint between the wall and the floor as a mould to form molten lead, which was thrown along this juncture. Multiple iterations of these castings were produced in the same space, forming an undulating fragmented surface as successive casts cooled and were pulled aside to make way for the next. As with *Brunhilde*, *Splash Piece: Casting* had to be presented in the location where it was formed. These works contributed to a shift in focus from the sculptural object, as a coherent form in space, to the plastic dynamics inherent in the specific properties of materials. This attention lends itself to practices that focus on the forces that constitute sculpture in the active determination of forming a work of art.

What is not in question here is the complex legacy that has seen the category of sculpture undergo constant transformation, particularly since the 1960s.³ What I am interested in is the manner in which artists engage with force relations in processes that render sensory or perceptible the imperceptible. These relations concern the capture of forces that Deleuze highlights in his writing on art. Initially I consider these relations in terms of forces of chaos captured as sensation in order to examine the force of sensations that open on to a world not lived or felt. Following this initial examination this understanding of the force of sensation is utilised to explore the relationship between forces and forms. Art for Deleuze is a continuous play of forces entailing, as Anne Sauvagnargues makes clear, 'as many art forms as there are possible modes for capturing forces, which results from our sensory apparatus, the social assemblage that renders the forces perceptible, the essential plurality of force, and the haecceity of material'.⁴ With the term 'haecceity' Deleuze develops a modal, non-substantial philosophy of individuation, which amongst other things changes the status of form. As a consequence, form is no longer configured as the imposition of content on to inert matter, as it is in the hylomorphic model; rather, Deleuze develops an understanding of individuation borrowed from Gilbert Simondon.⁵ Simondon

regards form taking as a process or event that places an emphasis on temporal appearance rather than the constitution of an individual or a secondary presentation. Simondon's understanding of individuation and the role of information exchange in this process will be investigated in this chapter in the context of forming used by artists.

The concepts borrowed from Simondon enable Deleuze and Guattari to reformulate a relationship between forces and forms, as a capture of forces, which displaces the form-matter relation and engages with the social assemblages that render forces perceptible. These assemblages are explored in this chapter through the influence of systems thinking initiated by Ludwig von Bertalanffy to highlight the interconnection between components of a system and its environment. I argue that the dynamic morphology proposed by Bertalanffy resonates with the understanding of individuation that Deleuze and Guattari develop from Simondon. Together they enable the *work* of works of art to be understood as processes of differentiations producing intensive composites of fluctuating force relations.

The understanding of art as a capture of forces contributes, Sauvagnargues notes, to 'its symptomatological function'.[6] This diagnostic function is a capacity that Deleuze attributes to writers and artists: to be symptomologists drawing a portrait of the world as symptom (DI 132).[7] Emphasising art's clinical capacity, Deleuze highlights the connections artworks identify that were previously dissociated, so as to mark the convergence of indicators that reflect a certain relation of forces. Sauvagnargues refers to this as 'a physics of affects' through which she suggests Deleuze draws attention to art's capacity to form 'a map of affects'.[8] This mapping function opens up a consideration of the plurality of forces at play in the production of art: forces that result from a range of sensory apparatuses and social assemblages that renders them perceptible. They include multiple economies of production and consumption, across various registers – material, social and economic. It is through a consideration of this plurality that I direct my discussion of the capture of forces to a selection of artworks influenced by systems thinking. This influence accentuates the heterogeneous character in the assemblages of affects and intensities that these

artworks extract from complex arrangements, including social and historical assemblages of interacting components.

These interacting components bring into relation forces as compounds of sensation. However, these compounds should not be confused with material. Sensation is neither represented nor realised in the material; rather, Deleuze and Guattari argue the material passes into sensation to become expressive (WP 193). As such the material is not an expression of sensation but sustains specific sensations.[9] Deleuze and Guattari maintain, '[i]t is the affect that is metallic, crystalline, stony, and so on; and the sensation is not colored but, as Cézanne said, coloring' (WP 167). These are rhythmic sensations in a state of dynamic modulation, and the spatialising energy that characterises these affects is found, they suggest, in an almost pure state in sculpture (WP 168). Although Deleuze and Guattari have little to say about sculpture in general or specific works, they refer to the sensations of stone and metal as vibrating according to the order of strong and weak rhythms. They write of the '[v]ibrating sensation – coupling sensation – opening or splitting, hollowing out sensation' of sculpture (WP 168). How these sensations of sculpture might be generated as vibrating sensations can only be inferred from exploring their other texts.

For instance, in *A Thousand Plateaus* they examine the tension between two differing modes of production, contrasting an iterative process of building used by stonemasons in the twelfth century constructing cathedrals and the architect who works from a pre-designed plan. They draw on the writings of Simondon to expose the insufficiency of the matter-form model, and argue it is 'less a form capable of imposing properties upon a matter than material traits of expression constituting affects' (TP 408).[10] By engendering the energy flows inherent to the stone rather than imposing form, the stonemasons were able to produce vaults in which the stones create a line or rhythm of continuous variation. Deleuze and Guattari claim '[i]t is the cutting of the stone that turns it into material capable of holding and coordinating forces of thrust, and of constructing ever higher and longer vaults' (TP 364). Through this understanding they reconfigure the form-matter couple associated with the hylomorphic model to articulate a series of dynamic relationships of material-forces (TP 369).

The force of sensation

The challenge for artists is to engage with these forces in forming processes of selection and framing that capture them as material expressions capable of passing into sensation.[11] These processes are not based on the relationship of matter and form that presumes matter receives form, content or meaning from elsewhere. Rather, these practices of forming entail an exploration of sensations registered as an interaction of forces and material. This is how Deleuze describes the activity of art, in an article originally published in *Artforum*: 'a relationship not of form and matter, but materials and forces – making forces visible through their effects on the flesh'.[12] This article became the preface to the English edition of Deleuze's most comprehensive account of the visual arts, *Francis Bacon: The Logic of Sensation*. Through a discussion that primarily focuses on the paintings of Bacon but also includes the work of Paul Cézanne and others, Deleuze develops a series of rubrics or guides that resonate with particular aspects and phases in Bacon's work. These guides are orientated by the rhythmic interrelations of their various elements and the manner by which they challenge bodily and pictorial clichés in order to convey sensation directly. Deleuze rejects a representational view of art, one he associates with habits of thinking that crowd the canvas with ready-made meanings, in order to focus on the forces painting captures as sensation. This is the task common to all arts that Deleuze stipulates, not to reproduce or invent forms, but to capture forces (FB 56).[13] The book's study of Bacon's artworks converges in a general logic of sensation, the summit of which for Deleuze is the colouring sensation he identifies in these paintings. This is a spatialising energy that modulates the relations between the formal elements enabling them to converge in a haptic sense of colour.[14] The tactile space of sensation is generated by a resonating vibration, a rhythmic coupling that, Deleuze states, 'no longer represents anything but its own movement' (FB 160).

In this haptic vision of colour painting discovers, Deleuze writes, 'in its own manner, . . . how to pass from the possibility of fact to the fact itself' (FB 160). How art can seize hold of the fact itself is explored more fully in *What Is Philosophy?*, where the arts

are examined more generally as a relation to chaos. This is a real, yet not empirical, undifferentiated reservoir of impersonal and imperceptible forces, simultaneously co-existing in a profusion of indistinguishable orders. Art, philosophy and science each interact with this undifferentiated profusion as distinct modes of thought and creation to harness the forces of chaos. Each is a creative confrontation whereby the virtual is actualised, in art through the creation of sensation, an activity that parallels philosophy's creation of concepts and the propositions created by science.

Art captures the forces of chaos, differentiating them through framing operations, to form compounds or blocks of sensation. This is a problem that all the arts respond to: how to incorporate something of the non-localisable vibrations of chaos that are without spatio-temporal determination. Art's goal, Deleuze suggests, drawing on Paul Klee's well-known assertion, is 'to render visible forces that are not themselves visible' (FB 56). This was the brilliance of Cézanne for Deleuze, 'to have subordinated all the techniques of painting to this task: rendering visible the folding force of mountains, the germinative force of a seed, the thermic force of a landscape' (FB 57). It is through these finite realisations that artworks arise from a becoming actual of the virtual. However, what surfaces ultimately surpasses the material qualities to resonate with the forces of chaos, in an operation that Deleuze and Guattari describe as the non-human becomings of the being of sensation. It is through this operation that a work of art passes to the fact itself, to allow sensations to stand on their own, as Claire Colebrook notes, 'beyond the body and mind of their creator – that opens onto perceptions of a world not lived, and affects of a world not felt'.[15] It is via this opening that Deleuze and Guattari claim artworks enact a passage that restores the infinite through the finite (WP 197).

The forces of chaos elaborated as sensation through art are grasped as a range of affective qualities. When the sensations captured by art are encountered but not recognised, when our habitual ways of making sense are inadequate, they provoke us to think (DR 138–9).[16] Unidentifiable as bodily perceptions and affections, these percepts and affects, Deleuze argues, challenge our habits of thought and clichéd modes of being in the world to give

rise to the new. The new is not a realisation of already known or imagined possibilities, a consequence or secondary effect; rather, it actualises the potential of chaos without determining, resolving or extinguishing this potential. This is the unpredictable capacity of invention that goes beyond the possibilities of causes and ends towards creative transformations (DI 31). The attention Deleuze and Guattari give to conditions that foster the production of the new is a pragmatic concern favouring the generative capacity of invention in the face of problematic tensions. Life responds to the encounter with this problematic by generating new ways to select, order and organise working solutions. Artworks are one way of responding to these problems through individuations that are continually reconfiguring responses to the problematic and problematising event that is the undivided totality of chaos.

This understanding of the practice of art insists on the open temporality of becoming between the virtual and the actual. It is through this movement of difference that Deleuze attributes artworks with the capacity of opening up assemblages to transformation. He describes them as war-machines – not that they have anything to do with war; rather, in the sense of 'inventing new space-times' (N 172).[17] As such, the emphasis on composition indicated in *What Is Philosophy?*, as noted at the outset of this chapter, should not be mistaken as only accentuating linkages between or within works of art. As Joe Hughes highlights, Deleuze draws on his earlier books on Spinoza and their attention to expression as the power to act when he emphasises composition. Composition refers equally to the way works of art assemble relations of forces and the manner in which affections organise, or are organised by, an encounter with a work of art. When Deleuze and Guattari suggest artworks are defined by composition, Hughes notes 'that this form is simultaneously formed and formative'.[18] This forming capacity of art is foregrounded by the artworks discussed in the following sections of this chapter. These works are not simply concerned with their formation as material relations; rather, it is through their forming that they are equally formative in the manner in which they engage with the world. This is particularly evident in the artworks of Hans Haacke. He has developed a practice of forming over the past fifty years that engages with a range

of forces through multiple apparatuses to map social assemblages, which focus on economies of production and consumption. It is through their forming capacity that the works discussed capture forces, which open on to a world not lived or felt, as noted above by Colebrook. The forces they open on to have the potential to disrupt our habits of thought and clichéd modes of being in the world.

Systems of forming

Through his engagement with the world Haacke is predominantly known as an artist associated with practices of institutional critique.[19] For example, Haacke conducted a series of visitors' profiles in the early 1970s, such as *MoMA Poll* (1970). This poll displayed responses to the question: 'Would the fact that Governor Rockefeller has not denounced President Nixon's Indochina Policy be a reason for your not voting for him in November?'[20] The accumulated answers, overwhelmingly affirmative, were visible in Plexiglas ballot boxes and automatically tallied using photoelectric counting devices. Employing systematic methods of gathering information, works such as *MoMA Poll* situate themselves at the nexus of power where the museum, part of the machinery that bestows value on works of art, intersects with the values of the culture at large. Further problematising these relations was the colour coding of the ballots according to the paying or non-paying status of the visitor.[21] This additional detail underscores the sociological interests Haacke would increasingly focus on; it foregrounds the networks of social and economic privilege in which the art world is enmeshed, at the same time as reflecting on the viewers who attended the site where the artworks were exhibited. These artworks incorporated a diagnostic mechanism identified by Deleuze that renders sensible the conditions at play in the social assemblage of the art institution. They perform this function through the identification of previously dissociated connections that mark the convergence of force relations.[22]

Haacke describes the series of visitors' profiles as compositions determined by the information provided by gallery goers.[23] The inclusion of auto-generating processes in these works accentuates the reduced visual considerations that come into play in determining

their form. Haacke minimises the role of the artist as producer, preferring to activate the contingency of procedures that offers access to a world beyond that which the artist can anticipate and control. He refers to these works as 'real-time systems' which acknowledge the entangled relations inscribing artworks as 'double agents', participating not only in systems of image production and communication, but also in sociopolitical networks.[24]

Although the sociopolitical emphasis of these works led to Haacke being associated with the practice of institutional critique, and conceptual art more generally, he frequently refutes these designations:

> I don't consider myself a naturalist, nor for that matter a conceptualist or a kineticist, an earth artist, elementalist, minimalist, a marriage broker for art and technology, or the proud carrier of any other button that has been offered over the years.[25]

Indeed, Haacke favours more open descriptions that allow for complexity and interaction. He insists on the interrelatedness of subsystems of knowledge production without hierarchy, remarking that '[t]he world does not break up into neat university departments'.[26] Preferring not to distinguish between working with wind and using computers to conduct a demographic survey, he regards both as systems of energy, stating, 'The energy of information interests me, a lot. Information presented at the right time and in the right place can be potentially very powerful. It can affect the general social fabric.'[27]

In recent years writers such as Luke Skrebowski and Caroline A. Jones have proposed more nuanced, although differing, appreciations of Haacke's practice that highlight certain continuities of influences at play in the development of his work since the early 1960s.[28] They draw attention to Haacke's initial works that engage ephemeral physical phenomena, such as the effects of condensation, water flow and wind currents, and biological events, such as swarms of seagulls or chickens hatching, to engage with the world as a system of exchanges encompassing both man-made and natural interactions. Haacke notes that he quickly came to realise

the biological and physical systems he was initially working with were interdependent on multiple elements that connected with the social sphere.[29] This systems focus attests to the influence of Bertalanffy, whose book *General System Theory* had a significant impact across various fields of contemporary thinking at the time. Together with the revised second edition of Norbert Wiener's *Cybernetics*, published in 1961, Jones contends, 'the artworld had its bookend bibles for a systems revolution'.[30]

Generally regarded as the instigator of systems thinking, Bertalanffy trained as an evolutionary biologist, initially focusing on the problem of the origin of organic matter. He developed an understanding of organisms as systems in a dynamic steady state, and insisted on explaining the co-ordination of parts and processes in a system on the basis of forces immanent to the organism. He maintained that 'the fundamental character of the living thing is its organization'.[31] Contrary to approaches that regarded organisms as relatively autonomous and discrete, he observed that '[l]iving systems are open systems, maintaining themselves in exchange of materials with environment, and in continuous building up and breaking down of their components'.[32] Introduced in 1940, Bertalanffy's understanding of life as a system of components that interact with their environment is, according to Debora Hammond, his 'most important contribution to the evolution of systems thinking'.[33]

In 1968 Bertalanffy synthesised his observations into a General System Theory that gave a dynamic account of quasi-stationary open systems that he defined as 'complexes of elements standing in interaction'.[34] He defined systems in terms of the arrangements of and interactions between sets of elements that connect them into a whole.[35] Rather than reduce an entity to the properties of its parts, Bertalanffy argued that a system is determined independently of the various components of the system. The key characteristic is the interconnection between elements. As such, the dynamic pattern of organisation that is the system as a whole is more important than its parts because of the constant interaction between components. Bertalanffy observed that the naïve formulations that result from thinking in terms of opposites were inadequate when the contrast between structure and process breaks down. The

living organism, he suggests, 'is at the same time the expression and the bearer of a continuous flow of matter and energy'.[36]

An interest in the transfer of heat into other forms of energy led Bertalanffy to observe that the Second Law of Thermodynamics, which states that everything moves towards stasis and entropy, did not apply well in living systems.[37] Although an organic system may appear stationary from a certain point of view, when examined more closely its maintenance involves incessant change. Bertalanffy argued that organic forms are an expression of oscillations and fluctuations that persist only in continuous change. He called this process that expresses an ordered system of forces '*dynamic morphology*'.[38] Later developments in biochemistry from the mid-twentieth century, aided by new instrumentation, allowed for a much more detailed examination of intra- and inter-cellular processes and more complex understandings of emergence.

These developments were explored by the physicist and chemist Ilya Prigogine, whom Bertalanffy credits with indicating that the 'biological point of view opens new pathways in physical theory'.[39] Prigogine's research into self-organising systems and non-equilibrium thermodynamics extended Bertalanffy's General System Theory and had a major impact on the field of non-linear complexity theory, which would later come to influence Deleuze and Guattari.[40] It had been Bertalanffy's endeavour to broaden General System Theory to be an overall organisational framework utilising mathematical models. He saw its potential to become, as he wrote, a theory of 'principles applying to systems in general irrespective of whether they are of physical, biological or sociological nature. ... irrespective of their particular kind, elements and the "forces" involved'.[41] While this aim was not fully realised, by the 1970s General System Theory had filtered out into a broad range of disciplines, such as engineering, computing, ecology, management and psychotherapy.

In the visual arts artists such as Haacke explored systems thinking through Bertalanffy's understanding of dynamic morphology, arising from feedback mechanisms within and between systems. Haacke was interested in exploring the potential of systems thinking to investigate non-human modes that allowed the forces and

operations of natural processes to appear.[42] A well-known example from this period is Haacke's *Condensation Cube*.[43] Canonised by art history, this artwork is usually referred to as a minimalist object or a container of processes existing 'independent of the viewer's perception'.[44] However, as Jones reveals, details of its actual function complicate these received understandings and allow for a greater appreciation of the interdependence of the artwork on inputs from outside to more fully exhibit its systems. Jones describes the box as 'less an object than a device for staging a slowly unfolding sequence of events that form a microclimate'.[45] Constructed of Perspex, it had a tiny hole drilled in a top corner to allow water to be added that cycled through several states, beginning as a liquid, evaporating into a vapour, and finally condensing again into liquid droplets. Jones describes the final phase of this steady state system as forming 'orderly yet subtly random patterns that run down the sides as rain'.[46]

During this period Haacke was focused on regulating the boundaries of the systems he was exploring. This is clear in his description of a system as

> a grouping of elements subject to a common plan and purpose. These elements or components interact so as to arrive at a joint goal. To separate these elements would be to destroy the system. Outside the context of a whole, the elements serve no function.[47]

Nonetheless, as Jones points out, '*Condensation Cube* would be unlikely to display its internal weather theater without two inputs from outside.'[48] On the one hand light was required to shine into the interior in order to raise the temperature, causing the water to evaporate. On the other hand a difference between the interior temperature of the box and the exterior temperature of the gallery was required for the condensation to occur.

An exploration of energy transfer is more fully evident in Haacke's *Grass Grows*. This artwork comprised a cone-shaped mound of topsoil mixed with peat moss and sown with fast-growing rye and annual rye seeds that grew for the period of the exhibition. *Grass Grows* featured in the seminal 1969 'Earth

Art' exhibition at Cornell University.[49] In relation to this artwork Haacke states,

> I'm not interested in the form, I'm more interested in the growth of plants – growth as a phenomenon which is something outside the realm of forms, composition, etc., and has to do with interaction of forces and interaction of energies and information.[50]

Haacke's exploration of energy transfer as an interaction of forces led him to correlate information with energy and develop an understanding of a flow of information as a physical system. This emphasis on physical systems is evident in Haacke's comment on the term 'system'. Systems for Haacke were not conceived in terms of perception; he states that 'the term system should be reserved for sculptures in which a transfer of energy, material, or information occurs, and which do not depend on perceptual interpretation'.[51] These systems engage physical, biological and/or social entities in dynamic interconnections and interactions between elements constituting an internal resonance. This resonance is produced from the difference between forces in these systems, which generates an exchange or communication of information.

Simondon's observations of internal resonance, in the often cited example of crystallisation, is key to his formulation of the dynamic processes of becoming that he attributes to all levels of individuation from technical objects to individual beings. Simondon is mostly known for his writing on the philosophy of technology and science. While a technical object comes from abstract reasoning, Simondon argues that the modes of existence for objects and individuals are intertwined in relationships with a milieu that an individuation both emerges from and transforms. Simondon understands information, as Pascal Chabot notes, 'in three different senses: syntactical, semantic and pragmatic'.[52] The broad range of questions this gives rise to leads Simondon to emphasise information as a relation of form and action, and to reformulate the question of formation as 'What is the *effect* of information on the milieu that receives it?'.[53] Simondon describes this effect in his observations of crystallisation, where information, in the form of a

difference, is introduced into a mother-water, an amorphous substance in a metastable state, and initiates a process of individuation. As Chabot notes, 'the problem is not to find out the origin of the germ, but to discover the conditions under which it will be able to have an effect.'[54] Key in his elaboration of crystallisation is the metastable state that provides an environment or milieu in which individuation is sustained in a process of becoming. In noting the importance of this identification, Deleuze remarks on the metastability of the pre-individual milieu, noting it is '[s]ingular without being individual' (DI 87).

The state of dissymmetry, on which Simondon's concept of disparation rests, is for Deleuze a fundamental difference from which individuation arises, '[a]n overlapping world of discrete singularities, which overlaps all the more given that the discrete singularities do not yet communicate, or are not yet taken up in an individuality: such is the first moment of being' (DI 87). The problem that disparate realities pose is resolved not through the integration, resolution or overcoming of difference but, as Deleuze writes, 'by organising a new dimension' (DI 87). Simondon's proposal is for a dynamic model of physical individuation that takes effect on the plane of forces and materials through processes of modulation. From this process emerges a provisional individuation stabilising the ongoing tension of the situation's dynamism in the interaction of matter–energy–information exchange. These observations highlight a distinction between structure and process that the material opening of difference makes evident. It is in response to the difference between structure and process in the work of certain artists that Jack Burnham developed his 'systems esthetics'.

Systems aesthetics

The preference for matter–energy–information exchange, favoured by Haacke in place of artefacts, was also shared by Burnham. Burnham introduced Haacke to systems thinking, recommending the writings of Bertalanffy, as well as those by Norbert Wiener on cybernetics.[55] Burnham was an artist who became a prominent curator and art critic and wrote a number of texts examining the

way artists were responding to the formidable technical innovations that were having an impact on approaches to the practice of sculpture. Unlike Michael Fried, who viewed trends towards a post-formalist objecthood and interdisciplinarity as undesirable, Burnham formulated a 'systems esthetics'.[56] Whereas the composition of visual elements was the basis of Fried's formalist interpretation, Burnham's aim was to encompass invisible elements and processes, taking into consideration the boundaries of art and how they connect with their context and the outside more broadly. Burnham incorporated a structuralist approach and developments in cybernetics and information theory, together with systems thinking, drawing on Bertalanffy's understanding of a system as a complex arrangement of interacting components. Burnham writes that a '[c]onceptual focus rather than material limits define the system', adding that 'a system may contain people, ideas, messages, atmospheric conditions, power sources, etc. . . . comprised of material, energy, and information in various degrees of organization'.[57] The systems consciousness Burnham argued for was less concerned with the skin of objects or 'the direct shaping of matter' than, as he writes, 'a concern for organizing quantities of energy and information'.[58]

The systems consciousness Burnham explored was equally influential in the field of psychotherapy, where it was utilised in the treatment of individuals. A prominent theorist in this field was Gregory Bateson, who explored an understanding of the family as a system and investigated the potential of this approach in family therapy. Bateson worked across a number of fields including cybernetics and systems theory and would come to feature in both Guattari's individual writings, as well as his work with Deleuze.[59] It was particularly the connections Bateson drew between psychology – what he referred to as the ecology of mind – and an ecology of nature that would be used by Guattari to develop an ecosophy.[60] This is an ecological approach to subjectivity and social assemblages that incorporates the three ecologies of the environment, the social and the psychological. Guattari's engagement with systems theory was influenced by his encounter with the Moroccan-born, mostly Belgium-based psychotherapist Mony Elkaïm. Guattari met Elkaïm while travelling in the

United States in the early 1970s, and quickly realised they held similar views regarding the need to engage with the larger sociopolitical context in the treatment of mental health issues.⁶¹ Their shared interest in Bateson's work and systems theory extended to the incorporation of Ilya Prigogine's idea of non-equilibrium open systems to counter the homeostasis inherent in Bateson's approach.⁶² While Bertalanffy recognised the value of the complex open systems theorised by Prigogine, Guattari regarded Bertalanffy's search for general laws applicable to all systems problematic as it discards singularity in favour of the general law.⁶³

While critical of systems theory as a discipline and its goal to extrapolate observations made in one domain more broadly, Deleuze and Guattari did not reject the idea of systems altogether. For example, despite the apparent non-systematic dispersion across multiple fields, Deleuze confirms Robert Maggiori's assessment of the systematic underpinnings of *A Thousand Plateaus*. Deleuze asserts that the rhizomatic structure of this book is an open system, understood as a set of concepts that 'relate to circumstances rather than essences' (N 32). He refers to the open systems in science and logic based on interactions that reject linear forms of causality as well as transforming the notion of time, adding the 'rhizome is precisely one example of an open system' (N 32).

The rhizome is one of several concepts that Deleuze and Guattari draw from Bateson, along with his notion of plateaus of intensity. The latter substitutes a state of continuous becoming for moments of crisis and resolution or states of excitation orientated towards climax. Deleuze and Guattari create a series of plateaus of intensity in *A Thousand Plateaus* in order to overcome the inherent teleology, as Robert Shaw argues, in the 'problems of the schizophrenic, the war-machine and the Oedipal complex'.⁶⁴ Although Bateson gets scant mention by Deleuze and Guattari, Shaw maintains that his influence is significant, particularly for Guattari's later writing such as *The Three Ecologies*, mentioned above. However, it is Bateson's emphasis on cybernetics, which renders the subject as a mere exchange of information, that Shaw notes separates his thinking from that of Deleuze and Guattari.⁶⁵

Despite systems thinking often being associated with cybernetics, Bertalanffy was keen to highlight their differences.[66] Cybernetics developed in the field of electrical and communication engineering to study the exchange of information, within and between natural and machine-based systems and their environments, and in particular the control of a system's function through feedback mechanisms. Its field of influence expanded as a consequence of a series of meetings, known as the Macy Conferences, held from 1946 to 1954, which attracted researchers from a wide range of disciplines – including anthropology, psychology and other social sciences – and prominent figures like Bateson. Although Bertalanffy regarded cybernetics as part of a general theory of systems, he maintained it was restricted to systems exhibiting self-regulation.[67] As a theory of control mechanisms, or circular causal goal-directed or self-regulating behaviour, Bertalanffy claimed the regulative mechanisms of cybernetics limited its applicability compared to the dynamic interactions of the open system model. The pre-determined structures of the feedback model, he suggested, predominantly related to secondary processes of regulation observed in nature. The structures of organisms, maintained through metabolisms and exchange of components, were primary regulations that, Bertalanffy insisted, necessarily evolve from the dynamics in an open system.[68] It is the insistence on an open system and the dynamics that this entails that signals Bertalanffy's importance for later developments in understandings of non-stationary structures and the dynamics of self-organisation.

The impact of systems thinking in the visual arts also persists where the transfer of energy, material and/or information is evident in numerous contemporary artworks that establish procedures to regulate the communication between components and their environment. These works deploy systems-based interactive processes that enmesh the viewer in physical and social entanglements. They attest to the flexibility of systems aesthetics, identified by Burnham, to describe a materially and historically diverse range of practices. For example, as Jones observes, a number of artworks included in 'Documenta 13' featured a systems approach.[69] This was highlighted by the importance artistic director Carolyn Christov-Bakargiev placed on the inseparable terrains of artistic

research, politics and the sensual energetic character of material. She choreographed the exhibition around a central core of disparate objects assembled in terms of their biography to foreground their encoded social, political and cultural connections. In advancing the potential of art to generate new ways of thinking, Christov-Bakargiev suggested an accord is required 'between human and the many non-human intelligences'.[70]

This accord was evident in the 2012 exhibition in artworks such as *Soil-erg* by Claire Pentecost. This multifaceted installation reimagined soil as a currency and emphasised soil health maintained through the activity of bacteria and fungi. The attention on this activity was coupled with consideration of the centuries-old practices of collecting seeds. As a material form of collective knowledge, Pentecost suggests, it is 'one of the longest-running open-source systems in history'.[71] Pentecost's practice actively engages in the politics of food, and, working with Brian Holmes and the 16 Beaver Group, she was involved in the Continental Drift seminars from 2005 to 2009 that enquired into geopolitical change and its local consequences, combining theoretical and on-the-ground exploration. For 'Documenta 13' Pentecost utilised local resources such as a collection of region-specific soil samples held by the museum in Kassel, and Germany's only agricultural research programme devoted exclusively to organic agriculture, based at the University of Kassel. *Soil-erg* proposed a new system of value based on living soil, rather than chemical inputs, a form of currency open to all through the activity of composting.

The abstract value of the dollar, Pentecost affirms, ultimately renders all commodities equivalent, enabling them to circulate and be traded on a global market. This levelling function of money tends to obliterate awareness of all the human and non-human effort it takes to sustain life. Pentecost and Holmes refer to this as 'an *aesthetics of visible blindness*: the capacity of select groups to enjoy the fruits of globalized capital while ignoring the price paid in drudgery and insecurity by others'.[72] Pentecost suggests that '[t]he important thing about the soil-erg is that it both is and is not an abstraction. Symbolically it refers to a field of value, but that value is of a special nature: it must be produced and maintained in a context.'[73] The heavy, loose structure of good organic soil makes

it inconvenient to circulate and so not easily commodified. The agricultural chemical industry overcomes this problem by isolating certain components that promise to increase the productivity of soil that they market as a suite of synthetic fertilisers. Pentecost maintains that 'soil-erg both evokes and denies the possibility of coinage. If currency as we know it is the ultimate deterritorialization, the soil-erg is inherently territorialized.'[74]

Forming territories

The territorialising functions Pentecost refers to entail processes of coding, decoding and recoding that operate in capitalism where any intrinsic value is replaced, such that qualitative differences become quantitative and are aligned with circulation. This formulation is explored by Deleuze and Guattari in the two volumes of *Capitalism and Schizophrenia*. In the first, *Anti-Oedipus*, they argue capitalism is the encounter of two forms of flows – the libido of desiring production and the social production of labour power (AO 33).[75] With this formulation they join Marx's understanding of labour and Freud's understanding of libido to examine the ways in which capitalism extracts a surplus from the connection that liberates the flows of desire through deterritorialising the social, while at the same time inhibiting this inherent tendency through the institution of private property and the family. Social production, they suggest, '*is purely and simply desiring-production ... There is only desire and the social, and nothing else*' (AO 29, original italics).

Through her investigations into the organic practices of maintaining soil and the social as well as biological knowledge attached to seed preservation, Pentecost forms an open system that attempts to formulate a new network of alliances. These alliances, in the proposal of a currency based on compost, engage with the human and non-human worlds. Her artwork breaks with the existing organisation of the social and economic networks, not as a diversion in the manner of a romantic notion of art or as simply a critique of the current situation. Rather, the lines of flight opened up in her practice align with what Guattari advocates when he suggests, 'it's not a matter of escaping "personally," from oneself, but of allowing something to escape, like bursting a pipe or a

boil. Opening up flows beneath the social codes that seek to channel and block them' (N 19). This is the forming capacity of artworks that deploy open systems to deterritorialise coded flows in order to reterritorialise them in new relations constituting new assemblages.

By the time Deleuze and Guattari wrote the second volume of *Capitalism and Schizophrenia*, *A Thousand Plateaus*, the terms 'territorialisation', 'deterritorialisation' and 'reterritorialisation' had taken on a much wider scope. Across a wide range of registers, a complex scheme is presented in *A Thousand Plateaus* to account for various regimes in an open system of arrangements, such as stratification that gives form to matters, the territorialisation that codes the earth, a micropolitics of desire and the segmentation of social organisation. Territoriality converges with processes of stratification, through reference to the flows of matter-energy, genetics, subjectification, linguistics and the formation of States, across a broad register of the physical, organic and social strata. Deleuze and Guattari utilise the geological inferences of this term they borrow from Bateson to incorporate a layering that takes place in space and time, which they explore through a series of plateaus. These plateaus allow for heterogeneous zones of mobile variation where segments connect within and between plateaus to actualise multiple interrelated strata and milieus.

The movements between these heterogeneous zones capture the flow of intensities on the plane of consistency, connecting them as aggregates through processes of coding and territorialisation. By slowing down the infinite speed of the forces of chaos, this process of stratification forms relatively stable consistencies. Deleuze and Guattari argue these fluxes and flows are traversed by a double articulation, of content and expression, form and substance, animated by forces that form and de-form assemblages as individuations composed of force relations. However, these extracted territories are always open to rupture by lines that deterritorialise fragments, freeing them from one context and enabling them to be reterritorialised in another. It is by this means that capitalism is constantly deterritorialising all of life and subjecting it to exchange.

It is via this dynamic of deterritorialising flows and capital accumulation that a mode of production develops from the soil, an

FORMING 69

interconnection between extracted minerals, allied with agriculture, animal raising, infrastructure and metallurgy. It is the boring of holes and mines that Deleuze and Guattari suggest constitutes the space of Europe (TP 414). These relations are particularly evident in the nexus of flows configured around resource extraction and the decoded and recoded flows evident in the sediments of our cities. The final artwork to be discussed focuses on these flows and the formations they generate that make the interrelations of physical and social assemblages perceptible.

In the suburb of Waterview in Auckland, New Zealand, for almost two years a mega drill bored twin tunnels as part of the Waterview Connection, a large infrastructure project undertaken by the Well-Connected Alliance involving extensive roadworks.[76] Affectionately named Alice, after Alice in Wonderland, by a nine-year-old boy following a competition amongst local primary school children, the tunnel-boring machine excavated 800,000

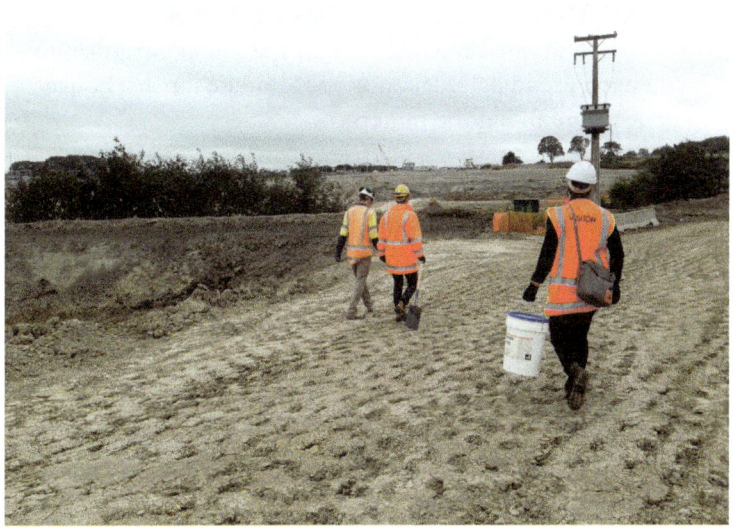

Figure 3.1 Public Share, clay collection site at Wiri, Well-Connected Alliance worksite – Wednesday, 26 November 2014. Photographer: Public Share.

cubic metres of earth, which was processed and deposited in an old quarry twenty-three kilometres away in Wiri. This site at Wiri was accessed by Public Share to source clay for their two-part project *Smoko*.[77] Public Share is an artist collective based in Auckland who have an interest in working together to engage in ideas of sharing, production and exchange. They have a particular interest in workplace rituals and have used their practices of object making as a means of exploring specific sites of production.

'Smoko' is slang for a work break, and this project was developed in response to the elimination in 2015 by the New Zealand government of the hard-won entitlement to two ten-minute tea breaks in the working day. It also recalls the events of February 1908, which Public Share recount on their take-away poster that accompanies the project:

> on the West Coast of the South Island, Blackball miners went on strike for a 30-minute lunch break rather than the 15-minutes allowed under their award. A union leader, Pat Hickey, had refused to finish his pie when the manager told him his 15-minute lunch break was up. Workers were fired, leading to the strike, which caught the public imagination when the presiding judge took a 90-minute lunch adjournment before fining the miners.[78]

Public Share recollect and assemble these events together at two sites, engaging with the specific publics at each. On both occasions tea was served in cups made from commercial slip and spoils recovered from the Wiri quarry site. For part one of this project, 100 slip-cast cups were brought to Melbourne in 2015 to share with participants in 'Performing Mobilities Assembly', a multilayer series of performances and exhibitions that drew together a hybrid collection of creative practitioners.[79] At the morning tea break participants at the assembly were invited to select and keep their cup, which saw them and their accumulated histories disperse across Melbourne and beyond. A further lot of forty cups was made for the second part of the project that saw it return to Wiri and the Well-Connected Alliance's Wiri site tearooms for a morning tea held with workers from that site on 13 June 2016.

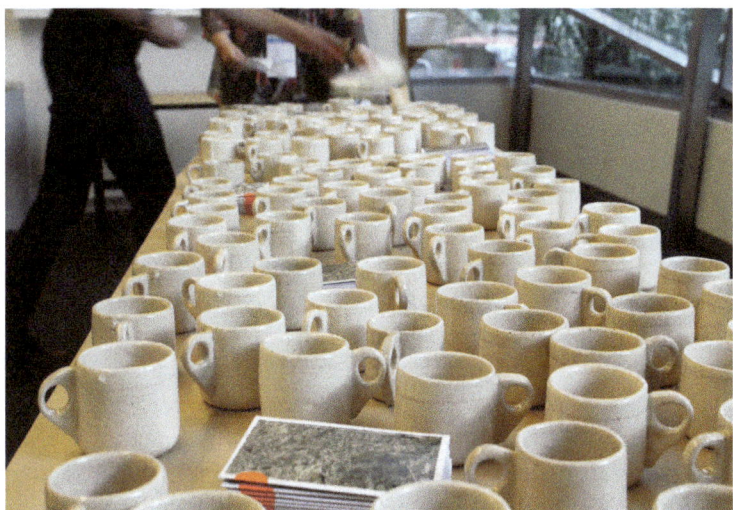

Figure 3.2 *Smoko (Part 1)*, Morning tea break, Performing Mobilities Assembly, Federation Hall, University of Melbourne – Saturday, 10 October 2015. Photographer: Public Share.

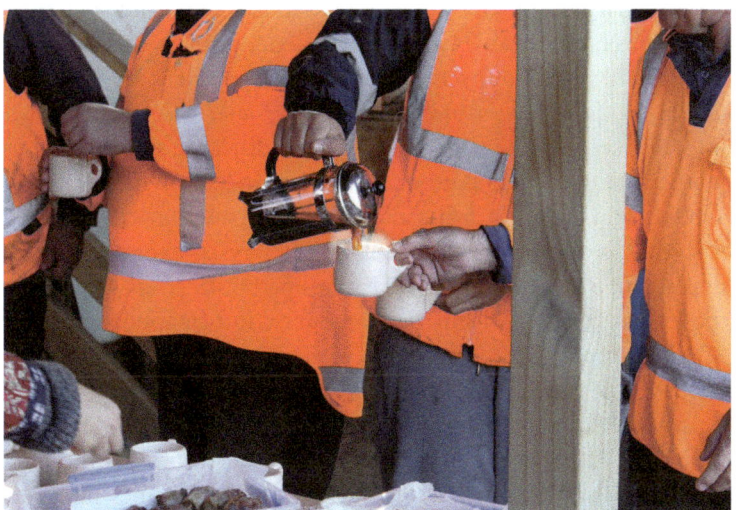

Figure 3.3 *Smoko (Part 2)*, Well-Connected Alliance, Wiri site tearooms – Monday, 13 June 2016. Photographer: Public Share.

The occasions of sharing foregrounded by this project focus on workplace rituals and the right of workers to pause, reflect and converse in a working day. Both this ritual and the activity of making the cups draw together the sites of production and the complexity of physical and social negotiations in any collective enterprise. Public Share acknowledge the controversy surrounding the Waterview Connection project, and the disruption that the ever-expanding road networks of our cities cause to affected communities. Their tea breaks facilitate the opportunity for individuals to come together, to form temporary social assemblages – organising a new dimension. These gatherings are a form of individuation that Simondon describes as 'collective unity'.[80] The individual is, Simondon writes, 'linked to the *group* by the preindividual reality that it carries inside itself and that, when united with the preindividual realities of other individuals, *individuates itself into a collective unity*'.[81]

Simondon's study of individuation considers 'the *forms, modes and degrees of individuation*, in order to situate the individual in being according to three levels: the physical, the vital and the psychic and psycho-social'.[82] These 'regimes of individuation' operate across different domains 'such as matter, life, spirit and society'.[83] This ontology, as Jean-Hugues Barthélémy points out, underpins Simondon's 'philosophy of information' in which the information is '*considered as genesis and as the taking-form*'.[84] As noted above, information is the tension between two disparate singularities, as in the case of crystallisation. In this operation of individuation a resolution emerges from a metastable system that Simondon describes as 'filled with potentials'.[85] The crystal expresses a form dependent on the constitutive features particular to its milieu and the interaction of molecular and chemical information.

Simondon insists the notion of form, that presupposes the existence of a principle that is anterior to the process of formation, must be replaced by that of information.[86] However, he warns this understanding is not premised on the notion of information used by cybernetics or information theory, which presumes information is a message or signal transmitted by a carrier. Information, Simondon suggests, 'is never a given thing'; rather, it is 'a primer for individuation' that presupposes a misalignment or incompatibil-

ity between forces in tension.[87] A disparate condition gives rise to individuations that respond by organising working solutions in the face of these problematic tensions. The crystal is a working solution that can be said to express the forces of its formation, and it is this characterisation that is evident in the artworks explored such as Public Share's *Smoko* project. A generative capacity of invention, highlighted previously, that Deleuze and Guattari identify in artworks that break with the habits of thought and reiteration of clichéd modes of being in the world.

Conclusion

The various relays assembled in the artworks discussed in this chapter, from Serra's *Verb List*, Haacke's visitors' profiles and Pentecost's *Soil-erg* to Public Share's *Smoko*, all engage with real-time systems encompassing matter-energy-information exchanges. Together they embrace something of the impetus identified by Burnham that led him to formulate his notion of 'systems esthetics'. They include multiple economies of production and consumption, across material, social and economic inventories. The plurality of these artworks registers the heterogeneous character of affects and intensities in assemblages influenced by systems thinking. This influence attests to complex arrangements of interacting components, in exchanges that are both forming and formative.

Deleuze and Guattari maintain 'art is never an end in itself; it is only a tool for blazing life lines, in other words, all of those real becomings' that they insist are not *in* art, 'but instead sweep it away with them toward the realms of the asignifying, asubjective, and faceless' (TP 187). This is the non-human potential of art – to which I referred at the outset of this chapter – to work across boundaries to capture forces, organising quantities of energy and information that register the imperceptible forces of chaos.

Notes

1. Deleuze and Guattari, *What Is Philosophy?*, p. 191. Here and throughout this chapter, this title is referred to as WP.
2. Krane, *Lynda Benglis: Dual Natures*, p. 27.

3. An initial mapping of this legacy in Rosalind Krauss's seminal essay 'Sculpture in the expanded field', from 1979, has been followed by many others, including 'The un/making of sculpture', written in 1998 by Hal Foster. More recently the two volumes of *Sculpture Unlimited* edited by Eva Grubinger and Jörg Heiser, published in 2011 and 2015, brought together contributions from two symposiums re-examining the history of sculpture and its contemporary practice.
4. Sauvagnargues, *Deleuze and Art*, p. 133. As a mode of individuation, a haecceity should not be confused, Sauvagnargues stresses, 'with that of a thing or a subject' (p. 196 n. 1). All forms, she explains, are composites of intensive and fluctuating force relations, 'capable of affecting and being affected' (p. 44).
5. As a tinkerer Simondon was engaged with hands-on experimentation, repairing and constructing in his own laboratory, and as Pascal Chabot recounts, 'he devoted himself to experiments in physics, acoustics, and mechanics ... and constructed one of the first television receivers in France' (Chabot, in de Vries et al., 'Book symposium', pp. 318–19). A familiarity with thinking through making is evident in Simondon's careful articulation of processes such as brick making, which lends a particular relevance to a discussion of forming in the visual arts.
6. Sauvagnargues, *Deleuze and Art*, p. 44.
7. Deleuze, *Desert Islands and Other Texts 1953–1974*, p. 132. Here and throughout this chapter, this title is referred to as DI. With this identification Deleuze extends Friedrich Nietzsche's characterisation of philosophers as 'physicians of civilization', suggesting that symptomology belongs to art as much as it does to medicine (DI 140).
8. Sauvagnargues, *Deleuze and Art*, pp. 23, 44.
9. Deleuze and Guattari write, 'The work of art is a being of sensation and nothing else; it exists in itself' (WP 164).
10. Deleuze and Guattari, *A Thousand Plateaus*, p. 408. Here and throughout this chapter, this title is referred to as TP.
11. See Attiwill in this volume for an exploration of the practice of framing in relation to the fabrication of interiors.
12. Deleuze, 'Books (on *Francis Bacon*)', p. 68. Deleuze begins this essay by referring to Bacon's painting *Triptych* (1972) in the Tate Gallery, London collection, featuring a figure on a stool. In these triptychs, Deleuze writes, 'one discovers rhythm as the essence of painting. For it is never a matter of this or that personage, this or that object

possessing rhythm. On the contrary, rhythms and rhythms alone become personages, become objects' (p. 69).
13. Deleuze, *Francis Bacon: The Logic of Sensation*, p. 56. Here and throughout this chapter, this title is referred to as FB.
14. The process of modulation Deleuze refers to draws on a distinction between moulding and modulation made by Simondon; see Deleuze's 'Metal, metallurgy, music, Husserl, Simondon'.
15. Colebrook, 'Vitalism and theoria', p. 42.
16. Deleuze, *Difference and Repetition*, 1994 edition, pp. 138–9.
17. Deleuze, *Negotiations, 1972–1990*, p. 172. Here and throughout this chapter, this title is referred to as N.
18. Hughes, *Philosophy after Deleuze*, p. 112. This is not to suggest the formative capacity of art is a synthesising activity that imposes form on the world in the manner of a Kantian subject.
19. 'Institutional critique' is a term used by critics and others to refer to a broad category of artworks that reflect on the art object's relation to its institutional context. These artworks engage critically in an analysis of, and often resistance to, art's institutionalisation within a system of commerce by highlighting a range of procedures, associations and networks that, although rarely foregrounded, operate to bestow meaning and value to works of art. This has been the predominating view of Haacke's work put forward by art theorist Benjamin Buchloh, amongst others.
20. At the time Rockefeller was a major donor and board member of the Museum of Modern Art in New York, with which his family had been associated since its founding. In 1970 he was running for re-election as Governor of the State of New York, a position he held from 1958 to 1973.
21. Jones, *Hans Haacke 1967*, p. 27 n. 63. Furthermore, Jones notes that in his memoirs David Rockefeller remarks on the dismissal of John Hightower, Director of MoMA at the time of the 'Information' exhibition that featured Haacke's *MoMA Poll*, commenting, 'he had no right to turn the museum into a forum for antiwar activism and sexual liberation' (ibid., p. 27 n. 64).
22. It should be noted that the critiques in many of Haacke's artworks are not clinical in the manner Deleuze advocates, as they privilege a moralising judgement of the social context with which they engage. Deleuze cautions against the privileging of judgement as he maintains it 'prevents the emergence of any new mode of existence' ('To have been done with judgment', p. 135). To have done with judgement, as

Sauvagnargues points out, 'is not to opt for indifference, but to substitute the difference of modes in existence for transcendent values. To opt for the struggles of life and against transcendent judgments' (*Deleuze and Art*, p. 34).
23. Haacke and Siegal, 'An interview with Hans Haacke', p. 245.
24. Ibid. Haacke is referring to an article by Jack Burnham entitled 'Real time systems'.
25. Ibid., p. 242. Elsewhere, Haacke notes, such terms often come to be used for promotional purposes, to distinguish between art movements, and consequently tend towards a reductiveness that ceases to be useful (Hileman, 'Romantic realist: A conversation with Hans Haacke', p. 81).
26. Haacke and Siegal, 'An interview with Hans Haacke', p. 242.
27. Ibid., p. 244.
28. This appraisal shifts the emphasis from what had been the dominant view evident, for example, in the writing of Benjamin Buchloh, who has argued that there is a significant distinction in Haacke's artworks once he starts developing the visitors' profiles (Buchloh, 'Hans Haacke', p. 106). Whereas Skrebowski argues more strongly for a fundamental continuity across Haacke's work, Jones contends that there is a gradual disenchantment with the earlier anti-humanist engagement with systems (Jones, *Hans Haacke 1967*, p. 27 n. 61). In any case, both Skrebowski and Jones have contributed to a general reappraisal of systems aesthetics under way since the mid-1990s, evident for example in the work of art historian Edward A. Shanken. Skrebowski was a participant in a symposium that accompanied the 2005 Tate Modern exhibition 'Open Systems: Rethinking Art c. 1970', curated by Donna De Salvo. This interest in the influence of systems thinking in the visual arts was also the motivation behind the 2007 'Systems Art' symposium at the Whitechapel Gallery. More recently, in 2014 the ICA London hosted a display of documents, installation photographs, press reviews, invitation cards and publications celebrating the 1968 exhibition 'Cybernetics Serendipity', curated by Jasia Reichardt. In addition to restaging Hans Haacke's 1967 MIT exhibition in 2011, Caroline A. Jones contributed to the fiftieth-anniversary issue of *Artforum*, 51.1 (September 2012), reviewing Burnham's contribution to systems aesthetics.
29. Haacke, quoted in Hileman, 'Romantic realist: A conversation with Hans Haacke', p. 82.
30. Jones, *Hans Haacke 1967*, p. 9.
31. Bertalanffy, *Perspectives in General System Theory*, cited in Bijvoet, *Art as Inquiry*, p. 65.

32. Bertalanffy, 'The theory of open systems in physics and biology', p. 23.
33. Hammond, *The Science of Synthesis*, p. 104. Hammond notes that Bertalanffy's understanding of life as a system of components provided 'the basis for further work in nonequilibrium thermodynamics, most notably by Ilya Prigogine' (p. 104).
34. Bertalanffy, *General System Theory*, p. 33.
35. This theory had three aims: to give 'a general definition of the concept of "organised system," [to] classify logically different types of systems, and [to] work out mathematical models for describing them' (Hammond, *The Science of Synthesis*, p. 132).
36. Bertalanffy, *General System Theory*, p. 247.
37. Bertalanffy, 'The theory of open systems in physics and biology', p. 25.
38. Ibid., p. 27, original italics.
39. Ibid., pp. 26–7.
40. Guattari met Isabelle Stengers and Prigogine through Mony Elkaïm, whose influence on Guattari is discussed later in this chapter. Stengers and Prigogine collaborated on several non-specialist books explaining aspects of Prigogine's work, including physical systems in which matter and energy flowed from the environment through open systems. Prigogine developed a theory of non-linear thermodynamics and showed that the self-organising characteristics of these systems were similar to those of biological systems.
41. Bertalanffy, *General System Theory*, p. 33.
42. Jones, *Hans Haacke 1967*, p. 7.
43. Although, as Jones points out, this artwork, initially conceived in 1963, was exhibited in 1967 under the title *Weather Cube* (*Hans Haacke 1967*, p. 11).
44. Jones quotes Benjamin Buchloh (Buchloh, 'Hans Haacke', p. 106), who she notes correctly relays Haacke's intentions at this time (Jones, *Hans Haacke 1967*, p. 13).
45. Jones, *Hans Haacke 1967*, p. 12.
46. Ibid., p. 13.
47. Haacke, quoted in Halsall, 'Open systems: Rethinking art c. 1970', unpaginated.
48. Jones, *Hans Haacke 1967*, p. 13.
49. An earlier iteration of this work, simply called *Grass*, was included in Haacke's 1967 exhibition at MIT List Visual Arts Center (Jones, *Hans Haacke 1967*, p. 17).
50. Haacke, in Oppenheim et al., 'The symposium', unpaginated.
51. Haacke, quoted in Bijvoet, *Art as Inquiry*, p. 83.

52. Chabot, *The Philosophy of Simondon*, p. 79.
53. Ibid., p. 80, original italics.
54. Ibid., p. 84 n. 10.
55. Jones, *Hans Haacke 1967*, p. 16.
56. Burnham, 'Systems esthetics', p. 31. Michael Fried's position is outlined in 'Art and objecthood'.
57. Burnham, 'Systems esthetics', p. 32.
58. Burnham, *Beyond Modern Sculpture*, p. 369.
59. See Robert Shaw's 'Bringing Deleuze and Guattari down to earth through Gregory Bateson: Plateaus, rhizomes and ecosophical subjectivity' for a detailed account of the influence of Gregory Bateson's work in the writing of Guattari and Deleuze.
60. Ecosophy aims to be a reconstruction of social and individual practices that Guattari defines as 'social ecology, mental ecology and environmental ecology' (*The Three Ecologies*, p. 41).
61. Dosse, *Gilles Deleuze and Félix Guattari: Intersecting Lives*, pp. 334–5.
62. Watson, *Guattari's Diagrammatic Thought*, p. 105.
63. Ibid., pp. 109–10.
64. Shaw, 'Bringing Deleuze and Guattari down to earth', p. 157.
65. Ibid., p. 155. Also see John Mullarkey's 'Deleuze and materialism: One or several matters?' for another account of the connections between the philosophy of Deleuze and cybernetic theorists.
66. Bertalanffy, *General System Theory*, p. 150.
67. Ibid., p. 17.
68. Ibid., p. 150.
69. Jones, 'System symptoms', p. 116. 'Documenta' is a major contemporary art exhibition that takes place in Kassel, Germany, every five years.
70. Christov-Bakargiev, 'The dance', p. 34.
71. Pentecost, *Notes from Underground*, p. 4.
72. Holmes and Pentecost, 'The politics of perception', unpaginated, original italics.
73. Pentecost, *Soil-erg*, unpaginated.
74. Ibid.
75. Deleuze and Guattari, *Anti-Oedipus*, p. 33. Here and throughout this chapter, this title is referred to as AO.
76. The motorway extension caused extensive disruption to communities, requiring 365 homes to be demolished, which was the subject of a series of angry public protests (see Dearnaley, 'Motorway to go ahead despite concerns').
77. Public Share have been working together since 2014 and the collective includes Monique Redmond, Harriet Stockman, Kelsey Stankovich, Deborah Rundle, Mark Schroder and Joe Prisk.

78. Public Share, *Smoko*, unpaginated.
79. See <http://www.performingmobilities.net> (last accessed 16 March 2017).
80. Simondon, 'The position of the problem of ontogenesis', p. 8.
81. Ibid., original italics.
82. Ibid., p. 10, original italics.
83. Ibid.
84. Barthélémy, in Simondon, 'The position of the problem of ontogenesis', p. 15 n. 19, original italics.
85. Simondon, 'The position of the problem of ontogenesis', p. 7.
86. Ibid., p. 12.
87. Ibid., p. 10.

Framing
What philosophy and art share

Both philosophy and art are creative. Philosophy creates concepts. Art creates blocs of sensation, which are composed of percepts and affects.

Concepts are not representations of the world, but new ways of thinking – new 'eyes of the mind' (Spinoza). These are not 'thoughts in the head of the philosopher' but genuine beings that exist (or insist) on their own terms.

Likewise, percepts and affects are new ways of seeing and feeling – not the perceptions or affections of the artist, but genuine creations.

> Percepts are no longer perceptions; they are independent of a state of those who experience them. Affects are no longer feelings or affections; they go beyond the strength of those that undergo them. Sensations, percepts, and affects are *beings* whose validity lies in themselves and exceeds any lived. (Deleuze and Guattari, *What Is Philosophy?*, p. 164)

Examples: percepts of the sea in *Moby Dick* (seeing from the point of view of the sea), harmonies as affects in music (feeling from the point of view of a harmony).

Both art and philosophy therefore break with clichés: in thought, but also clichéd ways of seeing things and feeling.

Framing

Framing as folding

Deleuze is hostile in general to the notion of interiority.

In terms of the subject: there is no inner self, no essential 'personhood'. A person, like

> an animal, [or] a thing, is never separable from its relations to the world. The interior is only a selected exterior. (Deleuze, *Spinoza: Practical Philosophy*, p. 125)

Deleuze calls this selection a fold: the inside is a fold of the outside.

Biological examples: the interior of a body is a fold in the material world – a selective membrane. In embryogenesis, a group of cells slowly forms an inside of a body.

Framing

Framing in art

Schematically, framing has two functions in art for Deleuze.

1) A negative task: clearing out, excluding, and destroying clichés.

Examples: framing a painting, constructing a stage, clearing land, dividing what is inside from outside of a shot.

The case of the painter is important for Deleuze:

> It is a mistake to think that the painter works on a white surface . . . The painter has many things in his head, or around him, or in his studio [which] are already in the canvas . . . before he begins his work. They are all present in the canvas as so many images, actual or virtual, so that the painter does not have to cover a blank surface, but rather would have to empty it out, clear it, clean it. (Deleuze, *Francis Bacon: The Logic of Sensation*, p. 86)

As this indicates, the negative task is preparatory in character.

2) A positive task: *selection*. To frame is to *sieve*.

The goal is therefore not entirely to eradicate everything (first task), but – as the other side of the coin – to select elements that will be included.

Framing

Two kinds of framing

But there are also two ways of framing, or two sets of criteria for selecting.

1) Selection on the basis of existing criteria = habit and cliché.

Instead of selecting for new percepts and affects, the artist is content to select existing representations, recognised perceptions and feelings.

In this way, contra the fold, the outside is only the projection of our habituated interiority.

For Deleuze, this kind of framing can never fully succeed – can never isolate only what is familiar and recognisable – because further encounters continue to take place to trouble it.

2) Selecting what is new, what challenges or troubles habituated experience, on the basis of 'categories like Interesting, Remarkable, or Important' (Deleuze and Guattari, *What Is Philosophy?*, p. 82).

We can see why Deleuze and Guattari will say that art is on the side of chaos, and why they will assert that '[a]rt takes a bit of chaos in a frame in order to form a composed chaos that becomes sensory' (*What Is Philosophy?*, p. 206).

Framing
Beyond the flesh

In all this, human beings are *enframers*. We habitually select.

More than this, we are ourselves *selections*, enframed. We are in a sense composed of habits or clichés – habitual ways of seeing and feeling, sitting and walking, sleeping, and of thinking.

So: art not only produces affects and percepts that do not belong to anyone, it functions critically towards these habits = art has an inhuman character (cf. Adorno, Lyotard).

Deleuze and Guattari write: 'Art begins not with the flesh but with the house' (*What Is Philosophy?*, p. 186).

What does this mean?

What is a house but a set of frames, a framing of the landscape which creates an interiority? It is not an agent, still less human.

First correlate: art does not begin with human being, with our existing ways of seeing and selecting – of framing. It is not made *for* us.

Framing

Deterritorialisation

Second correlate: it is not even necessarily made *by* us.

> Every morning the *Scenopoetes dentirostris*, a bird of the Australian rain forests, cuts leaves, makes them fall to the ground, and turns them over so that the paler internal side contrasts with the earth. In this way it constructs a stage for itself like a ready-made; and directly above, on a creeper or a branch, while fluffing out the feathers beneath its beak to reveal their yellow roots, it sings a complex song made up from its own notes and, at intervals, those of other birds that it imitates: it is a complete artist. This is not synesthesia in the flesh but blocs of sensations in the territory – colors, postures, and sounds that sketch out a total work of art. . . . In this respect art is continually haunted by the animal. (Deleuze and Guattari, *What Is Philosophy?*, p. 184)

So . . . the stage-maker is 'a complete artist' *and* 'art is continually haunted by the animal'?

The difference concerns the relative degrees of deterritorialisation. The stage-maker deterritorialises the forest milieu, reframing it as its home. The human artist is capable of opening this framing up to ever-greater contexts, out to the cosmos itself – a prodigious *de/reframing*.

Framing and deframing, selection and deterritorialisation go together in two senses, then:

1) Compositionally: to make work, one deterritorialises (deframes objects, impulses, materials) and then reterritorialises (reframes) them.

2) As an object of encounter: when we see/hear/feel art, we undergo our own deterritorialising (exposure to chaos), and then become a new selection of capacities as a result (in some way, however minimal, a new person is truly engendered).

4

Framing – ?interior

Suzie Attiwill

Practising with

When I reread Brian Massumi's foreword to *A Thousand Plateaus*, the sense of excitement and inspiration that I felt in 1987 rebounds again now, affirming 'the authors' hope . . . that elements of it will stay with a certain number of its readers and will weave into the melody of their everyday lives'.[1] Given this invitation to enter into the book, readers were encouraged to enter via any plateau and experiment, without an overriding sense of an imperative to understand and master its philosophical concepts.

> The question is not: is it true? But: does it work? What new thoughts does it make it possible to think? What new emotions does it make it possible to feel? What new sensations and perceptions does it open to the body?[2]

A feeling of liberation was experienced through a reorientation towards life as practice and as one of making connections, together with a sense of mischievousness and joy in the valuing of experimentation where the key issue is not whether something is correct so much as whether something is affirmed and activated in the encounter with an idea – becomes productive. Later, reading *Dialogues* and at that time involved in a creative practice research degree, I came across another melodic line with the sense of experimentation:

> You should not try to find whether an idea is just or correct. . . . You don't have to be learned, to know or be familiar with a particular area, but to pick up this or that in areas

which are very different. This is better than 'cut-up'. It is rather a 'pick-me-up' or 'pick-up' – in the dictionary = collecting up, chance, restarting of the motor, getting on to the wavelength; and then the sexual connotation of the word. (D 10)[3]

The phrase 'magpie-effect' is often used to describe an approach to theory and philosophy through creative practice research – where the practitioner picks up bits of theory from different areas including philosophers and texts connecting with an idea that makes a relation with their practice. The effect becomes akin to a bowerbird's nest – a collection of all things blue; of quotes and concepts arranged together because they reflect/connect with some aspect of the practice. While Deleuze's invitation to pick up, make connections, take a line of flight, make rhizomes, encourages such an approach, it also resists the principle of identity as the selection criterion for what is picked up coupled with an invitation to an apprenticeship in the 'exploration of encounters' (PS 27).[4]

The approach of an apprentice foregrounds a relation to practice as an ongoing practising with Deleuze; it is not to achieve mastery of his philosophical concepts nor to develop a set of principles so much as an acknowledgement of learning engaged in the world (DR 205).[5]

> We learn nothing from those who say: 'Do as I do'. Our only teachers are those who tell us to 'do with me', and are able to emit signs to be developed in heterogeneity rather than propose gestures for us to reproduce. (DR 26)

Deleuze's ideas cannot be simply applied to practice, as they intervene and disrupt processes of identification and representation. This produces 'a shock to thought'[6] that requires one to think as a creative act where the outcome is not given beforehand; to think beyond/in spite of/against the forces of the familiar, common sense, clichés and opinions – everyday thought that enables a consistency necessary for existence. 'Don't have just ideas, just have an idea . . .' (TP 25).[7] In relation to creative practice, another critical inversion is needed from a dualistic position where the

subject is the producer – a subject-centric position – to one where the subject is produced; where the subject is practised and produced each time anew.

There are references throughout Deleuze's writings to using theory like a 'box of tools', 'a pair of glasses directed to the outside' and 'an instrument for combat'.[8] These are different invitations from those usually encountered in reading philosophy or theory where one has to enter into a theoretical framework or a proposition and subscribe to a particular view or reject it. Reading Deleuze is more like being affected by something that propels thinking as a creative act.

The current chapter is an inflection of this thinking through doing – through practising with. Picking up a pair of glasses that suits, directed to an outside; an instrument of combat taken into the discipline of interior design – to combat assumptions embedded in common sense, self-givens, clichés – and which created a transversal practice experimenting with '?interior' across territories of curatorial practice, exhibition, writing and teaching.

This chapter continues in this spirit of practising with Deleuze. It is not a text that seeks to write about Deleuze and framing, nor to survey the concept of the frame and review his texts on the topic of framing. Instead it offers a thinking through connections that were made while practising that became useful and vibrant. This has resulted in a chapter where what some might consider obvious references are not cited; this could be because the particular text has not yet been read or the rhizomic offshoots have headed off somewhere else in an idiosyncratic manner. There are many quotes from Deleuze that are part of the arrangement of this chapter; they are here as the conversation with the matter of Deleuze's ideas continues. This chapter is another curatorial project in practising with Deleuze.

?interior

To return to the invitation of *A Thousand Plateaus*: 'Most of all, the reader is invited to lift a dynamism out of the book entirely, and incarnate it in a foreign medium, whether it be painting or politics.'[9] Or, indeed, interior design.

Interior design is often referred to as a 'slippery discipline';[10] it is a profession which engages with a range of practices that concern the inside of buildings as well as an array of practices which involve exhibitions, theatre, urban environments and so on. Depending on the country, professional context and education provider, the terms 'interior architecture', 'interior decoration' and 'spatial design' may designate the same or a similar practice. As a discipline it can be situated in the built environment area alongside architecture and landscape architecture, as well as in an installation, performance and object cluster that includes art and other design disciplines such as product, industrial and graphic.

My practice focuses on the question of interior. 'Interior' is a term that is rarely opened up theoretically or conceptually within the discipline; it is assumed as a given. In addressing 'interior', I am keen on 'interior design' as this can be posed as a verb – as interior designing and hence interior design as a practice of designing interior, of interiorization. The techniques I use are curatorial and involve processes of selection and arrangement in the production of rooms, exhibitions, texts, curricula and built space. 'Interior' is the outcome of a production and a practice that crosses disciplines.

Incarnating not only *A Thousand Plateaus* but Deleuze in interior design, the term and concept of 'interior' came to the foreground in the combat. In his 'Letter to a harsh critic', Deleuze refers to a 'hatred of interiority',[11] dismissing 'interiority' and 'interior' as independent autonomous entities. His use of the term 'interior' is not confined to a specific type so much as a condition: 'We're in the midst of a general breakdown of all sites of confinement – prisons, hospitals, factories, schools, the family. The family is an "interior" that's breaking down like all other interiors – educational, professional, and so on.'[12]

Yet in reading Deleuze with an attention to the question of interior, words such as 'in', 'internal' and 'inside' inflect through his writing but in ways that are never easily grasped and applied; each time they produce 'shock to thought' and require thinking otherwise. In reference to Deleuze's book *Foucault*, Constantin Boundas writes:

What is remarkable about this contribution is that it combines a radical critique of interiority with a stubborn search for 'an inside that lies deeper than any internal world'. In this sense, the search for the fold – 'the inside as the operation of the outside' – that Deleuze gallantly attributes to Foucault, is as much his own lifelong project and search as it was (for a more limited time span) his friend's.[13]

And in an entry titled 'Exteriority/interiority' for *The Deleuze Dictionary*, Jon Roffe writes: 'this describes one of the greatest aspects of Deleuze's philosophical labour – he insists that the interior is rather produced from a general exterior, the immanent world of relations.'[14]

The writings of others who engage Deleuze with architecture and art – Elizabeth Grosz, John Rajchman, Simon O'Sullivan, Brian Massumi and others – have also been valuable as thinking tools and lenses.[15] Being situated in a practice addressing the question of interior has enabled a thinking interior and interiority otherwise; in the discipline of interior design and other practices where self-givens about 'interior' are implicated and unquestioned in ideas of subjects, objects and space; subjectivity and objectivity.

An important reorientation I learnt through practising with Deleuze – and need to keep thinking through practice – is how to attend to the question of interior. In practice, there is a tendency to address it as a concept and hence to change and transform it. This is a catch as this approach then maintains the idea of 'interior' as an a priori principle, a model, an abstraction given in advance of practising. It also results in one coming up with another concept; of replacing one definition with another.

In the text 'Response to a question on the subject', Deleuze declined to put forward a new concept of the subject as others had done in response to the question. He says that concepts don't disappear 'at whim' as they are intricately connected to internal variables (functions) and external variables (states of things, moments of history): 'That is also why it is never very interesting to criticize a concept: it is better to construct new functions and discover new fields that make the concept useless or inadequate.'[16]

This idea of function foregrounds a concern with how as distinct from the question of what – what is interior? In my practice, the question mark moved from interior? to ?interior – a pickup from Deleuze and his invention of ?-being as a way of moving from being and non-being as a dialectical relation embodying negation: 'There is a non-being which is by no means the being of the negative, but rather the being of the problematic' (DR 253). Posing ?interior with each project creates 'a new problem . . . new orientations'.[17] It is a question not in search of an answer so much as a creative problematic that finds its vitality in practice as an ongoing provocation that invites a local solution each time anew and, as such, produces and spreads a multiplicity.

Pre-framed

In relation, then, to 'how' rather than 'what', there are a number of governing images, which one could call frames, that organise how 'interior' is engaged in practices of interior design and curatorial practice.

The act of containing is one of these images. 'Interior' is defined as existing 'within some kind of shell'.[18] While this quote comes from an architectural reference, it could also be extended to how 'interior' is understood in relation to subjects and objects: the subject is a discrete, psychological and independent individual whose subjectivity frames the world around it; objects contain meaning that resides within them that can be accessed and communicated. This then sets up an idea of practising between subjects and objects in space. There is a similarity in the way that the practice of interior designers and curators is positioned as a working between. The term 'middleman' is used as a term for a curator to describe the practice as one that mediates between viewers and artwork/artists. The international association for the interior design profession has defined the identity of interior designers as professionals who 'determine the relationship of people to spaces based on psychological and physical parameters, to improve the quality of life'.[19] These definitions of practice are based on the concept of working between givens where relations are determined by

their terms. This then leads to a practice concerned with processes of identification and representation.

Deleuze is critical of the logic of representation where difference is subordinated to identity, and as noted above the question of the subject and interiority, which he re-functionalises through understanding relations as external to their terms (ES 101).[20] This is a significant shift from the idea of working between existing subjects and objects and space. In contrast to the subject who produces experience, it is the subject who is produced by experience. 'Subjectivity is determined as an effect,' writes Deleuze (ES 26). The difference can be summed up as a difference between understanding relation as 'to' and as 'in'; between a practice that works with/asserts relations as existing between things, as relations 'to', and one situated in the midst of relations, as relations 'in'.[21]

It is interesting to note that the English translation of the title of Deleuze's essay as 'mediators'[22] is disputed; 'intercessor' is offered as another translation.[23] While 'mediator' can be inflected in several ways including as a process of mediation between existing things, and hence producing relations 'to', 'intercessor' more clearly articulates an effect of working in the midst of a flow of forces, the idea of always working in the middle – in the middle of 'the externality of forces and relations'.[24] As Deleuze writes:

> There's no longer an origin as starting point, but a sort of putting-into-orbit. The basic thing is how to get taken up in the movement of a big wave, a column of rising air, to 'come between' rather than to be the origin of an effort.[25]

This involves both an epistemological and an ontological reorientation that affects and effects how one practises and can practise as the subject position of the practitioner is brought into question. Practising with Deleuze, framing and interiorization become foregrounded in a practice situated in a generalised exterior and an exteriority of forces:

> Lodge yourself on a stratum, experiment with the opportunities it offers, find an advantageous place on it, find potential movements of deterritorialization, possible lines

of flight, experience them, produce flow conjunctions here and there, try out continuums of intensities segment by segment, have a small plot of new land at all times. (TP 161)

Experiment

An interest in 'interior' has been a refrain through my practice for the past twenty years and this has directed attention to subjects, objects and space and how they are accepted as natural givens in interior design and curatorial practice. Experiments have taken place in exhibitions and other small plots to pose ?interior.[26] In this section, I focus on how the ideas that came from these projects contribute to thinking about framing. They are offered as orientations – rather than methods to be reproduced – where to 'think *as* doing'[27] engaged with the problematics of objects, subjects, space and time. Exhibitions have been laboratories for experimentation and experience – where, as a curator, I was commissioned to develop a curatorial proposition, select works, arrange and install them, and write a curatorial text.

Spacecraft

SPACECRAFT was an exhibition experimentation with objects and space. The double reading of 'spacecraft' framed the curatorial approach, including selection of works which had qualities of unidentified flying objects (spacecraft as UFOs) and designing the exhibition as an activity of crafting space through arrangement, sightlines and circulation. These ideas were worked to intervene in the given frames and interiors that inhere as unquestioned givens in curating and designing an exhibition: objects as containers of meaning to be communicated; gallery space – the Platonic white cube – as a neutral, timeless, ideal backdrop; and viewers as key framers in the production of experience.

Objects selected for *SPACECRAFT* had qualities that made them UFO-like in that each resisted immediate identification – not in an eccentric, alien way so much as how they interacted with the surroundings. Each was then poised in a singular way in

the gallery's desert of whiteness. The term 'extra-object' was used during the curatorial process to effect an opening up of the object from a container of meaning with defined inside and outside to some thing where the exterior – or to employ the spacecraft reference 'outer space' – was active as a composing force; as a reminder that as a UFO it was more than the object of *SPACECRAFT* – 'an exhibition of extra-objects where the extra of the object is encountered'[28] with reference to Deleuze's '...And as extra-being, inter-being' (D 57).

Practising with Deleuze, one becomes sensitive to the logic of identity/identification and how it is a dominant force in, and maintained by, practice. In exhibitions, a curatorial proposition is usually thematic and comes from having identified a common thread through a range of existing works or acts as a proposition for new work to be done in response to the theme. As a framing device, the curatorial theme comes beforehand and determines the selection of works to be brought into this frame, hence as illustrations and representations of the theme. This logic is then extended to both the text – labels and curator's catalogue text – and the exhibition design and layout, where the work is grouped according to this logic of representation to make relations of resemblance, analogy, identity or opposition. The curatorial framework acts like a schema that is fixed in advance for the viewer to identify what is being represented. The way the objects are displayed further reiterates these relations through a frontal face-to-face encounter with the viewing subject that sets up the act of recognition. 'Representation has only a single centre, a unique and receding perspective, and in consequence a false depth. It mediates everything, but mobilises and moves nothing' (DR 67).

The curatorial selection of objects and the way they were arranged sought to intervene/intercede in the relations between the given relation of knower and known, subject and object, to create a pause in the stimulus/response processes of identification, communication and reception. The conventional hang of an exhibition is one where works are hung on walls along a horizon-line and the arrangement indicates key works – usually located on central sightlines. Brian O'Doherty, in his series of essays *Inside the White Cube*, wrote: 'Most of us now "read"

the hanging as we would chew gum – unconsciously and from habit.'[29] This was in 1976 – and could still be claimed almost half a century later. In *SPACECRAFT*, objects were arranged in a way to interrupt this habit and, instead, entice curiosity. The lines of projection from a viewer across the gallery and between objects were different from standard exhibition design specifications based on a 1500mm horizon line; objects were not placed so as to face the viewer as they approached and invite recognition; the surfaces and outlines of selected objects transformed perceptually as one approached them; peripheral rather than central sightlines were activated.

These arrangements sought to interrupt the stimulus/response mechanism of viewers and their habitual way of engaging with an exhibition through producing a pause – even if momentarily – which would then effect an opening up to an exterior – in this case, 'outer space'. This reframing then involved a deframing so as to shift from the expected and already known. Working in relations exterior to their terms and as an intercessor involves a deframing as part of framing, to intercede in the stimulus/response coupling of habit and break with all kinds of clichés that inhere. The following paragraph from Deleuze offers up a sense of the techniques that might be used as an intercessor:

> [E]ach composing representation must be distorted, diverted and torn from its centre. Each point of view must itself be the object, or the object must belong to the point of view. The object therefore must in no way be identical, but torn asunder in a difference in which the identity of the object as seen by a seeing subject vanishes. Difference must become the element, the ultimate unity; it must therefore refer to other differences which never identify it but rather differenciate it. Each term of a series, being already a difference, must be put in a variable relation with other terms, thereby constituting other series devoid of centre and convergence. Divergence and decentring must be affirmed in the series itself. Every object, every thing, must see its own identity swallowed up in difference, each being no more than a difference between differences. Difference must be

shown *differing*. ... The work of art leaves the domain of representation in order to become 'experience' ... (DR 68)

Deleuze's concept of the sign is important and enables a shift in the function of the object as container of meaning and the logic of representation that is then played out through signifiers and signified to a different relation. In *SPACECRAFT*, the heightening of craft and matter enabled experimentation with making relations that encouraged viewers to explore encounters as distinct from the intent of recognition, to enter into the relation and become sensitive to signs. 'Signs are the object of a temporal apprenticeship, not of an abstract knowledge. ... One becomes a carpenter only by becoming sensitive to the signs of wood, a physician by becoming sensitive to the signs of disease' (PS 4).

We recognize things, but we never know them. What the sign signifies we identify with the person or object it designates. We miss our finest encounters, we avoid the imperatives that emanate from them: to the exploration of encounters we have preferred the facility of recognitions. (PS 27)

The exhibition viewer as a subject is quite resilient in terms of maintaining a subject-centric position – as Claire Bishop notes in her book on installation art and its endeavour to decentre the viewer: 'Yet every theory of experience points to a more fundamental idea: the human being who constitutes the subject of the experience';[30] that even in 'seeking to contrive a moment of decentring, installation art implicitly structures the viewer *a priori* as centred'.[31] Hence the criticality of an 'experimentation on oneself' (D 11) with other exhibition set-ups than one that maintains and reinforces the centrality of the subject who experiences such as the phenomenological bracketeer or the Cartesian perspectival stationary viewer.

Deleuze writes of a spider in her web: she 'sees nothing, perceives nothing; remembers nothing'; she 'answers only to signs' – on a visceral level – to the slightest sensation of vibration and contracts a series of instants (PS 181–2). This is a move from centring the

subject and sensation as something that is experienced subjectively to sensation as affecting the nervous system. Here framing happens through synthesis as distinct from containment and pre-framing or as the act of framers; as a contraction – 'the thousands of passive syntheses of which we are organically composed' (DR 95) – which constitutes a sign that 'is interpreted or deployed in active synthesis' (DR 94).

A matter of time

Another 'small plot' was *a matter of time*, a touring exhibition of textiles and fibre in which ?interior was posed through curating and exhibiting textiles. An exhibition of twenty-three textile and fibre works, which was rearranged eight times over two years in eight different gallery spaces as it toured Australia, *a matter of time* explored textiles and time as a matter of time. Textiles and fibres are matters of time: the materials and dyes used are often seasonal, they are made for different rituals and functions, they are sensitive to the light of the sun, and time is embedded in their making – the repetition and rhythm of their production. In relation to posing ?interior, textiles have a history with interior design and in particular the production of interior as enclosure. Gottfried Semper – an architect and critic in the nineteenth century – claimed textiles, in particular weaving, as one of the four elements of architecture: specifically, as the act of enclosure.[32] He was referring to the use of woven textiles as walls to produce an interior in the desert exterior.

This experiment produced a shift in my practice from a concern with objects and space, containers and enclosures, from the pre-framed in relation to interior, and offered up an opportunity to experiment with the potential of framing as a practice of interiorization. Working with textiles and with time foregrounded – as a matter of time – the approach to the work and exhibition had different dynamics and forces to one interceding in relations producing objects and space as containers. Textiles do not necessarily hold their form, nor can they be easily placed on a pedestal. Instead they drape, fold, hang, wrap, cover and so on. There is also a strong haptic quality to textiles which invite the hand to touch

and force the eye to become sensitive to feeling texture – a close encounter of the haptic kind. There is also something where the body responds viscerally to textiles; a sensation of wearing and touching envelops the body. This is different, then, to objects as containers, and working with textiles entices different potentials and thinking regarding ?interior and framing.

'If the sensible surface could be seen from both sides it would no longer be a sensation but an object.'[33] The distinction made here between sensation and object makes sense of the above comments regarding the textiles in *a matter of time* which created an experience of pausing with the surface. Similarly, the impression that 'our sensual/visual field is *in front* of us'[34] is exposed as nothing more than a habit – like chewing gum – rather than a natural given. There is also an experience of the I/eye as ubiquitous rather than contained; as 'copresent to sensation and having neither proximity nor distance from sensation'.[35]

This experience produced a feeling of closeness, not so much one of proximity – where closeness is a measure of distance – as one where the separation has not yet happened, where space has not yet been produced. Instead one felt in the midst of forces of time, change, chance and flow – in an ocean. Even though the works were poised and held still in a white cube, the sensitivity of textiles to changes in temperature, light and movement actualised an experience of time. This was intensified with the installation that happened every few months in a different gallery, each installation a rearrangement in relation to both internal and external dynamics – the works, exhibition, gallery, city/town, world events. The works, exhibition and myself as curator were produced by the effects of time.

This differed from the given idea of a touring exhibition which is usually accompanied by an installation plan that determines the layout of the exhibition based on a narrative. A fixed plan reduces the work to an illustration of this narrative and the textile to a representation of the textual. Instead, the emphasis on thinking time before space led to a constant rearrangement through the repetition of the exhibition from one venue to another. It felt as though everything and everyone was produced through this dynamic.

Elizabeth Grosz's essay 'The thing' reframes how an object might be thought, where it is not the object that frames but rather movement and vibrations:

> The thing is positioned or located in space only because time is implicated, only because the thing is the dramatic slowing down of the movements, the atomic and molecular vibrations, that frame, contextualize, and merge with and as the thing.[36]

In the practice of interior design, time features usually as a product of movement in space from one point to another and as ephemeral, that is, not lasting in space. Practising with Deleuze, one is provoked to think otherwise – to foreground time before space, where space becomes a production of time: in time. 'State problems and solve them in terms of time rather than of space' (B 31)[37] writes Deleuze, with reference to Henri Bergson's intuition as method. In the accompanying footnote, he quotes from Bergson's *Matter and Memory*: 'Questions relating to subject and object, to their distinction and their union, should be put in terms of time rather than space' (B 118).

To think time is challenging. It is through matter and things that time can be encountered; matter as the actualisation of time became the focus of the experiment. The work selected for the exhibition actualised time as a matter of time and as distinct from being about time. This was an important difference which affected me as I visited people to consider their work for selection, and which I understand now as one that was resisting work that moved textiles to a form of representation which somehow then lost the intensity of an actualisation of time. This evaluation did not have a rationale at the time, nor was it an outcome of analysis; instead it was a gut response which through the lens of Deleuze can now be grasped – the reductive effect of representation on repetition, that is, on difference, rendering it subordinate to the same – '*re*-petition opposes *re*-presentation' (DR 69).

In the making of textiles, repetition is part of most techniques – such as weaving, knitting, screen printing, patchwork, pleating – and makes tangible Deleuze's idea of repetition and sensation,

of contraction and habit in making relations. The thread of the shuttle moves from side to side across the warp, weaving subjects composed of 'thousands of passive syntheses' (DR 95). Difference emerges through repetition, producing subjects: artists, works, curator and exhibition. In this sense, *a matter of time* enabled an experience of the production of subjectivities and subjects as distinct from the subject producing a synthesis of time.

There is something in the repetition of weaving that enables an engagement by the weaver with the flow of time in production which effects a feeling of calm – perhaps this could be what Deleuze refers to as 'contemplation'. He uses the word 'contemplation' in relation to a contraction coupled with relaxation in response to emotions of pleasure. While the given idea of 'contemplation' conjures the classic image of someone looking at a work of art in the white cube of the gallery, Deleuze changes the function of the subject. Rather than the subject who contemplates, the subject is produced through contemplation; from contemplation as a framing of the other through projection of oneself – a reproduction and re-presentation of self – to a passive synthesis through relaxation and contraction. Rather than contemplation as a solipsistic looping of the given subject, here contemplation is the passive synthesis of an exterior which is drawn in to produce an image of ourselves. 'We do not contemplate ourselves, but we exist only in contemplating – that is to say, in contracting that from which we come. . . . To contemplate is to draw something from' (DR 95).

The production of the textiles and the exhibition were contemplations in this way as productions of encounters with sensation, as a visceral response of contraction that selects many instants and brings them into a series that enables a sense of consistency and produces a subject through repetition and contraction: 'a *habitus*, a habit, nothing but a habit in a fold of immanence, the habit of saying I' (WP 48).[38] With reference to Deleuze and others, Paul Bains makes a distinction 'between subjectivity (or primary "subjectless" consciousness) and the secondary consciousness of a "subject"'.[39] This distinction highlights the complexity when posing ?interior as it raises both ontological and epistemological trajectories in practice.

In relation to practising, it is valuable to pick up the tool or pair of glasses taken from Deleuze in relation to representation and understand that we are always already formed by frames; the blank canvas is already filled with all kinds of clichés (FB 11).[40] Hence the practice of deframing as part of the process of framing becomes critical. 'What are the new modes of subjectivation which tend to have no identity? This is the present triple root of the questions: *What can I do, What do I know, What am I?*' (F 94–5).[41] This is posed through practice as a 'thinking through doing' where '[t]o think means to experiment and problematize' (F 95) through making relations.

This invites the intercessor to enter into the middle, to interrupt and make new relations. The choice, as Deleuze and Guattari note, is 'between transcendence and chaos' (WP 51), to reproduce or produce. Both involve framing and the production of interiors but, as discussed above, the differences between them are significant in their relation with the exterior; relations of 'to' between existing and given entities, and relations 'in' which produce entities, that is, subjects and objects.

Deleuze, thinking through Foucault in relation to the idea of the interior as a fold of the outside, writes of subjectivation as 'an operation of the outside ... an inside which is merely the fold of the outside as if the ship were a folding of the sea' (F 81); 'the boat as interior of the exterior' (F 101); and later, with Guattari, he writes of 'the Outside-interior with Foucault' (WP 113). As a folding of exterior forces, the production of ?interior involves a process of differentiation and actualisation; the production of an interior that enables inhabitation of an exterior. Interiority/the subject is the 'result of the folding of the outside, ... the subject is the individual who, through practice and discipline, has become the site of bent force, that is, the folded inside of an outside.'[42] The subject does not produce the fold but is rather produced through the folds as an actualisation of time.

> It is not time that is interior to us, or at least it is not specifically interior to us; it is we who are interior to time, and for this reason time always separates us from what determines us by affecting it. Interiority constantly hollows us out, splits us in two, doubles us, even though our unity subsists.[43]

In side Out

The problematic of ?interior and the relation of interior and exterior was one of the motivating forces for convening a symposium which brought the disciplines of interior design and landscape architecture – inside and outside – together for three days of papers and exhibition to experience what could be said and seen if the middle bit that usually pre-defines them – that is, the architectural structure – is removed. I was interested to think through 'the Outside-interior with Foucault' (WP 113) in relation to ?interior as a practice of interiorization and framing. The symposium, co-convened with Gini Lee, was titled *INSIDEOUT* to highlight the siding of 'in' and 'out' for interrogation and experimentation. We invited Grosz as a keynote speaker because of her provocations towards architecture in relation to space and the potential of posing time before space to ask how we might 'organise, inhabit, and structure our living arrangements differently'.[44] The assumption of space as the pre-defining condition of these practices became a focus of discussion and debate in the initial sessions of the symposium, with Grosz bringing a philosophical point of view which invoked the criticality of thinking space otherwise in relation to practising:

> Space is mired in misconceptions and assumptions, habits and unreflective gestures that convert and transform it. . . . According to Bergson, a certain habit of thought inverts the relations between space and objects, space and extension, to make it seem as if space precedes objects, when in fact space itself is produced *through* matter, extension and movement.[45]

It was also discussed how it is not possible to take architecture out of the discussion. Practising with Deleuze (and Guattari), Grosz picked up on their positioning of architecture as the first art of the frame – as 'an interlocking of differently oriented frames, which will be imposed on the other arts, from painting to the cinema' (WP 186). Deleuze and Guattari cite architect and furniture designer Bernard Cache, whose work experiments with this art

of framing in the production of architecture, furniture and urban spaces:

> By making architecture the first art of the frame, Bernard Cache is able to list a certain number of enframing forms that do not determine in advance any concrete content or function of edifice: the wall that cuts off, the window that captures or selects (in direct contact with the territory), the ground-floor that wards off or rarefies ('rarefying the earth's relief so as to give a free path to human trajectories'), the roof that envelops the place's singularity ('the sloping roof puts the edifice on a hill'). Interlocking these frames or joining up all these planes – wall section, window section, floor section, slope section – is a composite system rich in points and counterpoints. The frames and their joins hold the compounds of sensations, hold up figures, and intermingle with their upholding, with their own appearance. These are the faces of a dice of sensation. Frames or sections are not coordinates; they belong to compounds of sensations whose faces, whose interfaces, they constitute. (WP 187)

Titled 'Chaos, territory, art: Deleuze and the framing of the earth', Grosz's keynote speech, while also positioning 'the emergence of the "frame" [as] the condition of all the arts and [as] the particular contribution of architecture to the taming of the virtual, the territorialisation of the uncontrollable forces of the earth',[46] was inflected with a focus on interior and exterior in ways that opened up a posing of ?interior without the imposition of architecture's frames. Grosz spoke of framing as a relation 'in', in a fugacious and fleeting exterior that is also referred to as chaos, the virtual and time, where the frame is the first construction that establishes territory through a 'provisional ordering of chaos' that fabricates a space 'in which sensations may emerge, from which a rhythm, a tone, colouring, weight, texture may be extracted'.[47] A move from thinking about frames to the process of framing is useful in relation to posing ?interior and designing interior.

The frame separates. It cuts into a milieu or space. This cutting links it to the constitution of the plane of composition, to the provisional ordering of chaos through the laying down of a grid or order that entraps chaotic shards, chaoid states, to arrest or slow them into a space and a time, a structure and a form where they can affect and be affected by bodies. This cutting of the space of the earth through the fabrication of a frame is the very gesture that composes both house and territory, inside and outside, interior and landscape at once and as the points of maximal variation, the two sides, of the space of the earth.[48]

The concept of the architectural frame as external envelope, section and enframing form has particular techniques and practices that are different to those that have a curatorial inflection of selection and arrangement which has led to weaving a different melody through Deleuze's writings and practising with him. The curatorial aspects and practices of interiorization have focused on the relation and assemblage, and a focus on interior and interiority in relation to subjectification if inflected otherwise than architecturally. In *What Is Philosophy?*, Deleuze and Guattari move from architecture to discuss music in relation to the idea of frame and here the refrain is explored as an individuating closure involving counterpoints with an 'openness created by modulation, repetition, transposition, juxtaposition' (WP 190). The relation with music is also made by Grosz and with specific reference to von Uexküll's idea of *Umwelt* as a framing that creates a particular sensory world. Deleuze and Guattari's reference to activities of the Australian rainforest bird that Grosz presented as part of her keynote speech for *INSIDEOUT* made a strong connection with interior design and curatorial practices of selection and arrangement: working in an outside, the bird selects, highlights and rearranges to produce a performance and a territory – a temporary consistency that enables inhabitation; an interior.

> Every morning the *Scenopoetes dentirostris*, a bird of the Australian rain forests, cuts leaves, makes them fall to the ground, and turns them over so that the paler internal side

contrasts with the earth. In this way it constructs a stage for itself like a ready-made; and directly above, on a creeper or a branch, while fluffing out the feathers beneath its beak to reveal their yellow roots, it sings a complex song made up from its own notes and, at intervals, those of other birds that it imitates: it is a complete artist. This is not synesthesia in the flesh but blocs of sensations in the territory – colors, postures, and sounds that sketch out a total work of art. (WP 184)

Thisness: spatio-temporal co-ordinates

Practising with Deleuze, the potential to think framing interior/interiority otherwise was actualised through experiments and experience. Thinking interior and interiority otherwise involves an opening up of given frames and governing images that inhere in practice in an unquestioned way. While there are frames present in interior design that suggest they invite similar encounters as Deleuze's carpenter's sensitivity to wood or the temporality of situations, a closer inspection shows that a centre continues to organise and orchestrate as a framer and interiorizer. The phenomenological position is one that has much currency in both contemporary interior design and art practice – in part, as a way of critiquing and moving from the subject defined as a rational, autonomous being. In his self-described polemic on the value of interior design, Michael Benedikt defines the importance of 'interior design' as distinct from 'interior architecture' as the practice capable of addressing and producing:

> [T]he interiorist world view and all its sensitivities – sensitivities to texture, pattern, colour, style, touch, nearness, arrangement, personality, and domesticity, to 'charged' objects (the *life* in inanimate things), to class, and to the power of people themselves – of their clothed, warm, breathing bodies – to transform any environment by their presence.[49]

There is something here that resonates with Deleuze and Guattari's concept of haecceity and Grosz's discussion of the fabrication of space; however, in relation to ?interior, it is the phenomenological framer who resides in Benedikt's interiorist world and could not be further from the subject of haecceity produced through the 'thousands of passive syntheses' – this and this and this – 'a spatiotemporal immanence of unity in multiplicity, or of interiority in exteriority'.[50]

In both interior design and curatorial practice, there is also the negotiation with context and site specificity. 'Existing conditions' is a common phrase in the discipline of interior design and a designer works with these conditions through modes of representation and/or transgression. While there is a selection of exterior conditions, the relation 'to' is maintained rather than questioned; for example, the past is referred to as 'a package of sense'[51] and place and context as that which the 'interior inhabits'.[52] Hence practice is about reproducing and representing these given existing exterior conditions.

Practising with Deleuze, one is incited to question these assumptions and experiment in a way that is not reactive nor seeking to be transgressive – both of which keep one oscillating in a dialectical relation. The trick is to become an intercessor and work into the frames which inhere without question. It is handy to understand that Deleuze is 'ultimately a thinker of difference *by virtue of* the apparent *sameness* of sensible forms (rather than by virtue of oppositional constructs) and a thinker of "power" in terms of our capacity to "contract" sensible forms (rather than in terms of strategy or possibility)'.[53] In other words, practise in the middle!

Put into play the choice 'between transcendence and chaos' (WP 51); a choice that invokes different exteriors and ways of practising; a choice between assuming the pre-framed and already given as something to be given value and hence reproduced, and practising in the midst of forces, change and chance to produce something new. This is the difference between making relations 'to' something that is assumed as pre-existing and substantial, and making relations 'in' to produce a provisional consistency that enables habitation.

Framing and interiorization – the sensation of being somewhere, the sensation of belonging to something and the forgetting of oneself – becomes a critical practice if the choice is chaos. How then to think the experience and experiments of the projects that have effected a move in the practice from one addressing objects and subjects in space to the production of objects and subjects, objectivities and subjectivities; from relations between given things to interior and exterior relations as a process of selection and arrangement.

> The self does not undergo modifications, it is itself a modification – this term designating precisely the difference drawn. Finally, one is only what one *has*: here, being is formed or the passive self *is*, by having. (DR 100)

> So an animal, a thing is never separable from its relations with the world. The interior is only a selected exterior, and the exterior, a projected interior. The speed and slowness of metabolisms, perceptions, actions and reactions link together to constitute a particular individual in the world.[54]

> 'The interior is only a selected exterior, and the exterior, a projected interior': this statement could become an interiorizt motto.[55]

Interior design in some ways does not have the same project as art – which could be said to be a project 'of destroying equilibrium'.[56] Instead there is a concern with the provision of comfort and balance, terms which reiterate through the discipline as defining elements.[57] While this concern may seem at odds with chaos as an ontological model, practising interior design with Deleuze becomes an experiment in – to cite Grosz – 'how some force of order, some process of stabilization, may wrench from the turbulence of these forces of differentiation a measure of rest, a kind of cohesion or unity, a continuity over time'.[58]

This is the crux of posing ?interior and the value of posing each time anew to effect a pause between stimulus and response. To

intercede in habits and clichés, open up to the outside, to change, movement and chance. To produce a plan of immanence within a plane of immanence that makes a provisional stability – a composition that is also composed – and engages in the world because 'experimentation on oneself is our only identity, our single chance for all the combinations which inhabit us' (D 11).

Notes

1. Massumi, 'Translator's foreword: Pleasures of philosophy', p. xiv.
2. Ibid., p. xv.
3. Deleuze and Parnet, *Dialogues*, p. 10. Here and throughout this chapter, this title is referred to as D.
4. Deleuze, *Proust and Signs*, p. 27. Here and throughout this chapter, this title is referred to as PS.
5. Deleuze, *Difference and Repetition*, 2004 edition, p. 205. Here and throughout this chapter, this title is referred to as DR.
6. See Massumi, *A Shock to Thought: Expressionism after Deleuze and Guattari*.
7. Deleuze and Guattari, *A Thousand Plateaus*, p. 25. Here and throughout this chapter, this title is referred to as TP.
8. Deleuze and Foucault, 'Intellectuals and Power: A conversation between Michel Foucault and Gilles Deleuze', p. 208.
9. Massumi, 'Translator's foreword: Pleasures of philosophy', p. xv.
10. Hollis et al., *Thinking Inside the Box*, p. xi.
11. Deleuze, 'Letter to a harsh critic', p. 6.
12. Deleuze, 'Postscript on the societies of control', p. 178.
13. Boundas, 'Deleuze: Serialization and subject-formation', pp. 99–100.
14. Roffe, 'Exteriority/interiority', pp. 95–6.
15. For a detailed account of the connection between Deleuze and architecture see Brott, *Architecture for a Free Subjectivity*, and also Frichot and Loo (eds), *Deleuze and Architecture*.
16. Deleuze, 'Response to a question on the subject', p. 349.
17. Colebrook, 'The joy of philosophy', p. 226.
18. Pile, *A History of Interior Design*, p. 10.
19. International Federation of Interior Architects/Designers, 'IFI interiors declaration'.
20. See Deleuze, *Empiricism and Subjectivity*, p. 101. Here and throughout this chapter, this title is referred to as ES.
21. Williams, 'Immanence', p. 126.

22. Deleuze, 'Mediators'.
23. Massumi, *Parables for the Virtual*, p. 255: 'Deleuze uses the word "intercessor" for this disinterested but effectively engaged political risk-taking role'; n. 50: 'Unhappily translated as "mediator"'.
24. Deleuze, 'Letter to a harsh critic', p. 6.
25. Deleuze, 'Mediators', p. 281.
26. For a more detailed discussion of these projects see Attiwill, *?interior, practices of interiorization, interior designs*.
27. Grosz, *Architecture from the Outside*, p. 59.
28. Attiwill, 'Sightings, sitings, citings'.
29. O'Doherty, *Inside the White Cube*, p. 29.
30. Bishop, *Installation Art*, p. 8.
31. Ibid., p. 133.
32. See Semper, *The Four Elements of Architecture and Other Writings*.
33. Bains, 'Subjectless subjectivities', p. 109.
34. Ibid., p. 108.
35. Ibid., p. 109.
36. Grosz, 'The thing', p. 126.
37. Deleuze, *Bergsonism*, p. 31. Here and throughout this chapter, this title is referred to as B.
38. Deleuze and Guattari, *What Is Philosophy?*, p. 48. Here and throughout this chapter, this title is referred to as WP.
39. Bains, 'Subjectless subjectivities', p. 111.
40. Deleuze, *Francis Bacon: The Logic of Sensation*, p. 8. Here and throughout this chapter, this title is referred to as FB.
41. Deleuze, *Foucault*, pp. 94–5. Here and throughout this chapter, this title is referred to as F.
42. Boundas, 'Deleuze: Serialization and subject-formation', p. 115.
43. Deleuze, 'On four poetic formulas that might summarize the Kantian philosophy', p. 31.
44. Grosz, *Architecture from the Outside*, p. xix.
45. Ibid., p. 115.
46. Grosz, *Chaos, Territory, Art*, p. 19. The first chapter of this book, 'Chaos. Cosmos. Territory. Architecture', is a version of Grosz's *INSIDEOUT* keynote speech 'Chaos, territory, art', 23 April 2005, Domain House, South Yarra, Melbourne, which was published in *2005 IDEA Journal* (Queensland: QUT/IDEA), pp. 15–28, and online at <http://idea-edu.com/journal/2005-idea-journal/> (last accessed 24 April 2017).
47. Grosz, *Chaos, Territory, Art*, p. 12.
48. Ibid., p. 13.

49. Benedikt, 'Environmental stoicism and place machismo', p. 4.
50. Bains, 'Subjectless subjectivities', p. 107.
51. Brooker and Stone, *Rereadings*, p. 19.
52. Brooker and Stone, *What Is Interior Design?*, p. 8.
53. Young et al., *The Deleuze and Guattari Dictionary*, p. 2.
54. Deleuze, 'Ethology: Spinoza and us', p. 628.
55. Attiwill, 'Interiorizt', p. 114.
56. Colebrook, *Deleuze: A Guide for the Perplexed*, p. 156.
57. Kaufmann, *What Is Modern Interior Design?*. Written in 1951 as a catalogue for an exhibition at the Museum of Modern Art in New York City which sought to define the new emerging profession/discipline of interior design, this title articulates the qualities of the practice, which continue to have relevance to contemporary practice.
58. Grosz, 'Habit Today: Ravaisson, Bergson, Deleuze and Us', p. 230.

Experiencing

Who is the subject in Deleuze?

The starting question: what is the nature of human beings such that we have experiences? Who experiences?

Answer: this is a bad question.

Why: for Deleuze, the self or the 'I who experiences' is a *product*, not the basis of experience.

In this, Deleuze completely endorses Hume's famous remark:

> when I enter most intimately into what I call myself, I always stumble on some particular perception or other, of heat or cold, light or shade, love or hatred, pain or pleasure. I never can catch myself at any time without a perception, and never can observe any thing but the perception. [I am therefore] nothing but a bundle or collection of different perceptions, which succeed each other with an inconceivable rapidity, and are in a perpetual flux and movement. (Hume, *A Treatise of Human Nature*, 1.4.6.4)

Experiencing

Who is the subject in Deleuze?

Here is a Deleuzian text that makes the same general point. Who is the subject?

> It is at work everywhere, functioning smoothly at times, at other times in fits and starts. It breathes, it heats, it eats. It shits and fucks. What a mistake to have ever said *the* id. Everywhere *it* [*ça*] is machines – real ones, not figurative ones: machines driving other machines, machines being driven by other machines, with all the necessary couplings and connections. An organ-machine is plugged into an energy-source-machine: the one produces a flow that the other interrupts. The breast is a machine that produces milk, and the mouth-machine coupled to it. (Deleuze and Guattari, *Anti-Oedipus*, p. 1)

Both Hume and Deleuze and Guattari argue that *what* I am is a certain kind of retrospective apprehension, a certain synthesis of time: so *that's* what I was!

We make the mistake of assuming that there is an experiential self prior to experience because we take the *result* to be the pre-existent cause or condition.

Experiencing

Who is the subject in Deleuze?

New question: how does the flux of experience give rise to an experiential subject, one that will later (somewhat illegitimately) take possession of its experiences?

Deleuze's answer: habit, in the broadest sense.

Habit = stabilisation, gathering, ordering of dynamisms (habits of walking, sleeping, working, thinking . . .).

Like Hume, for Deleuze these habits are not mine but *ours*. Better, habits that constitute our social reality are the tendencies that make us into the subjects that we are.

Experiencing
Spinoza's ethics

When Deleuze deals with these kinds of questions, he tends to return to one of his great influences, Spinoza.

For Spinoza, a subject is:

- a body with a certain capacity to act, composed of parts that are organised in a particular way, *and at the same time*;
- a mind with a certain capacity to think, composed of parts that are organised in a particular way.

This means that all encounters take place in bodies and in thought at the same time, because the physical *is* the mental, and vice versa.

Examples: eat a great meal, and writing becomes easier. Have a depressing conversation, and you don't just feel physically weaker, you are.

In turn: what Spinoza calls *ethics* is not about 'right and wrong' but 'the increase or decrease in our power to act' = a matter of our *composition* and *capacity*, not *consciousness* and *free will*.

Experiencing
Spinoza's ethics

Here are four key upshots of all of this:

1) To become capable of more we need to know which encounters will make us stronger and which weaker = understanding cause and effect.

2) *But* we mostly begin by presupposing that we are not caused to act as we are, that we are naturally free, whole, rational, etc. = the belief in the foundational and sovereign human subject is an ethical failure of a basic kind.

3) Spinoza's ethics means that we have to begin by giving up the basic idea of the human being as the independent and free agent.

4) Or: the human being is not the moral animal, but an *obstacle* to ethical living.

Experiencing
Art beyond the phenomenological body

For Deleuze and Guattari, the aim of art is to create percepts and affects = ways of seeing and feeling that do not belong to any human being, and therefore exist on their own terms, expressed through the work of art.

= affects and percepts are pre-subjective sensations = they do not arise from the human body or human experience but from beyond it and exceed it.

Case of dance: the dancer's body must go beyond the lived experiential body and become a new, non-human body, so as to bear out these inhuman percepts and affects.

Experiencing
Affect, subject, ethics

1) Affect. At once:

 - what accompanies a change in our power to act (Spinoza), *and*
 - what art creates and expresses (Deleuze and Guattari)

2) Subject. At once:

 - what is produced through social habituation (habits of all kinds), *and*
 - what artists can use strategically in the creation of new affects and percepts, *and*
 - at the same time what (some) arts are directly trying to undermine

Experiencing
Affect, subject, ethics

3) Ethics. At once:

- the reworking of the subject to become capable of more, *and*
- the dismantling of the organisation of subjectivity itself

Hence ethical themes in Deleuze's work like:

- dismantle the organised body
- make yourself a body without organs
- free the head from the face
- engage in a movement of becoming-animal, etc.

5
Experience and its Others

Philipa Rothfield

> I think what Merce [Cunningham] was trying to express was the idea that anything the human body does is expressive and that the self is at best irrelevant and, at worst, a distraction from the real business of dancing.[1]

Rethinking experience

Dancers are very fond of the way their bodies feel while dancing. They spend a great deal of time focused on the experience of their bodies, during warm-up, as they dance, afterwards, in fact, most times of the day. They marshal these feelings so as to compose and recompose themselves in motion. The lived body is one way of explicating this sense of felt corporeality. A key component of Merleau-Ponty's phenomenological philosophy, the lived body integrates corporeal feeling, experience and (our sense of) subjective agency. Dancers may well embrace the lived body as a way of approaching their dancing so as to give primacy to their experiences and feelings of kinaesthetic agency. But there are times when the dancing does not quite line up with this kind of subject-centred approach, when the body seems to exceed the domain of embodied subjectivity. Such cases suggest the possibility of another notion of activity in the body quite apart from that which is felt by the dancer. These latter feelings can be tied to a different sense of agency, one which is expressed within the dancing rather than exerted by the dancer.

Gilles Deleuze offers a way of thinking this other notion of feeling, through the thought of Friedrich Nietzsche. Nietzsche does not subscribe to the phenomenological insight that the embodied subject stands behind all action. Although we are drawn to attribute action to the subject, agency derives elsewhere for Nietzsche, from the actions and reactions of subterranean drives and forces, all of which take place beneath the field of experience. For Nietzsche, 'the doing is everything', the doer a misrecognition on our part.[2] Nietzsche appeals to the activity of underlying forces, drives and instincts as an alternative way of understanding human action. Deleuze draws upon these terms, specifically that of force, in order to explain the way action unfolds without being the product of human agency. In so doing, he distinguishes between the way forces interact to produce human experience, and the way forces interact to provoke action. The two kinds of formation are different in kind. According to this framework, action arises because force takes hold of force, and not because a subject acts.

Although experience and subjectivity are usually thought to enjoy a cordial and harmonious relationship, such as in Merleau-Ponty's phenomenological philosophy, Deleuze's Nietzsche allows us to decouple these two terms in important ways, to make space for the activation of experience without a metaphysics of the subject. The Nietzschean denial of the subject as agent does not dispute the many experiences that arise in relation to doing. Both Nietzsche and Deleuze allow for, and approve, the uptake of experience in action insofar as action prevails and continues to do so. The pursuit of action, including the utilisation of experience in action, constitutes a certain type of ethos, which Deleuze calls the active type. The active type favours action over and above (the reification of experience within) subjectivity. The active type drives a wedge between the dancing and the dancer. In so doing, it allows experience to play a role within dance without the benefit of subjective agency.

This chapter will retain subjectivity's human associations so as to contrast two modes of agency, human and inhuman, alongside their distinct attitudes towards experience. It will look at the role experience plays within each paradigm, as this might occur within dance practice. Experience in both these cases belongs to the

event but, in the one case, it is predicated of a subject who stands behind the action and, in the other, it is immanent to the event, the product of its constituent forces. The discussion will draw upon Deleuze's extension of the Nietzschean distinction between active and reactive force into two distinct types (active and reactive) in order to foreground the relative superiority of dance as inherently active. The Deleuzian framework is able to explicate a number of kinaesthetic variations in terms of their type and function. This affords a general characterisation of dance as an avatar of the active type. Such a notion of dancing resonates with Deleuze's depiction of the body as a transitory and mobile formation of force, enabling a more dynamic and fluid approach towards the body's interactions and boundaries than the phenomenological account permits. Where experience occurs, it is promptly absorbed within the activities of the active type, in the dancing. The active type is fully realised in movement, rather than linked to a subject who acts. Virtuosity is similarly discerned within the dancing rather than seen as a property of the dancer.

The Nietzschean metaphysics of force understands action as the work of multiple forces, each with its own character. The distinction between the ways in which active and reactive forces function offers a difference and duality of perspective. This double perspective in turn enables two ways of thinking the activity of dancing: a subjective (reactive) point of view and an active point of view. It will be argued that both these perspectives are operative within postmodern dance practice and its allied somatic approaches. These dance forms offer a variety of ways of thinking the notion of experience, firstly in relation to the dancer but also as something more/other than that which is captured by the dancer's subjectivity. Such practices could be said to actively work this difference between human experience and corporeal force (non-subjective affect) for their own kinaesthetic purposes. Some embrace it, others harness it, prodding subjectivity towards a dancerly version of its own overcoming. Or, perhaps more accurately, they gesture *towards* the Nietzschean figure of overcoming. The aim of this chapter is not to idealise dance in superhuman terms; rather it is to open up the notion of experience to its inhuman counterpart as it might be found within the field of dance.

The suggestion is that certain modes of dance practice (and potentially others further afield) can be seen to orient the body *away* from the subjectivity of experience, and towards a non-human sense of corporeal agency, allied to Deleuze's Nietzsche.

Deleuze's approach to Nietzschean philosophy discerns a number of configurations, types and formations. These will be used in order to account for two ways of looking at experience and their attendant conceptions of agency (Nietzschean and phenomenological), but also to look at the movement between these two senses. Deleuze's notion of active destruction – as the will to be overcome – will be offered as a means of interpreting the kinaesthetic values of the postmodern sensibility in dance. From the point of view of the subject, active destruction represents the limit or endpoint of subjectivity. Active destruction cannot traverse the difference in kind between the lived and the active but it does gesture towards that shift. While the postmodern kinaesthetic sensibility of the dancer is perhaps oriented towards overcoming through the figure of active destruction, the baton can only be picked up on the other side of the equation: on the corporeal side. Perhaps postmodern dance may be better explicated in relation to Spinoza's view that we don't know what a body can do, by emphasising the body's achievements beyond the knowing subjectivity of the dancer. To that end, this chapter will conclude by gesturing towards Deleuze's pragmatic rendition of Spinozan philosophy. It will explore the sense in which a dancerly dialogue between subjectivity and the body could be framed as a practice-based, experimental version of the good, with Nietzschean and Spinozan overtones perhaps, but nonetheless faithful to its own concrete iteration.

Experience and the lived body

Merleau-Ponty's phenomenological philosophy offers a very bodily sense of subjective agency, grounded in experience. The body for Merleau-Ponty is the subject's wherewithal, the means whereby the subject lives his/her existential situation. The lived body unites experience, agency and action.[3] It resists reductive notions of the body as object, whilst preserving its embodied status against

any attempts to separate mind and body (and thereby isolate the mind as the seat of subjective agency). Merleau-Ponty's lived body expresses our 'motor intentionality'[4] or 'bodily purpose'.[5] Motor intentionality is a way of understanding human action in intentional terms, as the bodily expression of our intentions, aims, goals and purposes. The suggestion is that our actions have intentions embedded within them, that human movement is itself intentional (rather than the work of a Cartesian ghost in the machine). The lived body is the seat of agency within this paradigm. Merleau-Ponty emphasises the habitual means by which we act and live. Habit allows us to range freely over the world, and to orient lived experience towards the pursuit of individual goals and actions.[6] Habit belongs to the field of the everyday. It represents our grasp of the world, in action. This is reflected in terms such as 'grip', 'flow' and 'absorbed' coping.[7] There is an existential harmony to this picture, between the body as the seat of our agency and the many ways in which we live that body.

Merleau-Ponty's work on the lived body is fairly easily adapted to the field and example of dance. Its experiential, corporeal emphasis would appear to be at work according to most dancers' *modus operandi*. What differs are the nuances of the dancer's corporeal orientation, its explicit emphases, interests, values and 'somatic modes of attention'.[8] Although some phenomenologies of dance take a generic approach to the dancing,[9] others emphasise the differences that hold between dance forms.[10] The acknowledgement of difference in dance draws attention to the impact of kinaesthetic culture on each dancer's perceptions, demeanour and experiential orientation. It argues that kinaesthetic culture produces distinctive ways of perceiving the body in movement, in tandem with that which is valued in movement. To that extent, there is no single dancerly orientation, rather a multiplicity of lived bodies and their implied modes of agency.[11]

Movement subjectivity is one way of capturing these kinaesthetic differences, as they are refracted within movement and its experience.[12] Movement subjectivity includes the dancer's habitual dispositions, kinaesthetic preferences, performative demeanour and modes of somatic attention. These elements are at play in the way the dancer moves, in relation to what counts as dancing for

the dancer, in regard to the kinds of corporeal factors thought relevant to dancing and in the way in which perception seeks its object in the bodies of others (the kinds of qualities and activities attended to). At the level of value, these attitudes represent a kind of kinaesthetic sensibility, which is felt intersubjectively and expressed within the particular dance setting.[13] Kinaesthetic sensibility is the concatenation of movement values, preferences and modes of somatic attention which permeate the field, and is adapted by the dancer in virtue of participation in the field. Practice cultivates these elements in the body of the dancer. Both factors, the dancer's movement subjectivity and kinaesthetic sensibility, are embedded within dance culture. They arise in virtue of practice and performance, training and technique, focus and perception.

To illustrate, some form of experiential anatomy is fairly prevalent within Western, contemporary and postmodern dance practices. Experiential anatomy appeals to muscular-skeletal imagery and understandings in order to guide (and therefore shape) the dancer's awareness in movement. In *BodyStories: A Guide to Experiential Anatomy*, for example, Andrea Olsen describes the function and nature of bone within human anatomy, then guides the subject through a series of movement meditations:

> Lying in constructive rest: Bring your awareness to the bones. Begin moving from this position to articulate each bone in the body ... Move with awareness of the hard, cancellous bone ... Begin to travel through space, and to work standing.[14]

Olsen's text focuses on the key bones in the human body (skull, spine, pelvis, ribcage, shoulder and so on), taking the reader through a poetic and concrete journey of exploration but also an experiential sense of the bones in movement, of their location, weight and feel. These and many other similar muscular-skeletal approaches inaugurate practice-based modes of somatic attention which become, over time, established within the dancer's movement subjectivity. They may become part of the dancer's daily warm-up or inform his/her perceptual orientation (through

seeking the feelings associated with the bones in movement) and sense of his/her own body-schema.[15]

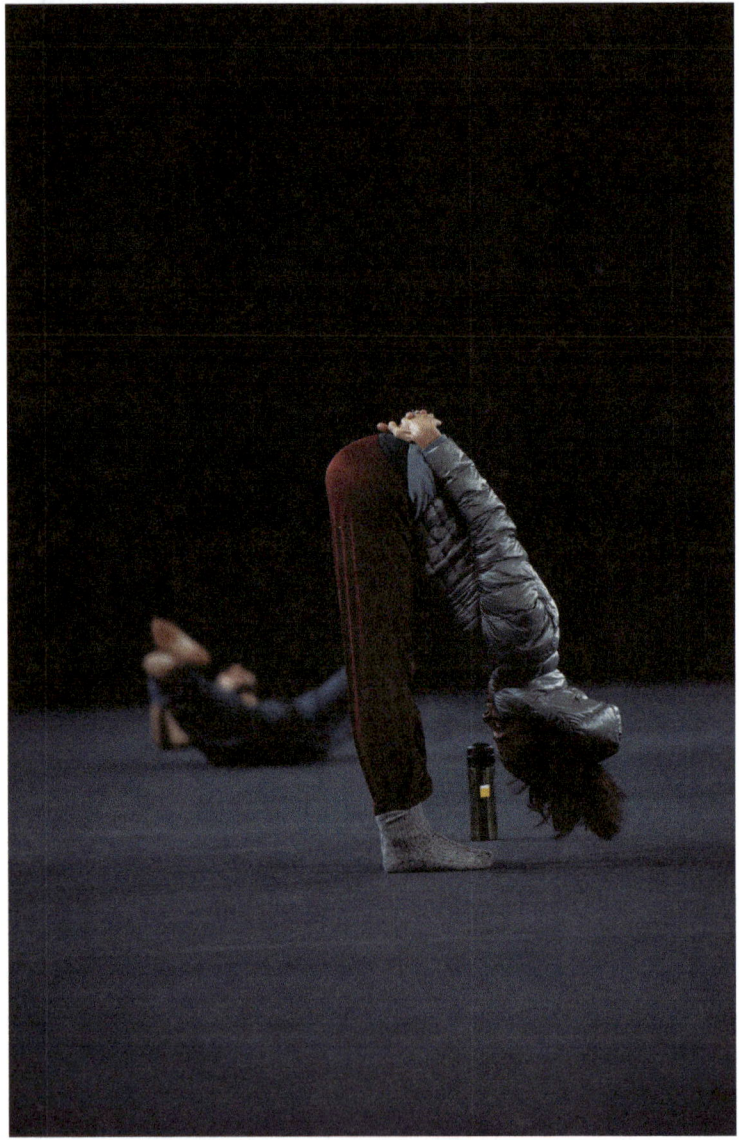

Figure 5.1 Trisha Brown Dance Company, Melbourne, 2014. Photographer: Ron Fung.

In short, they become embedded within the dancer's perceptual apparatus. Experiential anatomy not only draws attention to anatomic details, it appeals more generally to the muscular-skeletal system as an informative and relevant basis for sensed movement. It typically includes awareness of the spine, skull, pelvis, legs, arms and ribcage, drawing attention to the most efficient ways in which gravity and action can co-operate without using excessive muscular tension. Feeling the head balanced on the top of the spine, space in the channels of the vertebrae, scapulae falling down, softening in the hip joints, weight falling through the feet is one way of paying attention to the experience of movement, in motion. French choreographer Myriam Gourfink draws upon a muscular-skeletal framework through a yoga practice dedicated to the fine microperceptions of breath, weight and incremental movement.[16] There are many ways in which muscular-skeletal understandings enter into dance practice and its perception. They are often invoked to enable greater ease and efficiency of movement.

Other, more muscular approaches rely on a habitual postural schema, which is inculcated through daily practice. Classical ballet, for example, has a distinctive demeanour (a kind of muscular 'pull up' and characteristic turnout of the legs), which facilitates the range of movements that comprise the classical lexicon. Yet other approaches, such as Skinner Releasing Technique, value muscular release, leading to a very different 'launch' into action.[17] In each case, the trained and practising dancer adopts the specific values embedded within the field. These factors shape the dancer's experience as conceived within Merleau-Ponty's phenomenological thinking.[18] Once shaped, such values function as the dancer's performative facility, his/her 'I can'.[19] Movement subjectivity stands for a ready-to-hand body, poised to move according to the kinaesthetic values of the domain.[20] This is perceptual and action-based, to be found within the experiential character of dance culture.

The phenomenological paradigm appeals to experience as its ultimate court of appeal. Experience is the domain within which agency is exercised. To understand the nuances of experience, in its relation to the world, is to gather the intentional threads which enable us to live and to act.[21] Merleau-Ponty's phenomenology supports the dancer's sense of embodied agency. It can be refined to reflect kinaesthetic and cultural differences in the

field of performance practice, whilst nevertheless retaining its key emphasis in perception, experience and action.

The Nietzschean break with subjectivity

Nietzsche rejects the phenomenological account of the lived body, calling into question all that experience would suggest. In *Daybreak*, he writes:

> The habits of our senses have woven us into lies and deception of sensation: these again are the basis of all our judgements and 'knowledge' – there is absolutely no escape, no backway or bypath into the *real world!* We sit within our net, we spiders, and whatever we may catch in it, we can catch nothing at all except that which allows itself to be caught in precisely *our* net.[22]

Experience is not a window on the real here, rather a filter which bears little relation to that which it filters. And if experience says more about us than the world, the question of agency equally lies beyond our comprehension:

> The primeval delusion still lives on that one knows, and knows quite precisely in every case, *how human action is brought about* ... Is the 'terrible' truth not that no amount of knowledge about an act *ever* suffices to ensure its performance, that the space between knowledge and action has never yet been bridged even in one single instance? Actions are *never* what they appear to be![23]

Daybreak introduces the idea that a succession of drives underlies the surface phenomena of human experience.[24] Drives are competitive tendencies which gain prominence at the expense of other drives. According to Nietzsche, human being ensues from the momentary dominance of particular drives. Our sense of experience and agency, conceptualised in the lived body, has no inkling of the plurality of drives which constitute our being. While experience must interpret their ascendency and ultimate

manifestation in order to give them content, subjectivity is condemned to imagine their real character. To that extent, 'there is no essential difference between waking and dreaming'.[25] If action is the result of the dominance of one drive over its competitors, experience invariably misses its mark:

> What then are our experiences? Must we go so far as to say: in themselves, they contain nothing? To experience is to invent?[26]

Nietzsche thereby draws a distinction between the character of experience and that which occurs beneath its surface. Our tendency to think the identity of subjects and objects belies the greater activity and difference of the drives.

The Nietzschean world is thus less stable than we think, consisting of a changing multiplicity of forces, drives and impulses. Forces (or drives) are those competitive, impulsive tendencies that together form a chaotic multiplicity. This multiplicity takes shape – that is, resolves into temporary and transitional arrangements – only to give way to the formation of new arrangements of force. Forces resolve because one force imposes itself upon the others, working them towards its own ends. These latter forces (those imposed upon) contribute to the overall character of that which ensues, by way of their response to the activity and imposition of prevailing force. The world is continually becoming in virtue of these encounters between forces (drives, impulses). It may speed up or slow down, take shape or reform, depending upon the momentary formations which arise and their emergent interrelations. Nietzsche's appeal to the multiplicity of force undermines the veracity of experience and calls into question its diagnostic value. It also rejects the notion of subjective agency in favour of the activities of force (or drives).[27]

Nietzsche posited an element – the will to power – to signify the dynamic impulse that is expressed through these relations of force. The will to power is a principle of becoming embedded within relations of force. It is the dynamic of their transition from one state to another. The will to power has many faces, finding expression in all spheres, human and non-human, organic and

inorganic. Taken together, the will to power and the workings of force (drive, impulse) express the agency embedded in all becomings. Human action, although apparently attributable to subjective agency, is merely a special case of these activities. Merleau-Ponty's motor intentionality (intentional movement) is reframed within Nietzschean thought, as indicative of underlying relations of force which not only account for all action but also produce the subjective feelings and thoughts which attach themselves to action. In other words, relations of force are equally responsible for the character and composition of subjective experience. Everything comes down to relations of force which dynamically engage so as to become otherwise.

Nietzsche and philosophy

In *Nietzsche and Philosophy*, Deleuze draws together Nietzschean thought into a concise taxonomy of terms and relations. In so doing, he constructs a number of figures or types, which reveal the becomings of force in light of Nietzsche's critical approach. Typology, for Deleuze, shines a light on the workings of force. It is able to differentiate relations of force according to their manner of relating. These types, themselves provisional and momentary, are to be found in the concrete workings of force and their allied will to power.[28] Thought in conjunction with the specific pathologies of the human, such as *ressentiment* and bad conscience, typology speaks to the difference between the healthy expression of force in action and its redirection into the 'spider web' of subjectivity.

The body

The body, Nietzsche's 'guiding thread', is the first figure in this scenario.[29] The body is neither a stable identity nor the ground of perceptual experience but rather a momentary resolution of force. Klossowski speaks of the body as a succession of corporeal states, which come into being then pass.[30] A body is formed when one force selects and imposes itself upon other forces. Deleuze writes:

> Every force is related to others and it either obeys or commands. What defines a body is this relation between dominant and dominated forces. Every relationship of forces constitutes a body – whether it is chemical, biological, social or political ... In a body the superior or dominant forces are known as *active* and the inferior or dominated forces are known as *reactive*. (NP 40, emphases added)

The body is thus composed of evolving relations of difference. Its dynamic transformation ensues from the imposition of active force upon other, reactive forces which, for their part, accommodate, adapt and respond. Active and reactive force both contribute to the movement (or becomings) of force, but their roles differ. Force emerges as active because it imposes itself upon other forces, which similarly emerge as reactive because of their response to active force.

The human body is a special corporeal case, consisting of myriad constituent relations of force. Deleuze speaks of the body as a dynamic 'multiplicity' (NP 40). According to this way of thinking, the dancing body is able to signify a great range of interrelated activities and modes of organisation. Movement can be broken down into a set and series of component activities. This can be thought in any number of ways. Pushing into the floor yields length along the spine; softening the musculature invites the downwards flow of gravity, allowing the body to enjoy a corresponding upwards thrust; the torso finds support from the legs, the head and pelvis counter-balance each other in motion; the ribcage supports the mobility of the shoulder girdle; scapulae dropping down the back allow the arms to float upwards. These actions can be posed in terms of distinct forces at work: muscles soften so that the bodily structure can find length; the foot and ankle assert a push against the floor's resistance. In each case, we can posit a certain kind of activity (active force) which works those other elements that enter into the action. The identification of those components at work and their respective roles is an interpretive task.[31] Furthermore, an element may be active one moment, reactive the next, taking the lead in one respect, following the lead in

another respect. Movement moves and so do its constituent forces. Dancing often involves anticipatory modes of organisation, which pave the way for what follows. The play between anticipation and its utilisation produces those conditions which are in turn activated to generate that which ensues. These shifting circumstances are integral to the successive encounters of force that produce the dance.

Force of circumstance

Deleuze writes of active force exploiting circumstance (NP 42). Reactive force writ large is the field of circumstance, selected by active force and worked into motion. A wide range of factors comprise the circumstances of dance – physical factors, temporal factors, environmental elements (space, the floor, temperature, air, architecture, milieu), cultural precedent, performance habitus, the trace of training and technique within the body (corporeal provenance), the interaction between bodies, music and sound, the virtual and digital, also kinaesthetic, cultural factors that carry established values, patterns, styles, modes of performance and canons of spectatorship. Dancing draws upon any and all of these factors. Improvisation, for example, makes use of a wide range of available forces in order to 'seize the moment'. Circumstance is key even to improvisation: the good selection is not unconditioned but contextualised, in relation to the immediate past, the shape of the event, the flow of time, performer and audience anticipation, also experience in the body of the performers which opens the event to serendipitous moments of selection. In the case of improvisation, these elements do not necessarily belong to the single performer who 'chooses' but exist in between and amongst performer(s) and audience.[32] Deconstructive forms such as postmodern techniques of assemblage and recomposition likewise construct and address their own field of circumstance – the dancer's body, phrase material, habit, the field within which this kind of activity is valued, the predisposition and skill to make it happen – in order to produce new enunciations. For their part, active forces take up these

evolving circumstances, giving shape to their emergent regions of possibility. The field of dance selects the kinds of circumstances thought relevant, its particular kinaesthetic laying the groundwork for that which is taken up in motion.

Because the body is a transitory formation which arises out of relations of force, we could say that a body is formed through the foot's pushing into and out of the floor, that is, between the foot and the floor, or that a counter-balance between bodies creates a new conjoined entity/event.

The boundaries of the dancing body soften and reform in relation to the force of circumstance. Bodies jointly become otherwise, through the passage of weight, touch, intention and impulse, only to resolve into their distinct arrangements. Tradition seamlessly merges with innovation in performance.[33] What all of these corporeal formations share is the activity of one force upon other forces which, for their part, resist, react or accommodate, making available other qualities and tendencies in response to the workings of active force.

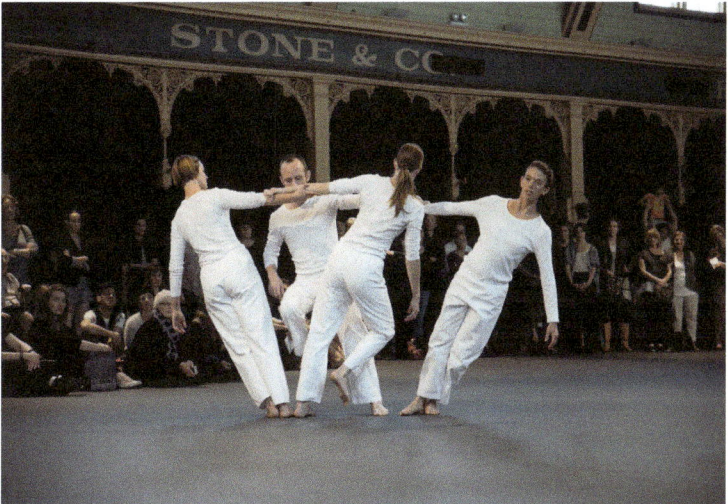

Figure 5.2 Trisha Brown Dance Company, Melbourne, 2014. Photographer: Ron Fung.

Type #1: master activity

The resolution of force into movement represents the relatively healthy expression of force in action. Nietzsche's *On the Genealogy of Morality* attributes corporeal activity to the master, the one who expresses a 'superabundance' of power, felt according to 'governing unconscious instincts'.[34] If the master reacts by way of some momentary thought or experience, such reaction is expressed forthwith, in an 'immediate reaction'.[35] Deleuze draws upon the figure of the master in action to outline what he calls the 'active type' (NP 111, 146). The active type functions by way of master activity, that is, through active force working reactive force. When active force works reactive force, reactive force is said to be '*acted*' by active force (NP 111, 146). In other words, the role of reactive force in action is to be acted, to enter into activity in reply to the assertions of active force. Releasing the body into the floor allows gravity to 'act' the body's softening musculature; reformulations of traditional idiom 'act' tradition to produce new variations; ideokinetic imagery 'acts' the habitual body towards an eventuating corporeal difference. Reaction is to be found here, in the way the body softens into the floor, through the way tradition provides the basis for variation, and in the habitual body's encounter with ideokinetic reformulation. The body arises out of these actions, moves and transitions. It dances their plays of force, moving in light of their dynamic interplay. All these examples find resolution in action, through the imposition of active force upon other factors which shape the ensuing movement. Master activity characterises the way forces 'normally' engage in action.[36] Dancing represents one sphere of master activity, expressed within a kinaesthetic, cultural, performative milieu.

Type #2: the reactive apparatus

The Nietzschean master was introduced in *On the Genealogy of Morality* to mark a point of difference and function from the image of the slave. The master is an affirmative figure, whose value is established in and through action. This differs from the slave, a

parasitic formation, which establishes its value through negating the work and value of the master. The slave prevails at the expense of the healthy paradigm. Beginning in *ressentiment* (towards the master), reaction triumphs in the slave by taking hold of healthy expressivity and holding it morally responsible. The slave turns upon the master through revaluing the merits of master activity. Nietzsche emphasises the imaginary nature of the slave's 'work', at the level of value and not action. That said, the *consequences* at the level of force are real enough.[37]

Deleuze draws together the many threads of *On the Genealogy of Morality* to show that the (slave's) negation of activity enables the sedimentation of reaction. What his analysis makes clear is the difference between a reaction which is simply acted (the healthy norm) and a reaction which for its part disables active force. When reaction triumphs, active force is disempowered, unable to exert itself upon reactive force (in the normal way). According to this scenario, reactive forces

> proceed in an entirely different way – they decompose; *they separate active force from what it can do*; they take away a part of almost all of its power. In this way reactive forces do not *become active* but, on the contrary, they make active forces join them and *become reactive* in a new sense. (NP 57, last two emphases added)

That new sense forms the basis of the Deleuzian account of subjectivity in Nietzsche. Deleuze draws upon the figure and function of *ressentiment* in Nietzsche's work to construe what he calls the reactive apparatus. The reactive apparatus is the means by which experience, interiority, consciousness and perception – in short, all the elements that comprise the world of lived experience – come about. The reactive apparatus functions through the redirection of force, the sedimentation of reaction and the dissolution of activity. The elements of the reactive apparatus are found in *On the Genealogy of Morality*, where Nietzsche writes of the 'turnaround' (internalisation) of force.[38] Force is internalised when it is not expressed in action, when reaction holds sway by defusing active forces, making them become-reactive (supra).[39]

Reaction becomes a type through defusing active force. This represents a mechanism for Deleuze, the means whereby reactive forces 'escape' the activity of active force to form their own terrain and type (NP 111). Through this 'escape', reaction takes the place of action in the reactive apparatus to form experience, the flow of interior thoughts, sensations and feelings. Deleuze cites Freud's topical hypothesis on the interplay between the systems conscious and unconscious as a way of explaining the formation of experience through the workings of force. He draws on the two systems to show how the system conscious can form the flow of experience at the expense of action. He focuses in particular on the ways in which external stimuli are able to leave a trace, qua reaction. Formation of the trace in the system unconscious is fairly straightforward. The system conscious is more complex precisely because it needs to 'refresh' itself, to make room for new content.

Deleuze supplements the Freudian model with Nietzsche's insight that forgetting is a productive activity. In this context, Deleuze credits forgetting with the ability to make room in the system conscious for the new. Forgetting enables the refreshment and fluidity of consciousness so as to open itself to new stimuli, and also new thoughts and responses to previous stimuli. A consequence of such mobility (of consciousness), however, is that the system conscious is of its nature unstable. Such instability is vulnerable to the following failure of function:

> suppose that there is a lapse in the faculty of forgetting: it is as if the wax of consciousness were hardened, excitation tends to get confused with its trace in the unconscious and conversely, reaction to traces rises into consciousness and overruns it. *Thus at the same time as reaction to traces becomes perceptible, reaction ceases to be acted.* (NP 114)

Deleuze uses the Freudian model to diagnose the formation of experience *at the expense* of activity. Reactions to traces emerge within experience (enter the system conscious) insofar as they escape the clutches of active force. In so doing, active force is demoted, no longer able to express itself; it *becomes* reactive. And

once that happens, reaction settles into the reactive apparatus, swapping reactive content for reactive content.[40]

There are thus two kinds of becoming here, the becoming-active of force in action, and the becoming-reactive of force in experience. The reactive apparatus builds upon the invasion of consciousness by the mnemomic trace (NP 114). The reactive apparatus is more than the mere formation of experience, however. It represents the world of interiority, its experiential flow, the psychological values it espouses including its sense of agency, responsibility and sensibility.[41] The reactive apparatus reifies *ressentiment*, through the quasi malfunction of forgetting and the emergence of the conscious trace (felt experience). Not only is this a kind of sickness for Deleuze, it is the mark *of* the sickness that characterises the human realm.

Dancing with Deleuze

Deleuze's treatment of Nietzschean philosophy offers a way of thinking dance as the work of force rather than the achievement of the dancer. Dancing is a form of master activity here, the healthy expression of active and reactive forces, propelled into movement through the immanent dynamic of the will to power. Master activity produces the body as its provisional and transitory outcome. The body's transitions are inherently unconscious. This is a mark of its superiority over consciousness in general, and the reactive apparatus in particular.

The master's riposte

According to this approach, dancing is the unconscious activity of force upon force, the activation of circumstance through kinaesthetic articulation. Many aspects and elements of dance can be situated within this model, drawing upon the field of force to be found in, around and amongst bodies. This is not to say, however, that there is no place for experience within dance. Both Deleuze and Nietzsche allow for the rhythmic formation and active utilisation of reaction (qua experience). Deleuze writes of the normal, healthy role of reactions which slow or hinder action, but which

are ultimately and inevitably put to work in the name of activity (NP 111). These cases represent the 'quick and precise' adjustments of the master who turns reaction into action: 'The master is said to react precisely because he acts his reactions' (NP 111). According to this scenario, reactions do rise to the surface (of consciousness) but they are promptly taken up and acted rather than sediment into the reactive apparatus.

To that end, sensation, perception, even conscious thoughts may comprise reactions subsequently pressed into the service of dancing by way of master activity. While kinaesthetic culture makes its own selections regarding which *kinds* of reaction are valued, master activity is that which reorients them towards action. Although one cannot universalise the role and nature of sensory perception within dance (or culture, for that matter), physical feeling, for example, plays a key role within many forms of Western dance. This is made explicit according to their modes of performative practice and is reflected in audience understanding and literacy.[42] Sensations offer biofeedback, qualitative responses to the body's encounter with itself (via touch, proprioception, muscular tone), and also with the environment (other bodies, the surface of the floor, the air, temperature, walls). Perceptual experience encompasses a wealth of thoughts, feelings and ideas. It also guides attention, thought and feeling between bodies. Perceptual experience follows established pathways, offering corporeal feedback in terms that belong to the specific cultural, kinaesthetic milieu. In a more psychological register, thoughts can be strategic lures, making suggestions or offering imagery to be taken up in action.

Very broadly, then, sensation, thought and perception may have a role to play within an active conception of dance depending upon the reactive nuances of the particular field. Kinaesthetic culture selects its domain of reactions, whether sensations, affects, energies, relations, images or thoughts. What these share as expressions of the master's riposte is (re)activation towards action: through becoming-active. The masterly (read dancerly) type draws our attention to the doing as such. It doesn't matter whether that doing draws upon felt or non-felt reactions. And once reaction is taken up in action, it enters the field of unconscious activity, where it is acted rather than settling into the reactive apparatus.

The point of difference from a phenomenological perspective is that these sensations and their uptake neither commentate nor reflect the dancer's agency but rather anticipate their entry into action. According to the active type, sensation and perception are the anacrusis of action rather than the signifiers of human agency. Agency is no longer a matter of the subject 'doing' anything, rather a question of enabling reactions to be acted.

Virtuosity and the sovereign individual

What follows is an exploratory discussion of the particular ways in which dance practice enunciates its own kinds of activity. The discussion begins with an account of virtuosity, culture and the sovereign individual. Virtuosity is one of the highest forms of cultural expression in the field of dance. As the product and expression of kinaesthetic culture, virtuosity is imbued with specific cultural values. And yet, virtuosity is also *in excess* of culture's customary force. To that extent, virtuosity parallels the Nietzschean concept of the sovereign individual, who is produced by culture on the one hand, yet able to legislate (culture) on the other. When paired with the Nietzschean conception of the sovereign individual, a tension can be seen to arise, however: between the untimely nature of virtuosity and the historical force of culture. If the sovereign perspective sees virtuosity in legislative terms, as legislating culture, then the very notion of virtuosity embodies a practical problem insofar as the body is historically situated yet is also the means whereby the virtuosic is achieved. How does the body facilitate such a movement *beyond* culture? Deleuze's account of the genesis of culture and the affirmative transmutation of the reactive sphere (in the Eternal Return) offers a way of thinking through this problem. This will be fleshed out in relation to virtuosity but also in connection with the field of postmodern dance which, it will be argued, offers its own means of practical resolution.

This chapter has throughout emphasised the role that (kinaesthetic) culture plays in relation to the cultivation of the dancer, and in relation to the content and character of the field. Kinaesthetic culture highlights and cultivates certain *kinds* of reaction, oriented towards an active uptake. In phenomenological terms, these are

embodied in the dancer's movement subjectivity and corresponding kinaesthetic sensibility as habitual dispositions and tendencies. Deleuze speaks of the generic role of culture as a mode of subject-production, which functions by instituting habits:

> It is always a matter of giving man habits, of making him obey laws, of training him. Training man means forming him in such a way that he can act his reactive forces. (NP 133)

Culture's role is therefore to produce a given field of reactions, 'suitable for being acted' (NP 134). These are inculcated in the body of the dancer. In the field of dance, culture functions via practice, initially through training and habituation, then reiteration by way of the dancer's everyday. Western contemporary dancers often refer to their own 'practice', as something they return to on a daily basis. Culture thus cultivates a dispositional readiness in the body, pertaining to particular kinds of reaction which are both elicited and rendered suitable to be acted. The role of culture is, in short, to produce a certain type of active type.

For both Nietzsche and Deleuze, culture also has the potential to bear 'fruit', in excess of the laws of habit and custom (NP 137).[43] This is embodied in the figure (and activity) of the sovereign individual. The sovereign individual is defined in terms of the ability to make promises, that is, to legislate rather than merely follow custom. The sovereign individual is the one 'who defines himself by power over himself' (NP 137). Can virtuosic dancing be seen as an exemplar of the sovereign individual? The question turns upon virtuosity's relation to culture. On the one hand, virtuosity is specified by culture. Kinaesthetic cultures each produce their own sense of excellence or virtuosity. Virtuosity is determined according to the dictates of the field. It is not a property of the dancer but an element of the field, to be found in practice, in the body's momentary achievements. And yet, virtuosic dancing represents the heights of cultural (re)deployment. Virtuosic dancing is a mode of mastery that turns the breadth of circumstance to its own ends.

Thought in this way, virtuosity is an expression of sovereignty over culture. Virtuosity is that which 'acts' custom. For its part, custom functions as virtuosity's field of circumstance, its body of

available reactions. What custom does in this context is give shape to the virtuosic. Some forms of custom will exercise a strong hold on the assertions of the virtuosic, limiting its freedom while nevertheless acknowledging its distinctive sovereignty. In concrete terms, this may mean that certain kinds of classical virtuosity will remain close to the field, while others might nudge it towards new modes of iteration. Again, this is a question of the concrete evaluation (of forces). We can assume neither that tradition precludes innovation nor that apparently contemporary forms embrace it. Jin Ok-sub, Korean author, artistic director and curator, argues, for example, that Korean traditional dance is constantly reinventing itself in light of changing circumstance, in contrast to Western choreography, which produces 'the work' as a fixed identity.[44] If custom is the work of culture, then virtuosity is a (re)working of that work. The sovereign individual is thus 'free' to act culture, to render movement subjectivity (qua field of reactions suitable to be acted) available but not compelled in any one direction.

The thing about dance, though, is that culture (qua training) plays an incredibly strong role in the formation of the dancer: it is a form of history in the body, a disciplinary formation of corporeal consequence.[45] Training is, by custom, a manner of habit-formation, iterated and reiterated again and again.[46] Training leaves a strong legacy in the body of the dancer, as disposition, as the taste for certain kinds of movement, even the desire for particular kinds of feeling in motion. This raises a problem for the sovereign individual 'who defines himself by power over himself' (NP 137): how does a trained body, thoroughly inculcated by training and technique, stage its own cultural overcoming? Nietzsche has a way of articulating this problem:

> There is a wicked dilemma to which not everyone's courage and character are equal: as a passenger on a ship to discover that the captain and steersman are making dangerous mistakes and that one is their superior in nautical knowledge – and then to ask oneself: how if you should incite mutiny against them and have them both seized? Does your superiority not give you the right to do so? And would they not also be in the right if they locked you up for undermining discipline?[47]

The question of mutiny (inciting change against the grain and trace of the past) poses a problem of justification for the one inciting mutiny, an 'agonising situation' which pits the past against a potentially different and unknown future.[48] In dance terms, the problem is the following: how does a trained body open itself to non-customary forces? What strategies enable a body to move beyond custom? Although initially a question of virtuosity, seen through the lens of sovereignty, there is a sense in which postmodern dance shares the same problem, between the givenness of the past and a future which differs, staged over the body of the dancer.

Although there are many ways of characterising and historicising postmodern dance, I want to focus on one aspect of this diverse field: on the way in which it challenged established ways of making dance through a process of questioning and investigating movement. The origins of this shift in approach can be discerned in the work of Yvonne Rainer, who, with many others, set the context for making work not geared for display. Such an attitude is articulated in Rainer's 'Manifesto', which rejected spectacle in favour of a workerly absorption in task-based activities.[49] The shift from spectacle to absorption is reflected in Rainer's landmark dance, *Trio A* (1966).

Trio A features one or more dancers performing a series of movement tasks. The work is not designed for performance on a proscenium arch stage with its frontal audience orientation, nor do the dancers orient their bodies towards the audience. Much later, Rainer described its mode of performance as

> low-keyed impersonation, suggesting a provisional or ambiguous self that is at once produced, erased, and confounded ... the performing self of *Trio A* takes care of its self *and* its expression by a mode of expression that recuses the self.[50]

This is achieved in *Trio A* through the performative demands of the work. Rainer writes of *Trio A*'s 'cool absorption in the *work* of dancing'.[51] This represents a characteristic aspect of certain strands

of postmodern dancing, a workerly orientation which ensures that experience is folded back into movement – the master's riposte. This forms what could be called the workerly type. Trisha Brown's 'early works' (1963–75) are also marked by task-based activities, which do not call for any kind of performance persona on the part of the dancer.[52] These task-based forms of choreography established a different way of dancing, beyond the display of knowing subjectivity on the part of the dancer. Rainer describes *Trio A*'s mode of performance as a form of expression which 'recuses' the self. The dancer's absorption in the task, which enables the formation of the workerly type, is an ongoing expression of the master's riposte.[53] Experience, sensation and perception are all reoriented towards action, activated according to the complex demands of the work at hand.

These endeavours and their allied workerly type are well-established modes of postmodern choreographic practice. A key element of these strategies is the desire to work beyond the knowing subjectivity of the mover, thereby to produce movement that lies beyond the mover's kinaesthetic sensibility. In practice, this means working with strategies that aim to decentre and displace the familiar kinaesthetic territory of the choreographer/dancer. There are many ways in which this might occur; for example, certain choreographic approaches rework movement materials through techniques of cut and paste; the production of retrograde variations; pleating, folding and suturing movement, so as to create new flows and new demands on the body of the dancer. While movement material might have begun with a set of movements that feel familiar and look recognisable, a completely new corporeal logic arises through inserting arbitrary breaks, and shifting the order and flow of movement. The task of the dancer is to find a way to perform these uncanny movements. This isn't merely a question of order; it has to do with what a body needs to do in order to enact a different corporeal logic. Producing a retrograde version of movement material inaugurates a completely different kinaesthetic regime. An action such as raising an arm, when reversed, cannot rely on familiar sensations and experiences of flow. Joining a series of 'partial' (dissected) movements likewise

requires the formation of novel corporeal capacities on part of the body, to traverse, connect and make possible new kinaesthetic assemblages.

Deleuze elsewhere discusses the notion of subtraction as a means of destabilisation that allows for the new to emerge in the midst of the given.[54] These choreographic techniques could be seen as a mode of subtraction which alters kinaesthetic provenance towards an untimely reformulation. The destabilisation of movement vocabulary pushes the givenness of technique beyond the habitual into new territory. Calling for more than mere mastery of the given, this poses a 'perpetual' problem for the dancer, requiring an ongoing virtuosity which must overcome its origins (in cultural familiarity). There is a sense in which postmodern dance resists habituation. To that end, Elizabeth Dempster emphasises postmodernism's deconstructive character.[55] This deconstructive aspect calls for a kind of virtuosity that does battle with its own provenance.

The deconstructive tendencies of the postmodern are not confined to reformulations of order and flow. The choreographer Deborah Hay also pushes the limits of movement subjectivity by offering a notion of the body as fifty-three trillion cells in a constant mode of becoming. Hay has over many decades created choreographic scores aimed at undermining the dancer's knowing subjectivity in favour of the body as a dynamic multiplicity. A dancer performing Hay's choreography cannot rely on predictable movements nor anticipate what's to come as far as actual movement is concerned. This is echoed in Hay's claim that 'there is no way for the body to look' in her work.[56] In other words, Hay's choreographic scores do not specify particular movements. They might ask the performer to suppose a state of affairs, to approach movement 'as if' it reflected such a reality, or to institute a perceptual attitude or follow particular instructions, all of which may even be paradoxical. Her instructions are nonetheless quite rigorous, the dancer constantly in the midst of unknown territory.

The aim is to see what the body might produce within these terms. Hay creates supplementary instructions for the dancer to open up to the body's productive differences. For example, the

EXPERIENCE AND ITS OTHERS

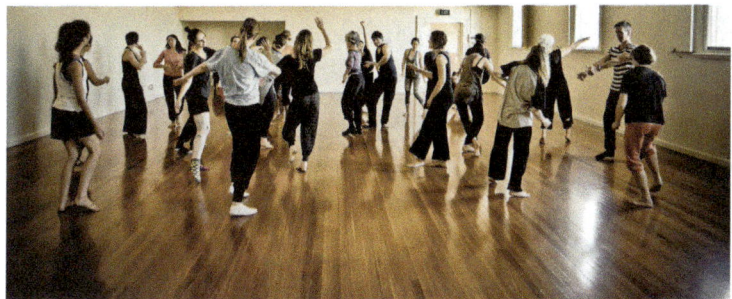

Figure 5.3 Deborah Hay, Learning Curve, Dancehouse, Melbourne, 2014. Photographer: Gregory Lorenzetti.

instruction 'here and gone, here and gone' is a mode of resistance to 'the invasion of consciousness' by the mnemonic trace (NP 114). In practice, 'here and gone' redirects reaction away from the reactive apparatus, promoting its utilisation within master activity, via the master's riposte to the formation of experience (reaction). Sustained practice of this perceptual instruction interrupts the memorial coherence of the dancer. Hay writes: 'My work relies on the persistent presence of the questions, rendering useless a reliance on memory and anticipation.'[57]

Russell Dumas similarly promotes a strategy of desubjectification which he calls 'slow rendering'.[58] Slow rendering resists habit-formation (finding a 'solution' to a repeated task, by allowing it to settle into habit), shifting the focus of practice, away from the subject presumed to know towards a form of subjectivity at odds with its very formation. In practice, this means avoiding the tendency to repeat a move until it becomes familiar and automatic; keeping the body open to the possibility of other variations and modifications. Slow rendering aims to make the body available to new material which for its part provokes the acquisition of new capacities in the body (non-customary relations of force).

Dumas understands that the movement investigations allied with his choreographic process place strong demands on the dancer, in opposition to the notion that a dancer, once trained, is ready to dance. To that end, he endeavours to find ways to

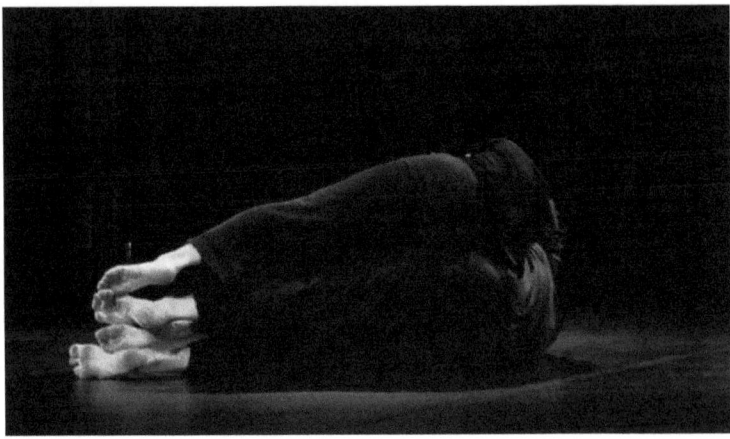

Figure 5.4 Dance Exchange, Australia (director: Russell Dumas). Dancers: Jonathon Sinatra, Nicole Jenvey. Photographer: Russell Dumas.

create contexts which undermine the (trained) body's resistance to change, and challenge those hegemonic forms of custom that limit the field of movement possibility.

Other somatic approaches problematise the intentionality of movement, through strategies of inhibition or a conception of 'non-doing'. Their reason for doing so is the view that consciously performed movement will inevitably return to the habitual everyday. By way of antidote, the Alexander Technique replaces the subject's motor intentionality with the Alexander directions, a form of thought-imagery to be deployed instead of 'doing' movement.[59] Ideokinesis does something similar. Working through a mode of vertical disruption (lying down in the horizontal plane, in constructive rest), ideokinesis offers multiple thought-image-actions that lure the body away from its habitual tendencies. For example, the subject is asked to imagine the body as a suit of clothes that collapses towards the floor along with the outbreath.[60] Both Alexander and ideokinesis counsel against doing, suggesting that 'to do' is inevitably to revert to the old ways. Their problem is how to find new ways for the body to move beyond the doing embedded in movement subjectivity. This is Nietzsche's mutinous predicament.

The deconstructive, investigative components of postmodern dance represent more than mere absorption in action, calling for the pursuit of active strategies that open up the body to difference. I want to take up Deleuze's notion of active destruction, as one way of approaching this demand. Deleuze formulates an attitude on the part of the subject towards its own destruction (NP 174). He attributes active destruction to Nietzsche thus:

> Zarathustra praises the man of active destruction: he wants to be overcome, he goes beyond the human, already on the path of the overman ... *And thus he wills his own downfall* ... (NP 174)

Active destruction is the will to be overcome. Insofar as it enjoys success, active destruction inaugurates affirmation in the will to power, the transmutation of the human into the affirmative realm of the Eternal Return, the return of difference. I want to propose the figure of active destruction in relation to the strategic production of corporeal difference beyond the confines of movement subjectivity, as a strategy exercised on the part of the postmodern dancer. To do so is to offer a reactive perspective on the transmutation of the human towards that which can be affirmed, the play of difference. While forces are ever subject to reactive capture, no less in the realm of dance than any other, dance's belonging to the active type renders it more liable to make use of active destruction in the name of corporeal difference. Such a move is supported by those postmodern kinaesthetic values and practices, which aim to exceed (or recuse) the subjectivity of the dancer towards other modes of performative practice. This is no mean feat. Klossowski credits the dissolution of identity with the ability to fully embrace difference, an unlikely outcome on the part of the assiduous postmodern dancer. To that end, I suggest that active destruction is more an asymptote, a figure of overcoming towards which the postmodern dancer may aim. Postmodern dancers often speak of opening themselves up to difference, of allowing the body to take the lead, of dampening down their subjectivity and of the challenges of moving beyond habit and the subject presumed to know. Active destruction offers a way of thinking this strategic resistance

to the sedimentation of force within the reactive apparatus. If the ultimate affirmation of the Eternal Return is beyond our reach, perhaps we can pose active destruction as an asymptote, something never reached but reached towards.

Conclusion

Deleuze offers an image of thought as an arrow shot into the air and picked up by another thinker (NP ix). The strategic deployment of subjectivity towards the production of corporeal difference could be thought in this way, as an arrow shot in the air by the dancer, and picked up by another type, by a body that momentarily forms beyond the confines of force outlined by that dancer's movement subjectivity. To that extent, we have moved beyond the familiarity of experience into another zone and domain, into a realm that values difference beyond the limits of experience, towards another mode of efficacy. The strategic deployment of subjectivity could also be framed as 'acting' the reactive apparatus, turning its function into a reactive basis for dancing rather than its usual function of sedimenting *ressentiment*. Such strategies can only ever hope for provisional, momentary or partial success. Perhaps they are better seen in experimental terms.

Deleuze's pragmatic discussion of Spinoza, in *Spinoza: Practical Philosophy*, situates us in the midst of Spinoza. The ethos of postmodern dance, beyond that which the dancer already knows, could be framed in ethical terms, as the promotion of affective capacity. Postmodern dance is not unique in this respect, merely more familiar than other instances further afield. The inherent limitations of consciousness (and experience more broadly) open the way for a new mode of thought, 'a discovery of the unconscious, of an unconscious of thought just as profound as the unknown of the body'.[61] As an avatar of the active type, dancing embraces the unconscious expressions of force in action. The master's riposte forestalls the sedimentation of *ressentiment*, whilst promoting its redeployment. The workerly type, found in certain regions of postmodern dance, espouses the value of activity beyond sovereign control. Taken further into the realm of active destruction, postmodernist dance ventures into ethical territory, not as a moral good but rather as the aesthetic pursuit of increased

affective capacity or agency. This notion of shifting agency no longer belongs to the dancer but is a product of the dancing. The dancer is pulled along in its slipstream, a version of Nietzsche's arrow, shot into the air by one thinker and picked up by another.

Notes

1. Rainer, 'Where's the passion? Where's the politics?', pp. 47–8.
2. Nietzsche, *On the Genealogy of Morality*, p. 28.
3. David Morris writes: 'There is no ontological separation between the experiencing "I" and the body as one lives it. Indeed, the lived body is one's intentional opening to the world, through which alone one experiences meaningful things in the first place' ('Body', p. 111).
4. Merleau-Ponty, *Phenomenology of Perception*, pp. 137–8.
5. Ibid., p. 99.
6. Ibid., esp. Part One, Chapter 3.
7. Dreyfus and Dreyfus, 'The challenge of Merleau-Ponty's phenomenology of embodiment for cognitive science', pp. 110–11.
8. Csordas, 'Somatic modes of attention'.
9. See Sheets-Johnstone, *The Phenomenology of Dance*.
10. See, for example, Rothfield, 'Differentiating phenomenology and dance'; see also Ravn, 'Embodying interaction in Argentinean tango and sports dance'.
11. See Rothfield, 'Differentiating phenomenology and dance'.
12. See Rothfield, 'Philosophy and the bodily arts', p. 25.
13. Ibid., pp. 25–6.
14. Olsen, *BodyStories*, p. 41.
15. Dancers who have adopted these ways of working intermittently think through and perceive the weight of the bones, the fall of gravity through an upright skeleton (called the centre line), the shape and nature of the highlighted bones and joints such as the pelvis, skull, vertebrae, ribcage and so on. In this setting, dancers think their alignment in relation to their bones, via imaginary (and real) gravitational lines that connect particular bones (for example, the fall of gravity from the sit bones into the heel, and the sensory fall of weight through the hip joints, centre of the knees, the experiential centre of the foot and so on).
16. So, for example, the breath is used to shift weight a little bit in one direction and then the other, returning to the centre to breathe and sense the space behind the forehead inside the skull and between

the eyes. Myriam Gourfink, Learning Curve workshop, Dancehouse, Melbourne, Australia, September 2016. See also <http://www.myriam-gourfink.com> (last accessed 14 March 2017).
17. See <http://www.skinnerreleasing.com> (last accessed 14 March 2017).
18. Elizabeth Dempster makes clear the link between habitual body-schemas and their perceptual orientation. She writes: 'Ballet is powerful in its effects upon the dancer. It marks deeply not only the neuromusculature but also the perceptual disposition of the dancer' ('Ballet and its other: Modern dance in Australia', p. 16). Dempster chronicles the hegemonic role that a balletic perception occupies within Australian contemporary dance.
19. Merleau-Ponty, *Phenomenology of Perception*, p. 137.
20. As Dempster indicates, the dancer's perceptual facility also grounds the evaluation of other dance forms according to its own (unacknowledged) modes of kinaesthetic sensibility. This is a political issue, sometimes found in combination with Western ethnocentric modes of perception.
21. Merleau-Ponty, *Phenomenology of Perception*, p. xv.
22. Nietzsche, *Daybreak*, p. 117.
23. Ibid., p. 116.
24. It also offers a genealogical perspective on their origin and the difference between that origin and the appearance of subsequent drives once they surface within human culture and subjectivity. *Daybreak* seeks to explain the hold that moral values have on us. Nietzsche posits an imperative structure of subjectivity (the morality of custom), comparable to the function of movement subjectivity, insofar as it signifies the tendency towards compliance for its own sake (whether as the habit of morality or habitual approaches towards movement practice). In the case of dance, this is felt as the tendency to move in particular ways, in terms of the values expressed by the dancer's kinaesthetic milieu. Kinaesthetic values function as a mode of morality or value, to be adhered to.
25. Nietzsche, *Daybreak*, p. 119.
26. Ibid., p. 120.
27. See ibid., §119, pp. 118–20.
28. Deleuze writes: 'A type is a reality which is simultaneously biological, psychological, historical, social and political' (*Nietzsche and Philosophy*, p. 115). Here and throughout this chapter, this title is referred to as NP.
29. Nietzsche, *Writings from the Late Notebooks*, p. 30.

30. Klossowski, *Nietzsche and the Vicious Circle*, p. 26.
31. Interpretation for Nietzsche is a very loaded activity in that interpretation is itself an expression of force, the emergence of a perspective which has imposed itself upon the workings of force (see Lingis, 'The will to power', p. 45). The identification of active force within movement is thus a pivotal question: is action to be attributed to a subject, to the muscular assertions of the body or to the activity of gravity? The open-ended nature of these potential interpretations is further complicated by the fact that we need to look to the concrete workings of force in order to make the call (NP 44). While the softening musculature may be a candidate for a reactive response to the activity of gravity, it could equally be argued that postural organisation is the active component that 'works' gravity. Muscular techniques may similarly be thought to 'assert' their muscularity, yet it could be argued that these muscular assertions are themselves a mode of reaction to the action of gravity. In each case, we need to look at what's at stake within a particular interpretation and what kind of perspective is being forwarded. Nuance is extremely important. Where a 'collapse' may be a reaction to the workings of gravity, a more managed softening might well be deemed active. The question of movement interpretation also includes the identification of force – what tendencies count as force within dance? Are we to include elemental, supernatural, incorporeal forces, and, if so, which ones and when?
32. See Rothfield, 'Chance encounters'; see also McLeod, 'The movement between'. The multifaceted, relational aspect of improvisation is quite palpable in Korean traditional dance, which places value on the improvisational moment. There, the value of the moment can be observed in relation to the timing and rhythm of movement, especially in the elastic moment *before* the dancer commits to movement. It also emerges in regard to the live negotiation between musician and dancer, which incorporates and enfolds the audience's appreciation of the event.
33. Although traditional dance might be viewed as mere repetition of the same, the performative nature of all dance demands its (re)iteration in changing circumstance. Franz Anton Cramer challenges the opposition between tradition and the contemporary, by referring to a conception of Japanese Noh performance that sees its engagement with contemporary conditions as the very enunciation of a tradition 'that remains unaltered since the early days of Noh performance in the sixteenth century' ('Speaking Africa, *Logobi*', p. 135).

34. Nietzsche, *On the Genealogy of Morality*, p. 23.
35. Ibid.
36. By this, Deleuze means to put forward a Nietzschean paradigm of health, one which is grounded in activity (NP 111–12).
37. See NP 57.
38. Nietzsche writes: 'All instincts which are not discharged outwardly *turn inwards* – this is what I call the *internalization* of man' (*On the Genealogy of Morality*, p. 61).
39. Michael Haas writes: 'The development of man's "interiorization" and the birth of his ethical consciousness takes its foothold and beginning from the impotence of the instincts, their powerlessness to find a way of expressing themselves outwardly and the resultant turn inward' ('Nietzsche and metaphysical language', p. 20). Inaction is given a moral inflexion by the slave, whose negation of master activity is articulated within a moral register, according to which virtue belongs to the one who refuses (to do) evil. The inauguration of the moral domain opens the door to the plethora of reactions that circulate the subject in place of action.
40. 'As a result of his type, the man of *ressentiment* does not "react": his reaction is endless' (NP 115).
41. Deleuze writes: 'We can see what Nietzsche's intention is: to produce a psychology that is really a typology, to put psychology "on the plane of the Subject"' (NP 116).
42. For those kinaesthetic cultures which differ from this model, it is entirely possible that sensation (qua sensory registration) plays an unconscious role in terms of master activity, but that this is implicit and therefore not a good example of the master's riposte. Such cultures may instead emphasise other kinds of experiential quality, which may in turn become a form of riposte. It should also be noted that there are many ways to 'think' feeling (or 'feel' thought), and that these are reflected and embodied within the various dance cultures. Some are quite muscular in orientation, others highlight certain regimes of the body, while others pair feeling with specific kinds of corporeal or spiritual imaginary. These differences all inflect the ways feeling enters into experience and is therefore featured within the master's riposte.
43. Nietzsche, *On the Genealogy of Morality*, p. 40.
44. Ok-sub, personal communication.
45. Foucault writes: 'The body manifests the stigmata of past experience ... the body is the inscribed surface of events' ('Nietzsche, genealogy, history', p. 148).

46. See Chakravorty, *Bells of Change*.
47. Nietzsche, *Daybreak*, p. 186.
48. Ibid.
49. Rainer, '"No" to spectacle'.
50. Rainer, 'Where's the passion? Where's the politics?', p. 49.
51. Ibid., p. 51.
52. These include *Sticks, Soft Phrase, Leaning Duet, Figure 8* and *Scallops*.
53. A related point can be made about the rise of 'pedestrian' movement within postmodern dance, and the way in which pedestrian movement likewise resists the performance persona allied with spectacular forms of display. Steve Paxton is the best-known exponent of this kinaesthetic move with works such as *Satisfying Lover* (1967), which consists of walking, standing and sitting. Russell Dumas writes of the unconscious aspect of such everyday movement, of its habitual, unthought character, in 'Necessary incursions'. To that end, we might accommodate elements of the pedestrian within the workerly type. The complexity arises when a pedestrian movement is 'performed', raising questions such as: to what extent is a clearly chosen 'ordinary' movement still part of the unconscious everyday, and how does performing movement change its status? Is absorption able to counteract the tendency to 'show' what one is doing? These are problems which also attend the workerly type in action.
54. See Deleuze, 'One manifesto less'. For an adaptation of subtraction to the problem of choreography, see Rothfield, 'Tinkering away'.
55. Dempster, 'Let's see a little how she dances'.
56. Hay, personal communication.
57. Hay, <http://www.deborahhay.com> (last accessed 20 March 2017).
58. Dumas, 'Dance for the time being'.
59. The Alexander directions are an attempt to activate a number of expansive directions in the body (head moving forwards and up, back widening and lengthening) without the 'benefit' of any explicit intention to move. See Alexander, *The Alexander Technique*.
60. See Sweigard, *Human Movement Potential*, pp. 233–5.
61. Deleuze, *Spinoza: Practical Philosophy*, p. 19.

Encountering
The encounter with art

For Deleuze, we are composed of habits, clichés.

Bodily habits, linguistic habits (including the habit of saying 'I'), affective habits . . .

These habits or clichés are necessarily intervened on by art.

Art *creates* new extra-subjective affects and percepts -> to encounter art is to be inhabited and changed by these blocs of sensation.

But how do we *encounter* art? There are two questions here:

1) *What* do we encounter when we encounter art? The event.
2) *How* do we encounter the event in art? In sensation.

The key point is therefore the one made with precision by Andrea Eckersley: 'art is an event felt as a difference in intensity.'

We will consider five moments in Deleuze's account of the passage from the encounter to the event.

Encountering
Habit and experience

Habit is conservative. In what way?

Deleuze and Bergson: habits filter new experiences, rendering them in terms of the already-seen, Beckett's 'nothing-new'.

For Bergson, perception is *subtractive*:

- What I expect is modelled on my habitually organised need and expectations.
- This is the sieve through which I experience the world as it is and as I expect it to be.
- So: habit is an unavoidable sieve and not a set of auxiliary behaviours I can choose to dispense with.

Perception gives me, not the thing, but a sieve-image of the thing, 'the thing *minus* the features filtered out by perception' (Bogue, *Deleuze on Cinema*, p. 35).

My response to the world is not based on how the world is, but on the image of the world that I give to myself -> habit reduces the world to a milieu in which I can act.

The sensori-motor schema: the habituated machinery of perception and action.

Deleuze: it is this that art interrupts, troubles, *bouleverse*.

Encountering

'The impulse of a shock'

But the sensori-motor schema only prepares me to encounter versions of what I have already encountered.

I am not prepared for traumas small and large: the first encounter with Szechuan food, a first boating trip and the sea-sickness that overwhelms, a new pain, the approach of death . . .

Deleuze's more technical presentation:

- What is recognised, acceptable to the sensori-motor schema, are *extended and qualified* objects of experience.
- A shock exposes me to what precedes and is presupposed by quality and extension: *intensity*.
- Intensity is the dynamic matrix of subjectivity and objectivity.

Example: Deleuze is obsessed with eggs. Inside a new egg is not a fixed body (of a small chicken, for instance), but a set of dynamisms, energetic tendencies, thresholds of change, etc. The embryo in the egg is presupposed by the adult chicken, but differs from it in kind.

Example: the first experiences of space by a baby have no metric rule or stable spatial context in which they can be made sense of. This space is a dynamic intensive space: between mouth and breast, a distance that has no measure.

Encountering

'The impulse of a shock'

The sensori-motor schema routinely obscures the intensive character of existence by giving me images of habitually recognisable and stable things.

Alternative definition: the sensori-motor schema is the habitual tendency to subtract intensity from experience.

Consequence: it is only when we encounter intensity that habits are broken open and we change.

> We never know in advance how someone will learn: by means of what loves someone becomes good at Latin, what encounters make them a philosopher, or in what dictionaries they learn to think. (Deleuze, *Difference and Repetition*, 1994 edition, p. 165)

Encountering

The case of cinema

Mainstream cinema is (mostly) organised to fit snugly with the sensori-motor schema. It gives our habits and the world (qua milieu of meaningful action) back to us, reinforced.

But: cinema can also challenge the sensori-motor schema, and this collusion.

Key example: the irrational cut. Two images are joined together in a way that we don't expect and can't make sense of as a result.

We are stupefied = we are forced to make sense of what we are seeing, though we lack the means to do so.

Deleuze: in this situation, there is another who thinks *inside* us: a 'spiritual automaton' (Spinoza), a mummy, a marionette . . . we are literally inhabited by a second thinker.

The strangeness of encountering the irrational cut = the strangeness of feeling the production of sense within us, but not at the hands of the sensori-motor schema.

Consequence: the modern cinema of the irrational cut forces us to think = to constitute new connections in thought so that these images come to have meaning.

Encountering
A new conception of learning

The concept of 'learning' normally means: passing from ignorance to knowledge.

Deleuze: no.

Learning is not about the attainment of information, pieces of knowledge, but about changing the person and thing that you are.

Real learning never ends: to exist = to undergo a perennial apprenticeship.

Encountering

What is encountered in sensation?

Deleuze's answer:

> That which can only be sensed moves the soul, 'perplexes it' – in other words, forces it to pose a problem: as though the object of the encounter, the sign, were the bearer of a problem – as though it were a problem. (Deleuze, *Difference and Repetition*, 1994 edition, p. 140)

We encounter something that 'can only be sensed'. That is:

- It cannot be recognised.
- It is intensive in character.
- It expresses problems.

But how?

Encountering
What is encountered in sensation?

In sum:

1) Every encounter is an encounter with intensity.
2) Intensity *expresses* problems.
3) For Deleuze, we can also identify the problem with the idea and with the event.

So: the encounter is always an encounter with an event, but an event is more than the sensible shock itself.

The encounter with a work of art = an encounter in experience with something that exceeds the sensori-motor schema = the encounter *in sensation* with a problem, that is, with an *event*.

6

Encountering Surfaces, Encountering Spaces, Encountering Painting

Andrea Eckersley

One never encounters a work of art at the beginning. We are always in the middle. In the middle of a gallery, in the middle of a conversation, in the midst of some sort of love, halfway between lunch and another cup of tea, in between taking off a jacket, securing a page of a book, betwixt and between experience and thought, between perception and affect. We are in the middle of a work of art even if we are the one making the work. There is no *tabula rasa*, not even a blank canvas, for there is always a history of experiences, a thought before, a collection of materials in the studio ready to be worked with: a mound of clay, a paint brush, a piece of paper, a sewing machine, a computer, a variety of instruments and tools at hand. All of these materials can be conceived of as bodies as they encounter my body, intensive forces acting on my body with the capacity to affect and be affected. These are some of the encounters immanent to art, in the event of art's constitution.

Affect is what happens when we encounter art. Affect is also what happens when I make art. An affect or feeling is a consequence of an encounter presupposing an idea from which it flows.[1] I encounter materials, as a deliberate engagement, composing a set of relations (some intended, some not) in order to foment another encounter. Encounters therefore describe the activity of making work *and* the activity of the viewer as she moves around to look at work, as she intersects or assembles with its ingressions. In this chapter I will discuss how an encounter with art

can be understood in order to theorise how art works through encounters, inasmuch as any given work involves spatial, temporal and affective encounters. In discussing my practice and that of painter Agnes Martin, I hope to make clear that all encounters with art have the potential to increase or decrease our capacity to act, transforming our very nature. Encounters are immanent to an event of art, whereby an artwork may be understood by way of the singularities, the differences in intensity, it generates.

This argument relies on a distinction between art conceived of as a static material artefact, a stable 'given', and painting understood as an active formulation, as part of an always unfinished event. The elements of a work – which may include the physical aspects of clay, screen, canvas, board or wall, gesso, pencil, pigment, fluids or liquids, along with non-physical or intensive elements such as the artist's intentions and desires – generate encounters by constituting an assemblage of affects in an event. This is an event characterised by intensities, sensations, affects and encounters.[2] Conceiving of art in these terms reveals how affects are produced in encounters between the intensive aspects of surfaces, such as the material surface of the work, the body of the viewer and the material surfaces of the art's environs or space of presentation. Such an understanding provides a conceptual language for describing what art does and, more importantly, what art can do.

My practice includes *the addition* of paint, wax, oil, laminates, timber or chemicals, a specific light source, or the creation of shadow; or *the removal* of paint or wax, as in polishing or sanding; or *the exposure* of linen, canvas, medium-density fibreboard; or *the folding of surfaces* such as paper. In the variety of materials that I encounter in my work I am interested in exposing the ambiguous relations between different kinds of surfaces, for example by sanding back sections of walls so that they may reflect transitory light in a wall painting. In contrast to the encounters I have when making my own work, I will also discuss how the spaces and distances in the paintings of Agnes Martin, described by Rosalind Krauss, can also be productively understood as encounters. Exploring some of the ways light affects the viewing of Martin's paintings, which are typically characterised by subtle colour washes and simple pencil lines, will also help to reveal the limitations of more traditional

appreciations of Martin's work. I reason that it is more productive to conceive of Martin's paintings as an event of art, in terms of the encounters that are immanent to this event, so that Martin's paintings may be experienced as differences in intensity.

What is distinctive about such an approach to Martin's paintings is the attention it brings to the affective qualities of encounters that Deleuze emphasises. I will not be arguing that Martin's paintings are somehow illustrative of these features of the event. Instead I will try to avoid the trap of presenting individual artworks as examples of particular affective qualities by bearing in mind the advice of philosopher Andrew Benjamin, who argues that a given artwork must never be regarded as external to the discourse surrounding it.[3] It follows that one never writes about art as if the object requires an explanation (or an excuse), but rather writing about art contributes to the very constitution of an object, practice or form as art. Consistent with Benjamin's distinction, I am more interested in how we can use various Deleuzian concepts as tools or devices, as ways of understanding what is happening when we encounter works, to unpack the work of the work of art. To this end I will focus on notions of affect, extension, intensity, individuation and ingressions as tools or devices for discussing my practice and some of Martin's paintings.

Deleuze asserts that an encounter 'can be grasped in a range of affective tones' insofar as it 'can only be sensed'.[4] However, the object of an encounter 'is not a sensible being but (rather) the being *of* the sensible' where 'it is imperceptible precisely from the point of view of recognition'.[5] This is why Deleuze poses the encounter in direct contrast to identification or recognition when he famously contends that the encounter is 'something in this world [that] forces us to think'.[6] I would argue that Deleuze's discussion of affect, sensation and imperceptibility is especially useful for starting to investigate how we encounter art. Indeed, this is art's affective power in that art has the potential to reveal to us qualities, relationships, properties and experiences of the world that we might not otherwise notice. So for me it is the thought-provoking character of the encounter that is most relevant for discriminating how sensation occurs in any experience of art. This encounter does not necessarily involve a big bang or shock but

instead can be understood as a transmission between bodies. It involves the proximity of bodies, such as the body of the painting and the body of the viewer, the body of the gallery space and the body of the paint. Such transmission, to borrow terms from Deleuze and Guattari, can be described as a passage from the virtual to the actual made possible through an intensification.[7] Later in this chapter I will discuss this process in terms of the activation of surfaces in the event of painting. The flow between the bodies of the work of art and the body of the viewer, the flow between the actual and virtual, between immanence and transcendence, all contribute to the potentiality of art as an encounter.

Deleuze's discussion of Benedict Spinoza's term *occursus*, literally translated as 'encounter', is dependent on Spinoza's theory of affect and the understanding of the body as a composite relation of forces.[8] It should prove useful to briefly review some of Deleuze's key arguments about affect in order to open up the idea of the encounter and its role in events of art. An affect is not an idea, much less an emotion or feeling, but rather a mode of thought, experienced before cognition and as the cause of material effects. An idea has a formal reality in that it represents something.[9] Affect has no representational quality – it doesn't refer to something else – and is often therefore confused with a feeling. Feelings are actually a by-product of affect in that they are produced by bodies, and experienced as effects in and on the body after an encounter.[10]

Affect is the mode of thought experienced by a body after that body enters into an encounter with another body (human or nonhuman), but this mode occurs just before conscious thought.[11] Affect produces transformations in each party to an encounter, shifting the affective state of each party (either increased joy or increased sadness) just as it transforms the body's power of acting.[12] It is in this sense that Deleuze stresses that affect is independent of the receiver-body, yet affect is still dependent on the body in its capacity to promote action. It is precisely the ability to enact or motivate the body in one way or another that makes the study of affect and its expression in art worthwhile. For this is what I mean when I argue that the study of affects as they circulate in encounters is central to a renewed understanding of what art does,

what it causes to happen. Affect is only relevant in that it provides an outcome of force. Deleuze refers to this force as the power of acting. For example, a positive affect, in that it involves a happy encounter or pleasant act, is often referred to as joy, and a negative affect, in that it involves a harmful encounter or outcome, can be understood as sadness. Moreover, the affect of joy is associated with an increase in the body's capacity to act and to affect others, whilst the affect of sadness leads to a reduction in the body's capacity to act.[13]

Surface event

Deleuze's notion of affect describes the effect of encounters between bodies in an event. This effect involves relative increases and decreases in a body's capacity to act (its power of acting). All encounters have this affective dimension in that all encounters between bodies, human and non-human, involve an increase or decrease in those bodies' relative powers of acting. In this section I will draw from this conceptual analysis to elaborate how a painting can be understood in terms of one body *affectively encountering* other bodies in the activation of surfaces in painting. If we conceive of painting in these terms, it follows that intensity is related to bodies and to the affects produced in the encounters between these bodies. Developing this logic indicates how affect emerges as a relation between the body of the painting, the space of the encounter and the body of the viewer. Intensity is thereby generated in painting as an assemblage of surface activations. I will clarify this argument in the following paragraphs with reference to some of my own recent paintings, emphasising the affective, productive nature of the surfaces of painting. My purpose in reviewing my studio practice is to generate an account of encounters with surfaces informed by the concept of affect.

The focus for the site-responsive wall painting project *Surface event* began with the consideration and selection of techniques for activating the extensive properties of surfaces, including dimensions, format and scale of individual works, along with the character of the exhibition space itself. *Surface event* was held in 2014 at Platform Contemporary Art Spaces, Melbourne's longest-running

Artist-Run Initiative and ongoing public art project. The exhibition featured twelve paintings that were directly administered on to the walls of the cabinets in Campbell Arcade, a subway thoroughfare at Flinders Street Station in Melbourne's city centre. The cabinets, built in the early 1950s, are rectangular display cases roughly 220 x 90 x 60 cm, with two sliding glass windows that partly cross over each other at the front. The cabinets are positioned about a metre off the ground and run along both sides of a salmon pink tiled subway leading from Degraves Street to Flinders Street Station. The site, which was originally constructed as a form for advertising, regularly featured contemporary art exhibitions at the time. I was particularly interested in working directly on to the walls, sides and bases of the cabinets in an attempt to allow the inherent qualities of the wall and all the marks, flaws, blotches and years of over-painting to operate as discrete surface activations in their own right.

The twelve paintings were slowly formed in the cabinets over a period of weeks. It was unfeasible to make all the paintings in the time allocated for installing so the work became a durational activity where every few days I would add another element to the painting. Adding another element primarily involved activating another surface. The various techniques I used for activating the surfaces in these paintings included the use of new colours and different paint mediums, including beeswax; I also sanded back sections and included painted wooden panels, which then cast their own shadows.

Surface event #1 (Figure 6.1) shows how in this work the top disappears into the white light and surface of the cabinet. The peripheries of the work are made ambiguous insofar as the inherent qualities of the existing wall also operate as part of the composition as a specific surface activation. Encountering these works made it difficult to see where the work ended and the existing wall began. *Surface event #1* also included painted wooden panels adding extra surfaces and shadows. I began this series of work by making a series of small paper maquettes. Whilst I use techniques originating in origami, I am not trying to create a recognisable object; rather, I am intent on creating abstract forms. The deliberate choice of folded paper maquettes for the compositions reflects

Figure 6.1 Andrea Eckersley, *Surface event #1*, 2014. Oil, acrylic, enamel, gesso and painted wood panel on wall. Dimensions variable.

my interest in exploring the relationship between the flat surface of paper and the various surfaces of painting.

In my practice, folding paper in the preparation of origami maquettes draws out other dimensions in ways that are analogous to how the activated surfaces of painting may be manipulated to draw out other spaces. The surface of the paper is extensive, yet through folding the paper the surface is activated in a manner that intensifies the spaces of the folded paper. Individual folds in the paper, and the shadows they create, correspond to the shapes of colour in the paintings. The differing folds of paper, and the shadows they cast, are not all on the same continuous surface, and as such the shapes of colour in each of the paintings in *Surface event* were all constructed separately as well. Each shape is painted separately by lifting the brush off the canvas with each application of a different colour. I often use masking tape to carefully delineate these various shapes.

More broadly, Deleuze's concepts of extensive and intensive space, sensation, affect and encounter are central to describing my studio practices of thinking, doing and making. In my studio

practice I am constantly making, looking at and responding to a variety of surfaces. When I mix colours I am observing, for example, if a surface of paint appears greener when placed next to a gold section. Or when I sand back a section of paint on the wall, I am responding to how a new mottled grey section from a previous paint job works in relation to the other surfaces. It is after these moments of treating or activating surfaces, when I physically step back, creating a greater physical space between myself and the work, that I often draw on these Deleuzian concepts to think about and respond to how various aspects of the artwork are operating and, more importantly, the potential of where it might go. Stepping back is considered a vital encounter in the act of painting. Stepping back is not just an act of cerebration to look at the work in progress, which may commonly be understood as a critical reflexive act. This encounter in the middle of making a painting can more productively be understood as a *spacing*. Artist and cultural geographer David Crouch uses the term 'spacing' 'to identify subjective and practical ways in which the individual handles his or her material surroundings'.[14] For Crouch, 'spacing is positioned in terms of action, making sense (including the refiguring of "given" space), and mechanisms of opening up possibilities'.[15] Describing spacing as a productive encounter in the making of art exposes more of the temporal intensive properties that are expressed in encounters between bodies, surfaces, affects, concepts and percepts. As Crouch adds, 'spacing occurs in the gaps of energies amongst and between things; in their commingling. Their interest thus emerges "in the middle", the in-between.'[16]

Crouch's analysis would suggest that spacing may be understood as a temporal activity of *encountering* immanent to the event of the work, which includes the preparation, the making and then the documentation, such that even writing this book chapter is a kind of spacing. It follows that spacing always entails an iterative process given the temporalities implicit in any event of encountering. In this respect, the work I make takes many iterative forms as it exists in many adaptions before, during and after an exhibition, where it then continues on as documentation, as images, as discussions, as writings. Before the exhibition *Surface event* I made a small version of one of the Platform cabinets in

my studio as an initial spacing. Encountering the model cabinet enabled greater experimentation with the paper maquettes and in the creation of shapes, light, shadows and form. In a further iteration of this spacing, I photographed the maquettes and painted small studies on linen to further explore composition and colour choices. Compositionally, I was interested in exploring the shapes of surfaces and the amount or quantity of the surfaces to be rendered in each individual work. To this end, I also experimented with various white paints to examine the effects of reducing colour as a condition of illusion and intensity in specific compositions. The reduction of colour involved further investigation of how colour works to create sensation, and the minimal conditions needed to maintain a sense of illusion, which I carried out through the exploration of other materials such as enamels, gouache, wax, and the sanding back of paint. The whites encountered for this project all had different properties; some were more reflective, some had a slight blue or cooler tone, whilst some were warmer.

By employing varying shades of white, *Surface event* explored how intensity could be activated through the use of different types of paint. Gouache contains a substantially greater amount of pigment than gesso, while in oil paints Titanium white is cooler than Zinc white, and even ostensibly similar white paints all display different properties depending on the brand and the oil content, pigment and quality. White oil paints are obviously different to acrylic whites, which then also differ depending on quality and whether they are made for commercial use, artistic use, or for children. Commercially produced acrylic whites used for painting buildings are also found in multiple shades of white, such as Whisper White, White on White and Antique White U.S.A., which again all contain different tints. The variety of whites available for use meant that reducing the selection of colours in the production of work for this exhibition did not necessarily decrease the number of hues I could use in a painting, or their intensities. In fact any reduction in variety only affected the vibrancy of the colour choices, such that I could still treat the various whites available to me as an assortment of colours despite their quieter magnitudes. In exploring the properties of these hues, tonalities and

magnitudes, I discovered that the quality of the lighting available to illuminate the work became vitally important in shaping relations between colours.

On this topic, Boris Groys writes how 'traditionally light comes from outside the works of art and thereby makes contemplation of these works possible ... In the past the museum light was owned symbolically by the viewer: he saw the work of art with this light.'[17] The temporality of light is another example of the benefits of thinking about painting in terms of the encounter. The role of lighting conditions becomes more apparent with a reduction in colour. It also draws attention to the encounters initiated by the activity of the viewer as he or she moves around to look at the work, to intersect with its ingressions, the various whites, the wax and pencil marks evident in many of the paintings at Platform, for example. In these respects, the subtle, intensive viewing of paintings changes with any alteration in gallery context, or in the ambient light, which plays an active role in tempering the event of the work's reception or enjoyment.

I should also add that the deliberate reduction in colour palette, and in particular the use of white interior house paints, served to expose the limits of the boundary of each painting in that the surfaces of the paint and the walls of the cabinets were often indistinguishable. The threshold of where the painting started and ended was not always clear as the existing painted wall was included as part of the composition. The paintings were deliberately incorporated into the cabinet, blurring any easy distinction between the surfaces of the painting and the surfaces of the cabinet it was applied to, thus making the painting, its boundaries and its environs or context ambiguous. The surfaces of previous artworks were also in a sense prolonged as I sanded back sections, removing layers of paint to reveal other coloured layers, the evidence of the cabinet's prior exhibitions. One can see in the detail of Figure 6.2 how, as I sanded back a section of the paint, a grey layer of paint from a previous exhibition was revealed, which I then incorporated into the composition. The mottled grey section was used as a darker panel imitating an illusional shadow and thereby operating as another surface activation.

Figure 6.2 Andrea Eckersley, *Surface event #3*, 2014. Oil, acrylic, gesso, gouache, wax, gloss and sanded back sections on wall. Dimensions variable.

In addition, works were variously positioned within the cabinets so commuters might see only some of the compositions on the way to work and others coming home. This was achieved by deliberately painting some of the compositions around the edges of the cabinets, activating different surfaces and complicating any easy distinction between composition, surface and wall.

Light continued to play an integral role in another work, *Depth is as good as range*, exhibited in the group show *Depthless Flatness*. Utilising the large gallery wall allowed the painting to incorporate the whole of the existing wall into the composition, obscuring the peripheries of the painting. Daylight permitted a fuller, more complete, viewing of the work with all its subtleties compared with the ambient light available at night (see Figure 6.3). The use of white glosses, enamels, sanding back of sections of the wall and layers of white on whites allowed the work to appear to radiate light. In fact, the work projected light back into the space, by reflection. In this way *Depth is as good as range* created its own sense of atmosphere and, as a result, I would say the encounter with the

painting was intensified. It is important to add that this intensification should not be taken to mean an intensification of meaning or effect understood in terms of positive affect. For Deleuze, 'intense' (or intensive) does not refer to symbolic significance, feeling or impact; it simply refers to differences in non-extensive qualities without representational content. To intensify the surfaces of a painting in this sense simply means to open up new non-extensive qualities.

In contrast to the other works in the group show *Depthless Flatness*, curated by Steven Rendall and Bryan Spier, which asserted their solidity and mass in comparison, my work manifested a space of light. At night, as the amount of light was restricted, it took some time for a viewer's eyes to adjust to the image. It was thus not easy to see the work. In shifting attention to the materiality of the wall itself, the viewer had to in a sense want to look, to pay more attention, to observe more carefully the environment whilst moving around, looking around. This effect introduced a striking temporal element to the work, besides the transitory nature of the painting itself, which only lasted as long as the exhibition.

Figure 6.3 Andrea Eckersley, *Depth is as good as range*, 2014. Acrylic, gesso, gouache and sanded back sections on wall. Dimensions variable. In the exhibition *Depthless Flatness* curated by Steven Rendall and Bryan Spier.

This temporal dimension of the activity of encountering painting is further discussed in the next section in relation to the work of Agnes Martin. My discussion of her work should also serve to further clarify this chapter's more general argument concerning the conceptualisation of art in terms of events and encounters.

The intensive space of sensation

Agnes Martin's paintings are generally canvases five or six feet square in size featuring faint washes of colours overlaying delicate hand-drawn pencil lines that often construct simple grid-like structures. Observing a specific ambience that often surrounds her work, art scholar and curator Lynne Cooke describes how Martin's 'combination of associative titles with delicately atmospheric spaces (sometimes pastoral, sometimes cosmic) retains vestiges of the phenomenal world'.[18] Cooke goes on to say that, due to the subtle nature of Martin's paintings, 'each painting requires a way of looking that is detached yet not passive'.[19] Indeed, Martin writes that she wants to provoke an active consideration in her work, a 'response that we make in our minds free from (the) concrete environment'.[20] She describes this encounter as 'infinite, dimensionless, without form'.[21] I would characterise this encounter as taking place in intensive space of sensation.

In the text 'Agnes Martin: The /cloud/', art critic and theorist Rosalind Krauss provides three distinct ways to further understand this intensive space of sensation in Martin's paintings. Krauss draws on Kasha Linville's close reading of Agnes Martin's paintings, Hubert Damisch's discussion of Brunelleschi's theory of linear perspective, and Alois Riegl's discourse on the role of autonomy in art history, to examine the spaces, expanses and distances (or what I would call encounters) that can be observed in Martin's paintings. Rather than limiting the discussion of these paintings to the romantic terminology of the transcendental, Krauss argues that the abstract sublime often identified in Martin's paintings is actually a function of three complex distances or 'sequences of illusions of textures that change as viewing distance changes'.[22] The first of the three distances is described as a 'close-to reading' where the viewer is engaged with the material aspects of the paintings, with

lines drawn, the soft washes of colour, the texture of the fabric covered with gesso and so on.[23] However, it is in moving back that the 'crucial second "moment" occurs in viewing the work'.[24] Kasha Linville labels this second stage 'atmosphere'. Krauss notes that Linville does not mean atmosphere in the literal sense of spatial illusion often associated with colour-field painting, but in the sense that 'the ambiguities of illusion take over from the earlier materiality'.[25] For example, in discussing the painting *Flower in the Wind*, Krauss outlines how Linville uses the word 'mist' to describe how the painting 'feels like rather than looks like atmosphere. Somehow the red lines dematerialise the canvas, making it hazy, velvety.'[26] It is in the second moment of atmosphere that Krauss identifies the abstract sublime in Martin's paintings. This second moment leads to the third where the viewer moves back again, which Krauss describes as a shutting down of the obscure illusionary elements experienced in the second stage, where the painting becomes 'completely opaque'.[27]

I believe that these three distances can be described as a spacing operation, to return to Crouch's analysis briefly introduced earlier, or more productively as an encounter between two extensive spaces, one of detail and one of totality, bookending an intensive space, a space within a space with no boundaries. Indeed, Krauss describes the three distances as constituting an entire system that needs the second distance or moment to allow for the system to exist. Krauss notes 'that /atmosphere/ is an effect set within a system in which an opposite effect is also at work'.[28] This tension is explained by Krauss in that the term 'atmosphere', in its ambiguity, is no longer considered 'a signified (the content of an image)' but is converted into a 'signifier'.[29] I would argue slightly differently that if you take atmosphere as intensive space then it does not necessarily exclude extensive space (the first and third of Krauss's spaces) in that it can be of both spaces at the same time, an intensive space of sensation, an encounter.

Further insights into the nature of encounters within the intensive space of Martin's painting are provided in Krauss's analysis of Filippo Brunelleschi's theory of linear perspective, particularly his notion of the cloud as space, plane or perspective. Krauss is interested in Hubert Damisch's assessment of Brunelleschi's theory of

perspective within three planes. Brunelleschi's 'legitimate construction, in which the vanishing point and viewing point must be geometrically synonymous', involves three planes: the first plane, that of the '"viewer" (stationary and monocular)', a second plane, 'that of display (constructed in terms of measurable bodies deployed in space), thus capable of being submitted to the determinations of geometry', and a final plane that is required to hold the viewer and the display together in a unified system.[30] Damisch claims that this final role belongs to the cloud. As the viewer looks through the hole in the back of the painted image at a mirror reflecting the Florentine Baptistery, the clouds are depicted not in paint but in silver foil, thus reflecting the sky, or view behind. It is 'the immeasurability and ubiquity of the sky' and 'the unanalyzable surfacelessness of the clouds that render these things fundamentally unknowable by the perspective order'.[31] For this reason, Damisch treats the cloud as unrepresentable or unknowable even as it maintains the function of linear perspective between the two planes of viewer and display. For Svetlana Alpers this example provides unique insights in the development of what she calls 'the Italian perspective system'.[32]

It is interesting to note that Brunelleschi hints at the limitations of linear perspective in the way he has rendered the clouds, in his attempt to produce an encounter, a difference in intensity, by activating the surface with silver foil. I would add that the atmosphere referred to by Linville in her discussion of Martin's paintings bears a strong resemblance to /The Cloud/ described by Damisch. One could say that each encounter exists in between the two planes of perspective as an unidentifiable space, an intensive space or space of sensation.

Krauss's discussion of Alois Riegl's assessment of the role of the viewer in this encounter offers additional insights into spaces of intensity and sensation in painting. In discussing the role of autonomy in art history's evolution, Krauss notes how Riegl traces a line from the 'haptic objectivism of the Greeks to the optical objectivism of Roman art' to a moment 'where opticalism [is] carried out in the service of the object' as solutions to the problem of subjectivity.[33] 'The art of antiquity,' Riegl wrote, 'which sought as much as possible to enclose the figures in objective, tactile borders, accordingly was bound from the very beginning to include a

subjective, optical element.'³⁴ It is this 'moiré' effect, the 'constant oscillation between figure and ground' depending on where the viewer stands, that becomes the third place or the place where the object has become entirely subjectivised.³⁵ Yet for Riegl this subjectification is not a form of subjectivism as the 'subject viewer has been fractured ... deprived of the security of a unitary vantage'.³⁶ Krauss then aligns Martin's paintings with an objectivist vision to 'make the optical a function of the field of the viewer'.³⁷ This place, where the role of the viewer is not fixed, is interesting to me as it may be regarded as a useful indication of an encounter with what might be called a site of intensity, or intensive space, in painting.

By characterising three unique places of intensity or spaces of sensation in Martin's painting – atmosphere, the cloud and the movement of the viewer in attaining 'objectivist opticality' – Krauss has, in effect, identified three encounters, encounters that transcend the extensive properties that bind them. By revealing the limitations of how we view Martin's paintings, Krauss has revealed a new way to think about how we actually encounter these paintings, opening up form, space and perspective to a new way of thinking, an aesthetic re-engagement, one of intensity, sensation and affect. Yet Krauss does not appear to be interested in characterising the nature of these intensive spaces. She primarily identifies how and why these spaces are created in Martin's painting but, as such, leaves the nature of the cloud or atmosphere as uncertain. I would argue that one needs a theory of encounter that includes a careful treatment of affect, intensity, sensation and the event to address these matters.

I would also take issue with another aspect of Linville's analysis that Krauss doesn't refer to, and that is the question of the order of how one actually encounters or physically experiences these three spaces in Martin's painting. I would argue that the lighting conditions are critical in determining how a viewer encounters Martin's paintings, as is the consideration of how one approaches the work, which would commonly be in direct reverse order to the one proposed by Linville. When approaching Martin's paintings in a gallery, such as Dia:Beacon, MoMA or the Pompidou, one inevitably walks into the gallery towards them. This doesn't change

the possibility of there being three distinct aspects, distances or spaces in these paintings but it does alter the order in which they are encountered. Hence, one would typically view these paintings firstly from the space of opaqueness, through to the hazy atmosphere, and then finally on to the details of Martin's subtle tints, tones and shades as they are revealed up close. It is hard to imagine how else one could experience these works.

Similarly, the lighting conditions in each of these three institutions vary greatly, with Dia:Beacon relying heavily on natural light from skylights to achieve a greater diversity of viewing versus the traditional flat internal lighting of the larger galleries at MoMA and the Pompidou. Such attention to the physical, embodied and affective moment of the encounter, the actual event of painting, emphasises the manner in which one enters the gallery itself and approaches the works, whether the works sit beside each other, how far they are displayed from each other and, crucially, the light in which one views the work. All of this is to suggest, more directly, that painting ought to be considered in terms of events involving encounters between activated surfaces, such as the surface of the gallery, the surface of the viewer, the surface of the wall, and even the varying temporality and intensity of light.

In developing a reading of the intensive encounter, Deleuze's concepts provide a means of naming what Krauss does not in relation to how one engages with Agnes Martin's paintings. By defining moments, planes or distances as functions of encounters in different kinds of extensive and intensive space, and by providing a conceptual understanding of intensity and how it is produced in art, Deleuze points to the ways in which we might come to understand the more affective elements that occur in Martin's paintings. Such understandings move one closer to the kind of conceptual or philosophical reading of painting that foregrounds painting as an activation of surfaces. Thinking about art as an event draws attention to the activity of surfaces and the ways encounters between surfaces become immanent to the work. Surfaces abound in art and yet it is how they are constituted in space and time that highlights the value of thinking about these works as encounters immanent to events.

There isn't really an end

Art is an encounter, or, more accurately, an assemblage of encounters. The encounter is a relation, a flow of affective forces between bodies. This affective flow, and the transitions it occasions, is a function of the encounters that comprise art. Affect, experienced in the body before cognition and as the cause of material effects, then constitutes an outcome of force. Affect happens when we encounter art because art is composed of differences in intensity expressed in extensive space. The intensive art object is central to this encounter, but it can never be abstracted from the environs, the extensive surfaces that make it, such as the surfaces of the artist, the surfaces of the gallery, the surface of the viewer, the surface of the wall, and even the varying temporality and intensity of light. Consistent with this conceptual framing, I understand my practice to involve a series of encounters that each depend on an engagement with various surface activations that include folding paper, paintings, spacings, lighting and sometimes writing. When I make works such as *Surface event* or *Depthless Flatness* I am attempting to engineer an encounter whereby the viewer slows down and looks around. I believe that Martin is also attempting to generate a similar type of encounter that demands attentive reflection. Krauss's discussion of the distances, spaces and perspectives expressed in Martin's paintings, and the role of the subject in activating these perspectives, reveals much about the encounter with her paintings. Yet something is missing in her discussion of this encounter, what I have called the intensive, affective space of sensation. The discussion I have advanced across this chapter of the spacing and surfaces in my work and that of Agnes Martin reveals an intensive dimension in the encounter with art that may be directly related to the extensive elements of the surface, but are not of it. The encounter within an event involves the entanglement of surfaces resulting in intensity. The passage of intensity felt in the body in the event of each encounter with the surfaces of art is affect.

The activated surfaces of painting are not given as such but involve a multiplicity of affective transitions, which combine in the individuation of surfaces, as they are encountered. As Deleuze argues, these encounters always involve affective flows that help

to account for the emotional, aesthetic and lived experience of a given work of art. Affects exist as intensive forces, as relations in the midst and in between. They are 'no longer feelings or affection; they go beyond the strength of those who undergo them ... affects are beings'.[38] This specific reference to being implies that the body and matter are crucial to understanding what affects are and, more importantly, in understanding how art, and in particular painting, gives rise to affects. Affects are imbued in and through painting, just as they inhabit the viewer's body. Massumi writes that 'there is no ... affect ... without an accompanying movement in or of the body'.[39] Affect is the capacity to affect or be affected, along with the transitions in a body's 'power of acting' occasioned by each encounter.[40]

Affects are transmitted in and through art, in the viewer's body. Affects, in a very real sense, cause the body to feel and behave differently. One is said to be moved by art, for example, and affect may be regarded as the principal mechanism of this emotional and intellectual movement. Hence, art ought to be understood, as Simon O'Sullivan writes, as 'a bundle of affects or ... a *bloc of sensations*'.[41] It is the relations between bodies, the collision of bodies, that interests me in relation to art insofar as affect is the change that occurs when the surfaces that make up the body of the painting encounter the body of the viewer, the surfaces of the spaces in which this event takes place, and the time of this encounter. An encounter with painting involves an activation of surfaces in an event felt as a difference in intensity. Surface activation describes the varied material methods that are employed to produce a painting, including the range of actions, additions, subtractions and treatments by which a surface is activated as a painting. Surfaces are activated in encounters between bodies, surfaces, spaces and times. It is an encounter with these intensive qualities of activated surfaces that brings an event of the painting into being. This event describes multiple surfaces encountering one another in the activation of the work. Throughout the discussion of my practice and that of encountering Martin's paintings, I have aimed to understand encountering as the affective force of painting. The encounter with activated surfaces directly contributes to the intensification of the encounter with painting, an

encounter that involves a transmission or flow between bodies. These encounters then activate more surfaces in an assemblage of affects in an event of painting. These assemblages are what bodies actually encounter in and with an artwork.

It is for this reason that there isn't really a beginning or an end; one always finds oneself in the middle of an encounter with painting as one comes into contact with the myriad surfaces that comprise it, as well as the myriad contextual forces that combine in the immanent materialisation of that painting. This is the event of painting, replete with the encounters that comprise it, as it is composed in intensive surfaces and spaces of sensation in the middle of a gallery, in the middle of a conversation, in the midst of some sort of love, between perception and affect. Encountering painting.

Notes

1. See Deleuze, *Expressionism in Philosophy*, p. 383.
2. See Deleuze, *The Fold*.
3. See Benjamin, *Disclosing Spaces*, p. 1.
4. Deleuze, *Difference and Repetition*, 1994 edition, p. 139.
5. Ibid., p. 120.
6. Ibid., p. 139.
7. See Deleuze and Guattari, *What Is Philosophy?*, pp. 156–7.
8. See Deleuze, *Spinoza: Practical Philosophy*.
9. See ibid., pp. 48–51.
10. See Massumi, *Parables for the Virtual*.
11. See ibid., pp. 27–8.
12. See Deleuze, *Spinoza: Practical Philosophy*, p. 48.
13. See ibid., pp. 48–51.
14. Crouch, *Flirting with Space*, p. 6.
15. Ibid., p. 45.
16. Ibid., p. 12.
17. Groys, *Media Art in the Museum*, p. 12.
18. Cooke, *Agnes Martin*, p. 12.
19. Ibid., p. 19.
20. Cited ibid.
21. Cited ibid.
22. Krauss, 'Agnes Martin: The /cloud/', p. 333.
23. Ibid.

24. Ibid.
25. Ibid., pp. 333–4.
26. Ibid., p. 333.
27. Ibid., p. 334.
28. Ibid.
29. Ibid.
30. Ibid., p. 335.
31. Ibid.
32. Alpers, *The Art of Describing*, p. 44.
33. Cited in Krauss, 'Agnes Martin: The /cloud/', p. 336.
34. Cited ibid.
35. Cited ibid.
36. Cited ibid.
37. Ibid.
38. Deleuze and Guattari, *What Is Philosophy?*, p. 164.
39. Massumi, 'Of microperception and micropolitics', p. 5.
40. See Deleuze, *Spinoza: Practical Philosophy*, pp. 125–8.
41. O'Sullivan, 'The aesthetics of affect', p. 126.

7

Practising Philosophy

Jon Roffe

If philosophy's critical task is not actively taken up in every epoch, philosophy dies – and the images of the philosopher and the free human being die with it.

Deleuze, *Nietzsche and Philosophy*

As Hugh Tomlinson and Graham Burchell note at the beginning of their translators' introduction, *What Is Philosophy?* is perhaps above all 'a book of philosophy as a practice of the creation of concepts' (WP vii).[1] The various, complementary views of philosophy as a quasi-passive contemplation of eternal Truths, or as a reflective investigation into the structure of human cognition and its limits, or even the schematising of and politicking for the circulation of opinion in contemporary capitalist democracies, are all banished. In their place, an unmediated practice: the creation of concepts.

The picture, at least at this level of detail, is well known by Deleuze and Guattari's supporters and detractors alike. Less well known is the fact that, in his first book, Deleuze presents us with precisely the inverse position. *Empiricism and Subjectivity* presents a fully fledged theory of philosophy. It is one that echoes its central claim about Hume's philosophy, namely that 'subjectivity is essentially *practical*' (ES 104).[2] Subjectivity – that is, *thought* itself insofar as it is active – is practical in the sense that it is not given in advance, but must be constituted and perpetually reconstituted, commencing and recommencing on the basis of multifarious, heterogeneous encounters. But if subjectivity is always an aleatory

adventure, in both form and substance, a philosophy that accounts for it cannot be aligned with any kind of necessity. Consequently: 'We must constitute philosophy as a theory of what we do, and not a theory of what there is' (ES 133, translation modified).[3]

Deleuze's first book presents us with philosophy as a theory of practice; his last, with philosophy as practice itself; the mirror slowly turns around on its hinge to face the philosopher. But between these poles there are two substantial accounts of philosophy, each of which situates itself within the sphere of practice. What is this practice?

The poverty of philosophy

The first answer is not a happy one: the practice of philosophy is an impoverished and delusory one. Deleuze's books in the sixties return to this point over and over again.[4] The practice of philosophy is underwritten by a conception of thought that condemns it to the trivial repetition of the already trivial domesticated quotidian inanities. This is what Deleuze calls the image of thought, 'a dogmatic, orthodox or moral image' (DR 131),[5] an implicit set of commitments that obscures everything that is really at stake in thinking. This image presents thought as essentially *domesticated*. Philosophy's practice, in the main, consists in reifying the ordinary. You look out of the window of your office, recognising what you see, and perhaps approve or disapprove of it (John Armstrong might muse about 'puerile student sculptures . . .'). And, as a philosopher, you would then reflect on or systematise these features of everyday experience, perhaps for an Oxbridge publishing house, perhaps for the 'Arts' section of a local newspaper – the philosopher as the contemporary form of the sage, dispensing wisdom to the 'thinking man', who then posts it on Facebook for other friends of wisdom. And the correlate of this practice of philosophy is its placid notion of truth as a well-turned description of what everyone 'already knows' (DR 130).

For Deleuze, Nietzsche exposes this image first and most clearly as what it really is: 'essentially moral' (DR 132). Its essential function is to recapitulate in a 'higher' register the dispatches of the 'established powers' (NP 106).[6] Consequently, and to a troubling

degree, today's philosopher is most often just 'the philosopher of the State, the collector of current values and the functionary of history' (NP 107). The truths that it produces and defends are paraphrased press releases.

Correlatively, for Proust – a point that Deleuze repeats frequently in *Proust and Signs* – the notion of a voluntary search for truth characterises a certain notion of philosophy itself. For philosophy, this search originates 'from a mind seeking the truth', and we believe this mind possesses, a priori, a 'benevolence of thought, a natural love of truth' (PS 16).[7] Now, it is true that thought conceived of as a voluntary activity does produce something – what is called 'philosophy' in public discourse today is proof of this. But the asymptotic proximity of these publications to the least volume of self-help proves something too. It may produce 'interesting ideas' that reflect 'conventional significations' (PS 16), but it does not approach the true nature of thought.

This farrago against the image of thought and its philosophy reaches an apex in the central chapter of *Difference and Repetition*, where some of Deleuze's most forceful – wild, even angry – texts are to be found:

> Certainties force us to think no more than doubts. To realise that three angles of a triangle should be equal to two right angles does suppose thought ... All truths of this kind are hypothetical, since they presuppose all that is in question and are incapable of giving birth in thought to the act of thinking ... They lack the claws of absolute necessity – in other words, of an original violence inflicted upon thought; the claws of a strangeness or an enmity which alone would awaken thought from its natural stupor or eternal possibility: there is only involuntary thought, aroused but constrained within thought, and all the more absolutely necessary for being born, illegitimately, of fortuitousness in the world. *Thought is primarily trespass and violence, the enemy, and nothing presupposes philosophy: everything begins with misosophy.* (DR 139, translation modified, emphasis added)

A moment of humour

In the early work of Deleuze, then, the word 'philosophy' most often designates a very specific and pernicious type of failure, one that replaces the practice of denouncing superstition, rejecting what the State sanctions as what 'everyone knows', or should know, and 'turning stupidity into something shameful' (NP 106), with a tenured stenography of 'established feeling'.

In the midst of this roasting, there are nevertheless elements of a positive account of the practice of philosophy. It does not appear under the name of philosophy itself, however, but as what Deleuze calls 'thought'. Here he is again in *Nietzsche and Philosophy*:

> does not critique ... express new forces capable of giving thought another sense? A thought that would go to the limit of what life can do, a thought that would lead life to the limit of what it can do? A thought that would *affirm* life instead of a knowledge that is opposed to life. Life would be the active force of thought, but thought would be the affirmative power of life. Both would go in the same direction, carrying each other along, smashing restrictions, matching each other step for step, in a burst of unparalleled creativity. Thinking would then *mean discovering, inventing, new possibilities of life*. (NP 101)

The same point is repeated in *Proust and Signs*: 'to think is to create, and primarily to create the act of thinking within thought' (PS 97).

It is notable that when Deleuze gives this creative, affirmative thought a more precise name in these works of the sixties, that name is most often *art*. It the artist who rejects with a dismissive laugh the philosophical labourers of the present, and '*art* which invents the lies that raise falsehood to this highest affirmative power, that turns the will to deceive into something which is affirmed in the power of falsehood' (NP 103), just as genealogy – 'that filigree art of grasping and comprehending in general',[8] Nietzsche calls it – should be conceived of as 'the art of difference' (NP 56). In *Proust and Signs*, it is '[o]nly by art [that we can

emerge from ourselves',[9] only by art that we attain essence and truth, while the philosopher bumbles around with opinion at dinner parties. And the conclusion of *Difference and Repetition* does not demand anything of philosophy, but instead speaks of the critical task of art, one that furnishes the grounds for a genuine critique: 'the insertion of art into everyday life' (DR 293).

The signal instance in which the word 'philosophy' unreservedly names the positive capacity in thought in the books of the sixties is in *The Logic of Sense*. There, Deleuze identifies the self-deceptive philosophical labour discussed above with a specifically Platonist orientation in thought, a 'properly philosophical disease', and an addiction to the ideal, and to the heights in which they are stationed (LS 127).[10] This philosophy of the heights orients thought by what is beyond and superior to the world, the Ideas or rather Idols of self-identity: Truth, Beauty, Piety . . . Correlatively, the practice of philosophy 'is always determined as an ascent and a conversion, that is, as the movement of turning toward the high principle [*principe d'en haut*]' (LS 127). Deleuze contrasts this vaporous philosophy of Platonism, along with the pre-Socratic image of a strictly corporeal philosophy (the philosophy of the depths), with the philosophy of the Cynics and the Stoics: a new philosophy of the surface. The key difference is that the dynamic nature of truths and the shifting nature of reality, broken open and forced into new configurations in the wake of events, are not subject to some higher order of ideality, but engaged with here and now as their actualisation unfolds.

But what does the Stoic philosopher *do* exactly? What constitutes her practice as a philosopher? It involves working *within* established truths, taking the accepted meanings (sense) of what happens (events) and what is said and pressing on the contingent limits of what counts as legitimate. In contrast with the Platonic approach, this Stoic challenge takes place not by ascending to a position of superiority where the philosopher discerns the true suitor from the false. Existing norms, 'what everyone knows', are troubled by following the letter of the law beyond the limits of these norms themselves. If the life of the mind really is the essential part of human existence, then why not assuage the needs of

the body immediately and in public whenever they arise – why not masturbate in the marketplace? Define the human being as a featherless biped and I will throw a plucked chicken over your back fence. Pose a technical question about logic, and I will hit you with my staff – and so on. In each case, the irreducible plurality of meaning borne by statements in language or by events allows for a practice that breaks down established truths from within.

Strictly speaking, as Deleuze points out, this constitutes a perverse and humorous conception of philosophical practice. In his study of Sacher-Masoch, Deleuze shows that the perversion known as masochism holds strictly to the letter of the law. I *am* guilty of wanting to depose the Oedipal law of the Father and found a new form of sexual relation with the Mother – so I'll take the punishment, and then feel licensed in all innocence to commit the crime. The perverse philosopher does the same thing – assert an absolute, or an untouchable ideal, and I will pursue its consequences to the point that its unexpected correlates appear in all their paradoxical force.

In this way, humour, the philosophical 'adventure of humour' of the Stoic (LS 136), demonstrates 'the co-extensivity of sense and non-sense' (LS 141), where the former is only the latter within certain habituated, stabilised and sanctioned limits. It suffices to repeat a word, even those great Platonist words like Truth, or God, enough times and this limit is quickly approached.

On being had by an idea

Such would be the trajectory of the first account of philosophy in Deleuze. What of the second? Its most well-known expression is, of course, found in *What Is Philosophy?*, but the position this late work espouses can already be found in nascent form in various texts of the eighties. Chief among these is perhaps a lecture Deleuze gave in 1987 to a class of student cinematographers, entitled 'What is the creative act?'.

In this lecture, Deleuze makes three general points about the practices of art, philosophy and science. The first is that thinking, conceived as a creative practice rather than slavish reproduction, is always a response to an idea. And while Deleuze's language in this little text can convey the sense that an idea is something that

one can 'just come up with', his point is closer to the role that the event has in *The Logic of Sense*, and the problematic Idea in *Difference and Repetition*. The idea comes first, and constitutes a problem that demands a response. In this sense, we less have ideas than they have us, and to be had by an idea is to be possessed or afflicted by it. To make a film, to write a work of philosophy, to engage in science is to create something that responds to the impetus or affliction of the idea.

Indeed, most often when Deleuze addresses this element of creative practice, he invokes what the philosopher *needs*. The imperative character of the encounter implies a concomitant necessity to assemble materials adequate to the task at hand. The composition of *Foucault*, for instance, was in response to an 'inner need' (N 94)[11] felt by Deleuze. With respect to the concept of shame, he states: 'A small problem concerns me a great deal. Why are some troubled people, more than others, vulnerable in a greater way, and perhaps even dependent on, shame? . . . I need, therefore, a certain concept of repression.'[12] In more general terms, as he says in 'What is the creative act?', 'A creator only does what he or she absolutely needs to do.'[13] Consequently, 'there has to be necessity, in philosophy and elsewhere; otherwise there is nothing.'[14]

The second point Deleuze emphasises is that art, science and philosophy are completely different in character. It is true that, since they all begin with the idea, 'We are all faced with somewhat similar tasks.'[15] But their similarity ends with the fact that a task is required of them. Deleuze borders on derisive when he insists that

> Philosophy is not made to think about anything. Treating philosophy as the power to 'think about' seems to be giving it a great deal, but in fact takes everything away from it. No one needs philosophy to think. The only people capable of thinking effectively about cinema are filmmakers, critics and those who love cinema. Those people don't need philosophy to think about film. The idea that mathematicians need philosophy to think about mathematics is comical. If philosophy had to be used to think about something, it would have no reason to exist. If philosophy exists, it is because it has its own content.[16]

Third, and alongside this unilateral relationship between the idea and philosophy, science and art, each in their own way, Deleuze will develop a theory of the multilateral provocations that take place *between* the various creative responses: philosophy is not needed in order to think about the cinema, or to do mathematics, but the creations of the filmmaker and the mathematician can nevertheless provoke the philosopher in turn.

The thesis outlined in 'What is the creative act?' finds its first expression in the interviews surrounding the publication of *Francis Bacon: The Logic of Sensation*. In one such interview, Deleuze is asked whether he found the experience of writing about Bacon pleasing. His reply – and the fear and difficulty that it speaks of – is an important one for a theory of philosophical practice:

> It frightened me. It seemed genuinely difficult. There are two dangers: either you describe the painting, and then a real painting is no longer necessary ... Or you fall into indeterminacy, emotional gushing or applied metaphysics. The problem specific to painting is found in lines and colors. It is hard to extract scientific concepts that are not mathematical or physical, and that are not just literature superimposed on painting either, but that are almost carved in and through painting.[17]

The title of this interview is itself telling: 'Painting sets writing ablaze'. Equally telling is an earlier article from 1979, whose full title reads 'How philosophy can be useful for mathematicians or musicians – even and above all when it does not speak about mathematics or music'.[18] But perhaps the most concise presentation of this view is found on the closing page of *Cinema 2*. There Deleuze emphasises not just that 'philosophical theory is itself a practice', but that this 'practice of concepts ... must be judged in the light of the other practices with which it *interferes*'.[19]

Together, then, these texts of the late seventies and eighties – and then *What Is Philosophy?* itself, above all – present us with a positive, discrete and creative definition. Nevertheless,

since our concern is with the specific character of the *practice* of philosophy, the entire survey produced above may seem to be somewhat beside the point.

One way of siding with the disaster

In *On the Genealogy of Morality*, Nietzsche attacks Kant for having – in his miserly, short-sighted way – mistakenly identified the significance of art with the significance of art for the spectator. Nietzsche, instead, insists that it is only from the point of view of the artists themselves, those powerful and sensuous beings, that art can be understood.[20] When we read *What Is Philosophy?*, looking to understand what precisely constitutes the practice of philosophy itself, a related but even more serious charge seems apropos. We learn there what a concept is, and that it is and must be created – but what is the practice of philosophy from the point of view of the one who practises it? What exactly is it like to create a concept from the point of view of a philosopher?

If philosophers are more than just clueless *bon vivants* or cheerful labourers keeping the runnels of democratic-capitalist 'communication' free of rubble, what are they? It may indeed be the case that philosophers' lives 'are rarely interesting' (N 137), ultimately taking place in some analogue of a 'modest student's room', furnished only with 'a lamplit armchair for reading, and an unremarkable table for writing'.[21] But what exactly is taking place in those modest accommodations, in that chair and on that table?

The answer I would like to schematically present here, a sort of image of the practice of philosophy in the spirit of Deleuze's philosophy – itself partly drawn from what we have already seen – involves three moments, the first of which is *dispossession*.

Dispossession

Deleuze said it: 'Everything begins with misophy' (DR 139). The first moment in the practice of philosophy is the encounter with what Deleuze variously calls the problem, the Idea or the

event. It is an encounter that punctures the habituated modes of thinking – recognition, the simple repetition of 'what everybody knows', conservative anticipation. Being an event in the strong sense, it is absolutely in excess of our existing grasp on the world: 'We never know in advance how someone will learn: by means of what loves someone becomes good at Latin, what encounters make them a philosopher, or in what dictionaries they learn to think' (DR 165).

In its literal sense, the word 'disaster' invokes the loss of the fixity of stars' guidance, whether by their loss altogether or in the encounter with stars not known: 'The stars above the hill were no stars his eyes had ever seen.'[22] The dispossession that characterises the encounter in thought is the signature of its aleatory character.

It would be a mistake, consequently, to think that Deleuze's emphasis on creativity and life means that the practice of philosophy itself is bliss. When philosophy is not impoverished – and, indeed, shamed – by trucking in a puerile democratic-capitalist image of thought, it first of all becomes miserable. But this very real misery is the only way for the philosopher to be able to think. Philosophy begins there where it is impossible – or, thought's degree-zero is also the matrix for creation within thinking.

In turn, the concept that is created through this contact between an event, problem or idea and the instantly witless mind in the form of the encounter means that we should conceive of concepts less as meteorites (WP 11) than as *fulgurites*: one of those unpretty branching edifices that are produced when lightning makes contact with the earth.[23]

Assembly

There is a sense in which this dispossession is double, for not only does the practice of philosophy involve a manifest incapacity to think, it also marks the inadequacy of existing means. In other words – a point emphasised in *Difference and Repetition* – there is no philosophical *method*.

Now, there is also a sense in which dispossession is hardly a matter of practice itself. Deleuze's Spinozism allows him the

notion that we can organise our encounters in a general sense, but we cannot legislate over the event, the event being the name for what absolutely supersedes and undoes the present constitution of the agent. What we can do is respond to it in a particular way – namely, create concepts. But, having been dispossessed of habitual means, what is to be done? From beginning to end, Deleuze's account of philosophical practice both shows and insists that we have to assemble the means for this construction. This is what accounts for the curious sense Deleuze sometimes gives his readers that he never makes use of the work of philosophers, artists or scientists the way that university academics 'use' others. Deleuze's references never constitute a *secondary literature*. Instead, we see him, magpie-like, a *bricoleur*, looking for materials with which he can fashion concepts.

If the affect that accompanies dispossession is inevitably misery, the moment of assembly is characterised by a manic attentiveness, a casting about that has no respect for the standard boundaries of discipline, genre or address. Describing Leibniz's practice of philosophy, Deleuze will go so far as to speak of psychosis. In response to the collapse of the vast network of habits that are known as classical philosophy, Leibniz's 'Baroque solution is the following: we will multiply principles – we can always pull out a new one from our sleeve – and consequently we will change its use. We will no longer ask what giveable object corresponds to this or that luminous principle, but rather what hidden principle corresponds to this given object, that is to say, this or that "perplexing case".'[24]

Coadaptation

There is one moment of *What Is Philosophy?* in which the living practice of the philosopher appears on its own terms, and it concerns the prima facie peculiar notion of taste. Deleuze and Guattari argue that while philosophy can be defined as the creation of concepts, it necessarily involves two other concomitant creations: of a plane of immanence and conceptual personae. So, in total, we can say that there are four elements in play: the problem to which a philosopher responds, the concept he or she creates, the plane

of immanence or image of thought that the concept presupposes, and the conceptual personae, who are the thinkers implicit in the concept.

But now a question arises: how can we determine whether the concepts we create are good or not, whether the plane of immanence or image of thought that a particular concept presupposes orients the concept in the right way with respect to the problem, and so on? The only necessity here is that a response be made to a problem, that a concept be created. Which concept, which plane, which personae, none of these elements necessitate each other. Consequently, the philosopher is required to engage in a further task of fitting these elements together – *coadaptation*.

> Since none of these ... elements are deduced from the others, there must be a coadaptation of the three. The philosophical faculty of coadaptation, which also regulates the creation of concepts, is called *taste* ... taste is like the rule of correspondence of the three instances that are different in kind. (WP 77)

If there is a place in Deleuze and Guattari's construction for the individual human being who creates concepts, it is here – the philosopher as the embodiment of a certain sensitivity or keenness with respect to the work of philosophical creation.

Now, in advance of the concept's creation, the faculty of taste functions as a kind of orientation proper to the philosopher in question. Deleuze and Guattari write that 'if the philosopher is the one who creates concepts, it is thanks to a faculty of taste that is like an instinctive, almost animal *sapere* – a *Fiat* or a *Fatum* that gives each philosopher the right of access to certain problems, like an imprint on their name or an affinity from which his works flow' (WP 79). During concept creation itself, though, taste 'is like the rule of correspondence of the three instances that differ in kind' (WP 77). Now the orientation that taste involves becomes concerned with the mutual modulation of concept, plane and persona, such that they come to fit together.

Finally, once a concept, plane and persona are established, 'what appears a philosophical taste in every case is love of the well-made

concept, "well-made" meaning not a moderation of the concept but a sort of stimulation, a sort of modulation in which conceptual activity has no limit in itself but only in the other two limitless activities' (WP 77). It is the faculty of taste that allows the philosopher to determine whether a concept is 'Interesting, Remarkable, or Important' (WP 82).

Repetition

In the end, and – why not? – to speak as a philosopher, the experience of practising philosophy is an affair of difference and repetition, and it is under the aegis of a certain repetition that these three moments of philosophy's practice unfold. Here is Deleuze on the opening page of that book:

> To repeat is to behave in a certain manner, but in relation to something unique or singular which has no equal or equivalent. And perhaps this repetition at the level of external conduct echoes, for its own part, a more secret vibration which animates it, a more profound, internal repetition within the singular. (DR 1)

The second half of this citation takes us on to the ontological terrain of *Difference and Repetition*, but here it is the first clause that is of importance. True, creation in thought always arises because of the encounter with the problem which has its own repetitions, always beneath or within the stratum of what we encounter. But to practise philosophy is to respond to it by repeating in turn, even if what is repeated is singular, irreducible to the response. Nor is this repetition the kind that belongs to the tracing of a circle back to an origin: as Deleuze repeatedly emphasises, repetition in the profound sense breaks the circle of habit open, instituting a decentred circle or dynamic, serial, eccentric movement as a result.

This is why practising philosophy can often feel like being hammered over and over again against an obdurate sea wall by the ocean. When Leibniz writes that '[a]fter establishing these things, I thought I had reached port, but was as it were thrown back onto the open sea',[25] he is considerably understating things.

This is also why starting to practise philosophy and practising philosophy are essentially the same thing. Because the problem persists – true problems not being 'solvable', as if they were puzzles in a newspaper, but possessing a genuine being proper to the problem, a ?-being – the effort of creation never departs from any of its three moments. It is not merely that *other* problems necessarily arise, but that the singular 'something', the problem or Idea, resonates throughout the practice itself, repeating itself in its singularity.

Consequently, 'The logic of someone's thought is the whole set of crises through which it passes; it's more like a volcanic chain than a stable system close to equilibrium' (N 84). Or, as Derrida remarks in his very fine obituary, 'Deleuze never lost sight of this connection of necessity with the aleatory.'[26]

To practise philosophy is to always begin (and perpetually begin again) at the task that can appear impossible from the point of view of established knowledge, the protocols of the academy and the canonical shackles that it offhandedly snaps on. That task is to think something new – create something new in thought – as the result of encountering something new. The essential moments of philosophy's practice are not therefore contemplation and communication: I ponder the 'big questions' and then publish my answers in convivial prose. This is not even wrong (which wouldn't be so bad), as Deleuze points out – 'the problem isn't that some things are wrong, but that they're stupid or irrelevant' (N 129). The essential moments are in fact dispossession, assembly and coadaptation, under the (frankly) tyrannical sovereignty of the repetition that belongs to the problem.

There is no question that, at a certain point, you will not be able to progress any further. It will not just be that this or that concept only went as far as it could, but that you're no longer capable of taking even one more step, of undergoing one more repetition. You too will find yourself recalling the words of Maine de Biran that Deleuze and Guattari cite in *What Is Philosophy?*: 'I feel a little too old to start the construction again' (WP 51).

Philosophy's practice always ends in death, like every other activity. But it also begins in death, this time the death of the knowing imbeciles that we were. The same epigraph from *The*

Logic of Sense is thus good for both: 'better death than the health we are given' (LS 160).

Notes

1. Deleuze and Guattari, *What Is Philosophy?*, p. vii. Here and throughout this chapter, this title is referred to as WP.
2. Deleuze, *Empiricism and Subjectivity*, p. 104. Here and throughout this chapter, this title is referred to as ES.
3. This intersection between empiricism as a philosophical doctrine and subjectivity as a dynamic process of constitution is discussed in more detail in Roffe, *Gilles Deleuze's Empiricism and Subjectivity*, esp. Chapter 6, 'The singularity of empiricism'.
4. This is putting aside *Kant's Critical Philosophy* (which unfolds entirely within the Kantian framework) and his essay on Masoch (which does not raise either the spectre of philosophy or the image of thought). The key exception, *Bergsonism*, is notable for arriving at a positive assessment of philosophy – following Bergson – only by situating it as (1) secondary in relation to society, emotion, mysticism and art (thus linking it back not only to the reading of Hume but also to the primacy of art in *Nietzsche and Philosophy*), and (2) legitimate only when it fully identifies its means with the method of intuition, itself a kind of critical transformation of the intellect that leads us back down the path of a static and idealising conception of philosophy.
5. Deleuze, *Difference and Repetition*, 1994 edition, p. 131. Here and throughout this chapter, this title is referred to as DR.
6. Deleuze, *Nietzsche and Philosophy*, p. 106. Here and throughout this chapter, this title is referred to as NP.
7. Deleuze, *Proust and Signs*, p. 16. Here and throughout this chapter, this title is referred to as PS.
8. Nietzsche, *Ecce Homo*, in *Basic Writings*, 'Why I am so wise', §1, p. 679.
9. Proust, *Time Regained*, cited at PS 42.
10. Deleuze, *The Logic of Sense*, p. 127. Here and throughout this chapter, this title is referred to as LS.
11. Deleuze, *Negotiations*, p. 94. Here and throughout this chapter, this title is referred to as N.
12. Deleuze, 'Desire and pleasure', in *Two Regimes*, p. 126, translation modified.
13. Deleuze, 'What is the creative act?', in *Two Regimes*, p. 316.
14. Ibid., p. 313.
15. Deleuze, 'Making inaudible forces audible', in *Two Regimes*, p. 160.

16. Deleuze, 'What is the creative act?', in *Two Regimes*, p. 313, translation modified.
17. Deleuze, 'Painting sets writing ablaze', in *Two Regimes*, p. 183.
18. Deleuze, 'How philosophy can be useful for mathematicians or musicians', in *Two Regimes*, pp. 166–8.
19. Deleuze, *Cinema 2*, p. 280, emphasis added.
20. Nietzsche, *On the Genealogy of Morality*, Essay 3, §6.
21. Lyotard, 'Il était la bibliothèque de Babel'.
22. Le Guin, *The Wizard of Earthsea*, p. 95.
23. It is only the work of many hands that we call tradition that turns concepts into smooth and easily stacked objects – turns a rhizome into a coffee table ornament, for instance.
24. Deleuze, *Le Pli*, pp. 90–1.
25. Leibniz, *The Shorter Leibniz Texts*, p. 73.
26. Derrida, 'Now I'll have to wander all alone', p. 194.

Bibliography

Alexander, F. Matthias, *The Alexander Technique: The Essential Writings of F. Matthias Alexander* (New York: Carol Communications, 1967).
Alpers, Svetlana, *The Art of Describing: Dutch Art in the Seventeenth Century* (Chicago: University of Chicago Press, 1983).
Aristotle, *Metaphysics*, trans. C. D. C. Reeve (Indianapolis: Hackett Publishing Company, Inc., 2016).
Aristotle, *Nicomachean Ethics*, trans. C. D. C. Reeve (Indianapolis: Hackett Publishing Company, Inc., 2014).
Aristotle, *Poetics: With the Tractatus Coislinianus, Reconstruction of Poetics II, and the Fragments of the On Poets*, trans. Richard Janko (Indianapolis: Hackett Publishing Company, Inc., 1987).
Attiwill, Suzie, *?interior, practices of interiorization, interior designs* (Melbourne: RMIT University, 2012), <http://researchbank.rmit.edu.au/view/rmit:160402> (last accessed 14 March 2017).
Attiwill, Suzie, 'Interiorizt', in Graeme Brooker and Lois Weinthal (eds), *The Handbook of Interior Architecture and Design* (London: Berg, 2013), pp. 107–16.
Attiwill, Suzie, 'A matter of time', in *A Matter of Time: 16th Tamworth Fibre Textile Biennial* (Tamworth: Tamworth Regional Art Gallery, 2004).
Attiwill, Suzie, 'Sightings, sitings, citings', in *Spacecraft 0701* (Melbourne: Monash University Gallery, 2001).
Badiou, Alain, 'Destruction, negation, subtraction – on Pier Paolo Pasolini', lecture at Art College Center of Design in Pasadena, 2007, available at <http://www.lacan.com/badpas.htm> (last accessed 14 March 2017).

Bains, Paul, 'Subjectless subjectivities', in Brian Massumi (ed.), *A Shock to Thought: Expression after Deleuze and Guattari* (London and New York: Routledge, 2002), pp. 101–16.

Baugh, Bruce, 'Experimentation', in Adrian Parr (ed.), *The Deleuze Dictionary* (Edinburgh: Edinburgh University Press, 2005), pp. 91–2.

Beekes, Robert, *Etymological Dictionary of Greek*, bilingual edition (Leiden: Brill, 2016).

Benedikt, Michael, 'Environmental stoicism and place machismo', *Harvard Design Magazine*, 16 (Winter/Spring 2002), pp. 1–8.

Benjamin, Andrew, *Disclosing Spaces* (Manchester: Clinamen Press, 2004).

Benveniste, Émile, *Dictionary of Indo-European Concepts and Society*, trans. Elizabeth Palmer (Chicago: HAU Books, 2016).

Bertalanffy, Ludwig von, *General System Theory: Foundations, Development, Applications* (New York: George Braziller, 1968).

Bertalanffy, Ludwig von, *Perspectives in General System Theory* (New York: George Braziller, 1974).

Bertalanffy, Ludwig von, 'The theory of open systems in physics and biology', *Science*, 111.2872 (13 January 1950), pp. 23–9.

Bijvoet, Marga, *Art as Inquiry: Toward New Collaborations between Art, Science, and Technology* (New York: Peter Lang, 1997).

Bishop, Claire, *Installation Art: A Critical History* (London: Tate Publishing, 2005).

Bogue, Ronald, *Deleuze on Cinema* (New York: Routledge, 2003).

Boundas, Constantin V., 'Deleuze: Serialization and subject-formation', in Constantin V. Boundas and Dorothea Olkowski (eds), *Gilles Deleuze and the Theatre of Philosophy* (London: Routledge, 1994), pp. 99–116.

Bowden, Sean, 'Human and nonhuman agency in Deleuze', in Jon Roffe and Hannah Stark (eds), *Deleuze and the Non/Human* (Basingstoke: Palgrave Macmillan, 2015), pp. 60–80.

Brooker, Graeme, and Sally Stone, *Rereadings: Interior Architecture and the Design Principles of Remodelling Existing Buildings* (London: RIBA Enterprises, 2004).

Brooker, Graeme, and Sally Stone, *What Is Interior Design?* (Mies, Switzerland: RotoVision SA, 2010).

Brott, Simone, *Architecture for a Free Subjectivity: Deleuze and Guattari at the Horizon of the Real* (Farnham: Ashgate, 2011).

Brown, Wendy, *States of Injury* (Princeton: Princeton University Press, 1995).
Buchloh, Benjamin, 'Conceptual art 1962–1969: From the aesthetic of administration to the critique of institutions', *October*, 55 (Winter 1990), pp. 105–43.
Buchloh, Benjamin, 'Hans Haacke: Memory and instrumental reason', *Art in America*, 76.2 (February 1988), pp. 96–109, 157–9.
Burnham, Jack, 'Art and technology: The panacea that failed', in John Hanhardt (ed.), *Video Culture: A Critical Investigation* (New York: Workshop Press; Layton, UT: Peregrine Smith Books, 1986), pp. 232–48.
Burnham, Jack, *Beyond Modern Sculpture: The Effects of Science and Technology on the Sculpture of this Century* (New York: George Braziller, 1968).
Burnham, Jack, 'Notes on art and information processing', in *Software Information Technology: Its New Meaning for Art* (New York: The Jewish Museum, 1970), pp. 10–16.
Burnham, Jack, 'Real time systems', *Artforum*, 8.1 (September 1969), pp. 49–55.
Burnham, Jack, 'Systems esthetics', *Artforum*, 7.1 (September 1968), pp. 30–5.
Cassin, Barbara, et al. (eds), *Dictionary of Untranslatables: A Philosophical Lexicon* (Princeton: Princeton University Press, 2014).
Chabot, Pascal, *The Philosophy of Simondon: Between Technology and Individuation*, trans. Aliza Krefetz and Graeme Kirkpatrick (London: Bloomsbury, [2003] 2013).
Chakravorty, Pallabi, *Bells of Change* (Calcutta: Seagull, 2008).
Christov-Bakargiev, Carolyn, 'The dance was very frenetic, lively, rattling, clanging, rolling, contorted, and lasted for a long time', in Carolyn Christov-Bakargiev and Bettina Funcke (eds), *Documenta 13: The Book of Books* (Ostfildern, Germany: Hatje Cantz, 2012), pp. 30–45.
Clackson, James, *Indo-European Linguistics: An Introduction* (Cambridge and New York: Cambridge University Press, 2007).
Clackson, James, and Geoffrey Horrocks, *The Blackwell History of the Latin Language* (Malden, MA: Wiley-Blackwell, 2010).
Colebrook, Claire, *Deleuze: A Guide for the Perplexed* (London and New York: Continuum, 2006).

Colebrook, Claire, 'The joy of philosophy', in Ian Buchanan and Adrian Parr (eds), *Deleuze and the Contemporary World* (Edinburgh: Edinburgh University Press, 2006), pp. 214–27.

Colebrook, Claire, 'Vitalism and theoria', in Chris Danta and Helen Groth (eds), *Mindful Aesthetics: Literature and the Science of Mind* (New York: Bloomsbury, 2014), pp. 29–46.

Cooke, Lynne (ed.), *Agnes Martin* (New Haven: Yale University Press, 2012).

Cramer, Franz Anton, 'Speaking Africa, *Logobi*: A German–Côte d'Ivoire performing arts dialogue', in Thomas F. DeFrantz and Philipa Rothfield (eds), *Choreography and Corporeality: Relay in Motion* (London: Palgrave Macmillan, 2016), pp. 135–51.

Crouch, David, *Flirting with Space: Journeys and Creativity* (Farnham: Ashgate Publishing, 2010).

Csordas, Thomas, 'Somatic modes of attention', *Cultural Anthropology*, 8 (1993), pp. 135–56.

De Salvo, Donna (ed.), *Open Systems: Rethinking Art c. 1970* (London: Tate Publishing, 2005).

de Vries, Marc J., Andrew Feenberg, Arne De Boever and Aud Sissel Hoel, 'Book symposium on the philosophy of Simondon: Between technology and individuation', *Philosophy and Technology*, 28.2 (2014), pp. 297–322, <https://www.sfu.ca/~andrewf/art_10.1007_s13347-013-0144-5.pdf> (last accessed 14 March 2017).

Dearnaley, Mathew, 'Motorway to go ahead despite concerns', *NZ Herald*, 12 September 2009, <http://www.nzherald.co.nz/nz/news/article.cfm?c_id=1&objectid=10596813> (last accessed 14 March 2017).

Deleuze, Gilles, *Bergsonism*, trans. Hugh Tomlinson and Barbara Habberjam (New York: Zone Books, [1966] 1988).

Deleuze, Gilles, 'Books (on *Francis Bacon*)', *Artforum*, 22.5 (January 1984), pp. 68–9; reprinted in *Francis Bacon: The Logic of Sensation*, trans. Daniel W. Smith (London: Continuum, [1981] 2003), pp. x–xv.

Deleuze, Gilles, *Cinema 2: The Time-Image*, trans. Hugh Tomlinson and Robert Galeta (London: Athlone, [1985] 1989).

Deleuze, Gilles, *Desert Islands and Other Texts, 1953–1974*, trans. Michael Taomina (New York: Semiotext(e), [2002] 2004).

Deleuze, Gilles, *Difference and Repetition*, trans. Paul Patton (London: Athlone, [1968] 1994).
Deleuze, Gilles, *Difference and Repetition*, trans. Paul Patton (New York and London: Continuum, [1968] 2004).
Deleuze, Gilles, *Empiricism and Subjectivity: An Essay on Hume's Theory of Human Nature*, trans. Constantin V. Boundas (New York: Columbia University Press, [1953] 1991).
Deleuze, Gilles, 'Ethology: Spinoza and us', in Jonathan Crary and Sanford Kwinter (eds), *Incorporations*, trans. Robert Hurley (New York: Zone Books, [1970] 1992), pp. 625–33.
Deleuze, Gilles, *Expressionism in Philosophy: Spinoza* (New York: Zone Books, [1968] 1990).
Deleuze, Gilles, *The Fold: Leibniz and the Baroque* (London: Athlone Press, [1988] 1993).
Deleuze, Gilles, *Foucault*, trans. Seán Hand (New York and London: Continuum, [1986] 2010).
Deleuze, Gilles, *Francis Bacon: The Logic of Sensation*, trans. Daniel W. Smith (London: Continuum, [1981] 2003).
Deleuze, Gilles, 'Letter to a harsh critic', in *Negotiations, 1972–1990*, trans. Martin Joughin (New York: Columbia University Press, [1973] 1995), pp. 3–12.
Deleuze, Gilles, *The Logic of Sense*, ed. Charles Stivale, trans. Mark Seem with Constantin Boundas (London: Athlone, [1969] 1990).
Deleuze, Gilles, 'Mediators', in Jonathan Crary and Sanford Kwinter (eds), *Incorporations*, trans. Robert Hurley (New York: Zone Books, [1985] 1992), pp. 280–94.
Deleuze, Gilles, 'Metal, metallurgy, music, Husserl, Simondon', trans. Timothy S. Murphy, <https://www.webdeleuze.com/textes/186> (last accessed 14 March 2017).
Deleuze, Gilles, *Negotiations, 1972–1990*, trans. Martin Joughin (New York: Columbia University Press, [1990] 1995).
Deleuze, Gilles, *Nietzsche and Philosophy*, trans. Hugh Tomlinson (New York: Columbia University Press, [1962] 1983).
Deleuze, Gilles, 'On four poetic formulas that might summarize the Kantian philosophy', in Daniel W. Smith and Michael A. Greco (trans.), *Essays Critical and Clinical* (Minneapolis: University of Minnesota Press, [1963] 1997), pp. 27–35.

Deleuze, Gilles, 'One manifesto less', in Constantin V. Boundas (ed.), *The Deleuze Reader* (New York: Columbia University Press, [1979] 1993), pp. 204–22.

Deleuze, Gilles, *Le Pli: Leibniz et le Baroque* (Paris: Minuit, 1988).

Deleuze, Gilles, 'Postscript on the societies of control', in *Negotiations, 1972–1990*, trans. Martin Joughin (New York: Columbia University Press, 1990), pp. 177–82.

Deleuze, Gilles, *Proust and Signs: The Complete Text*, trans. Richard Howard (Minneapolis: University of Minnesota Press, 2000).

Deleuze, Gilles, 'Response to a question on the subject', in *Two Regimes of Madness: Texts and Interviews 1975–1995*, ed. David Lapoujade, trans. Ames Hodges and Mike Taormina (New York: Semiotext(e), [1988] 2007), pp. 349–51.

Deleuze, Gilles, *Spinoza: Practical Philosophy*, trans. Robert Hurley (San Francisco: City Lights Books, [1970] 1988).

Deleuze, Gilles, 'To have been done with judgment', in Daniel W. Smith and Michael A. Greco (trans.), *Essays Critical and Clinical* (Minneapolis: University of Minnesota Press [1993] 1997), pp. 127–35.

Deleuze, Gilles, *Two Regimes of Madness: Texts and Interviews 1975–1995*, ed. David Lapoujade, trans. Ames Hodges and Mike Taormina (New York: Semiotext(e), 2007).

Deleuze, Gilles, and Michel Foucault, 'Intellectuals and power: A conversation between Michel Foucault and Gilles Deleuze', in Donald F. Bouchard (ed.), *Language, Counter-Memory, Practice: Selected Essays and Interviews by Michel Foucault* (Ithaca: Cornell University Press, [1972] 1977), pp. 205–17.

Deleuze, Gilles, and Félix Guattari, *Anti-Oedipus* (vol. 1 of *Capitalism and Schizophrenia*), trans. Robert Hurley, Mark Seem and Helen R. Lane (Minneapolis: University of Minnesota Press, [1972] 1983).

Deleuze, Gilles, and Félix Guattari, *A Thousand Plateaus* (vol. 2 of *Capitalism and Schizophrenia*), trans. Brian Massumi (Minneapolis: University of Minnesota Press, [1980] 1987).

Deleuze, Gilles, and Félix Guattari, *What Is Philosophy?*, trans. Hugh Tomlinson and Graham Burchell (New York: Columbia University Press, [1991] 1994).

Deleuze, Gilles, and Claire Parnet, *Dialogues*, trans. Hugh Tomlinson and Barbara Habberjam (London: Athlone Press, [1977] 1987).

Dempster, Elizabeth, 'Ballet and its other: Modern dance in Australia', in Erin Brannigan (ed.), *Movement and Performance (MAP) Symposium* (Melbourne: Ausdance, 1999), pp. 10–17.

Dempster, Elizabeth, 'Let's see a little how she dances', in Alexandra Carter (ed.), *The Routledge Dance Studies Reader* (London and New York: Routledge, 1998), pp. 223–9.

Derrida, Jacques, 'Now I'll have to wander all alone', in Pascale-Anne Brault and Michael Naas (eds), *The Work of Mourning* (Chicago: University of Chicago Press, 2001), pp. 192–5.

Dosse, François, *Gilles Deleuze and Félix Guattari: Intersecting Lives*, trans. Deborah Glassman (New York: Columbia University Press, 2010).

Douglas, Mick (ed.), *Performing Mobilities*, <http://www.performingmobilities.net> (last accessed 14 March 2017).

Dreyfus, Hubert L., and Stuart E. Dreyfus, 'The challenge of Merleau-Ponty's phenomenology of embodiment for cognitive science', in Gail Weiss and Honi Fern Haber (eds), *Perspectives on Embodiment: The Intersections of Nature and Culture* (London and New York: Routledge, 1999), pp. 103–20.

Dumas, Russell, 'Dance for the time being', in Angela Conquet (ed.), *Dancehouse Diary #1* (Melbourne: Dancehouse, 2012), p. 10.

Dumas, Russell, 'Necessary incursions: Rethinking the unstable body in dance', unpublished PhD thesis, Victoria University, Melbourne, Australia, 2014.

Flaxman, Gregory, 'People, places, things', in *Aéroport Mille Plateaux*, Catalogue of Elmgreen and Dragset Exhibition at PLATEAU Contemporary Art Museum, Seoul, South Korea, 2015, pp. 44–53.

Foster, Hal, 'The un/making of sculpture', in Gordon Hughes and Hal Foster (eds), *Richard Serra* (Cambridge, MA: MIT Press, 2000), pp. 175–200.

Foucault, Michel, 'Nietzsche, genealogy, history', in *Language, Counter-Memory, Practice: Selected Essays and Interviews by Michel Foucault*, ed. Donald Bouchard (Ithaca: Cornell University Press, 1977), pp. 139–64.

Freud, Sigmund, *The Psychopathology of Everyday Life*, trans. James Strachey et al. (New York: The Macmillan Company, 1914).

Frichot, Hélène, and Stephen Loo (eds), *Deleuze and Architecture* (Edinburgh: Edinburgh University Press, 2013).

Fried, Michael, 'Art and objecthood', *Artforum*, 5.10 (Summer 1967), pp. 12–23.
Gourfink, Myriam, <http://www.myriam-gourfink.com> (last accessed 14 March 2017).
Gramsci, Antonio, *Selections from the Prison Notebooks*, ed. Quintin Hoare and Geoffrey Nowell Smith (New York: International Publishers Co., 1989).
Grosz, Elizabeth, *Architecture from the Outside: Essays on Virtual and Real Space* (Cambridge, MA: MIT Press, 2001).
Grosz, Elizabeth, *Chaos, Territory, Art: Deleuze and the Framing of the Earth* (New York: Columbia University Press, 2008).
Grosz, Elizabeth, 'Habit today: Ravaisson, Bergson, Deleuze and us', *Body & Society*, 19.2/3 (2013), pp. 217–39.
Grosz, Elizabeth, 'The thing', in Fiona Candlin and Raiford Guins (eds), *The Object Reader* (London and New York: Routledge, 2009), pp. 124–38.
Grosz, Elizabeth, 'A thousand tiny architects: Art and the animal', paper presented to the Thursday Night Lecture Series, Department of Architecture, University of Sydney, 31 July 2008.
Groys, Boris, *Media Art in the Museum* (Vancouver: Belkin Art Gallery, 2012).
Grubinger, Eva, and Jörg Heiser (eds), *Sculpture Unlimited* (Berlin: Sternberg Press, 2011).
Grubinger, Eva, and Jörg Heiser (eds), *Sculpture Unlimited 2: Materiality in Times of Immateriality* (Berlin: Sternberg Press, 2015).
Guattari, Félix, *The Three Ecologies*, trans. Ian Pindar and Paul Patton (London: Athlone Press, 2000).
Haacke, Hans, and Jeanne Siegal, 'An interview with Hans Haacke', in Alexander Alberro and Blake Stimson (eds), *Conceptual Art: A Critical Anthology* (Cambridge, MA: MIT Press, 1999), pp. 242–6.
Haas, Michael, 'Nietzsche and metaphysical language', in David B. Allison (ed.), *The New Nietzsche* (Cambridge, MA: MIT Press, 1977), pp. 5–36.
Halsall, Francis, 'Open systems: Rethinking art c. 1970', *caa.reviews*, 7 November 2005, <http://www.caareviews.org/reviews/769#.WF8AvxTYvUA> (last accessed 14 March 2017).
Halsall, Francis, *Systems of Art: Art, History and Systems Theory* (Bern: Peter Lang, 2008).

Hammond, Debora, *The Science of Synthesis: Exploring the Social Implications of General Theory* (Boulder: University Press of Colorado, 2010).

Hayles, Katherine N., *How We Became Posthuman: Virtual Bodies in Cybernetics, Literature, and Informatics* (Chicago: University of Chicago Press, 1999).

Hileman, Kristen, 'Romantic realist: A conversation with Hans Haacke', *American Art*, 24.2 (Summer 2010), pp. 74–93.

Hollis, Ed, Alex Milton, Drew Plunkett, Andy Milligan, Frazer Hay and John Gigli (eds), *Thinking Inside the Box: A Reader in Interiors for the 21st Century* (London: Middlesex University Press, 2007).

Holmes, Brian, 'Guattari's schizoanalytic cartographies, or, the pathic core at the heart of cybernetics', <https://brianholmes.wordpress.com/2009/02/27/guattaris-schizoanalytic-cartographies/> (last accessed 14 March 2017).

Holmes, Brian, and Claire Pentecost, 'The politics of perception: Art and the world economy', <http://brianholmes.wordpress.com/2009/09/26/the-politics-of-perception/> (last accessed 14 March 2017).

Hughes, Joe, *Philosophy after Deleuze: Deleuze and the Genesis of Representation* (London: Bloomsbury, 2012).

Hume, David, *A Treatise of Human Nature*, ed. David Fate Norton and Mary J. Norton (Oxford: Oxford University Press, 2011).

International Federation of Interior Architects/Designers, 'IFI interiors declaration', <ifiworld.org/programs-events/interiors-declaration-adoptions/> (last accessed 24 April 2017).

Jones, Caroline A., 'Haacke, systems and "nature" around 1970: An art of systems/systematic art', in Camilla Skovbjerg Paldam and Jacob Wamberg (eds), *Art, Technology and Nature* (Burlington: Ashgate, 2015), pp. 211–23.

Jones, Caroline A., *Hans Haacke 1967* (Cambridge, MA: MIT List Visual Arts Center, 2011).

Jones, Caroline A., 'System symptoms: Caroline A. Jones on Jack Burnham's "systems esthetics" (1968)', *Artforum*, 51.1 (September 2012), pp. 113–14, 116, 534.

Kant, Immanuel, *Critique of Pure Reason*, trans. Paul Guyer and Allem W. Wood (Cambridge and New York: Cambridge University Press, 1999).

Kant, Immanuel, *Practical Philosophy*, ed. Mary J. Gregor (Cambridge: Cambridge University Press, 1999).

Kaufmann, Edgar Jr, *What Is Modern Interior Design?* (New York: Museum of Modern Art, 1953).

Klossowski, Pierre, *Nietzsche and the Vicious Circle*, trans. Daniel Smith (London and New York: Continuum, [1969] 2005).

Krane, Susan (ed.), *Lynda Benglis: Dual Natures* (Atlanta: High Museum of Art Atlanta, 1990).

Krauss, Rosalind, 'Agnes Martin: The /cloud/', in M. Catherine de Zegher (ed.), *Inside the Visible: An Elliptical Traverse of 20th Century Art in, of, and from the Feminine* (Cambridge, MA: MIT Press, 1996), pp. 331–9.

Krauss, Rosalind, 'Mechanical ballets: Light, motion, theater', in *Passages in Modern Sculpture* (New York: Viking Press, 1977), pp. 201–42.

Krauss, Rosalind, 'Sculpture in the expanded field', *October*, 8 (Spring 1979), pp. 30–44.

Laplanche, Jean, and Jean-Bertrand Pontalis, *The Language of Psycho-Analysis* (New York: W. W. Norton & Company, 1974).

Le Guin, Ursula, *The Wizard of Earthsea* (Harmondsworth: Penguin, 1968).

Lee, Pamela M., *Chronophobia: On Time in the Art of the 1960s* (Cambridge, MA: MIT Press, 2004).

Leibniz, G. W. F., *The Shorter Leibniz Texts*, trans. Lloyd Strickland (London: Continuum, 2006).

Lingis, Alphonso, 'The will to power', in David B. Allison (ed.), *The New Nietzsche* (Cambridge, MA: MIT Press, 1977), pp. 37–63.

Lyotard, Jean-François, 'Il était la bibliothèque de Babel', *Libération*, 7 November 1995, <http://next.liberation.fr/culture/1995/11/07/il-etait-la-bibliotheque-de-babel_150474> (last accessed 14 March 2017).

McLeod, Shaun, 'The movement between: Dance improvisation, witnessing and participatory performance', unpublished PhD thesis, Deakin University, Melbourne, Australia, 2016.

Marx, Karl, and Friedrich Engels, *Economic and Philosophic Manuscripts of 1844 and the Communist Manifesto*, trans. Martin Milligan (Amherst, NY: Prometheus Books, 1988).

Marx, Karl, and Friedrich Engels, *The German Ideology, Including Theses on Feuerbach* (Amherst, NY: Prometheus Books, 1998).

Massumi, Brian, 'Of microperception and micropolitics: An interview with Brian Massumi', *Inflexions: A Journal for Research-Creation*, 3 (2009).
Massumi, Brian, *Parables for the Virtual: Movement, Affect, Sensation* (Durham, NC, and London: Duke University Press, 2002).
Massumi, Brian (ed.), *A Shock to Thought: Expressionism after Deleuze and Guattari* (London and New York: Routledge, 2002).
Massumi, Brian, 'Translator's foreword: Pleasures of philosophy', in Gilles Deleuze and Félix Guattari, *A Thousand Plateaus* (vol. 2 of *Capitalism and Schizophrenia*) (Minneapolis: University of Minnesota Press, 1987), pp. ix–xv.
Merleau-Ponty, Maurice, *Phenomenology of Perception*, trans. Colin Smith (London: Routledge & Kegan Paul, 1962).
Morris, David, 'Body', in Rosalyn Diprose and Jack Reynolds (eds), *Merleau-Ponty: Key Concepts* (Stocksfield: Acumen, 2008), pp. 111–20.
Mullarkey, John, 'Deleuze and materialism: One or several matters?', *The South Atlantic Quarterly*, 96.3 (Summer 1997), pp. 439–63.
Nietzsche, Friedrich, *Daybreak: Thoughts on the Prejudices of Morality*, ed. Maudemarie Clark and Brian Leiter, trans. R. J. Hollingdale (Cambridge: Cambridge University Press, [1881] 1997).
Nietzsche, Friedrich, *Ecce Homo*, in *Basic Writings*, ed. and trans. Walter Kaufmann (New York: The Modern Library, 1992).
Nietzsche, Friedrich, *On the Genealogy of Morality*, ed. Keith Ansell-Pearson, trans. Carol Diethe (Cambridge: Cambridge University Press, [1887] 1994).
Nietzsche, Friedrich, *Writings from the Late Notebooks*, ed. Rüdiger Bittner, trans. Kate Sturge (Cambridge: Cambridge University Press, 2003).
O'Doherty, Brian, *Inside the White Cube: The Ideology of the Gallery Space* (San Francisco: Lapis, 1986).
Olsen, Andrea, *BodyStories: A Guide to Experiential Anatomy* (Barrytown, NY: Station Hill Press, 1991).
Oppenheim, Dennis, Robert Smithson, Neil Jenney, Günther Uecker, Hans Haacke, Richard Long and Thomas W. Leavitt, 'The symposium', in Nita Jager (ed.), *Earth Art* (Ithaca: Andrew Dickson White Museum of Art, Cornell University, 1970), unpaginated.

O'Sullivan, Simon, 'The aesthetics of affect: Thinking art beyond representation', *Angelaki: Journal of the Theoretical Humanities*, 6.3 (2009), pp. 125–35.

Pentecost, Claire, *Notes from Underground* (Ostfildern, Germany: Hatje Cantz, 2012).

Pentecost, Claire, *Soil-erg*, <http://www.publicamateur.org/?p=85> (last accessed 14 March 2017).

Peters, F. E., *Greek Philosophical Terms: A Historical Lexicon* (New York: NYU Press, 1970).

Phillips, Adam, *One Way and Another* (London: Hamish Hamilton, 2013).

Pile, John, *A History of Interior Design* (London: Laurence King Publishing, 2009).

Pont, Antonia, 'An exemplary operation: Shikantaza and articulating practice via Deleuze', in Nahum Brown and William Franke (eds), *Immanence, Transcendence and Intercultural Philosophy* (New York: Palgrave Macmillan, 2016), pp. 207–36.

'Practice, n.', *OED Online*, *Oxford English Dictionary*, <https://en.oxforddictionaries.com/definition/practice> (last accessed 25 April 2017).

'Practise | Practice, v.', *OED Online*, *Oxford English Dictionary*, <https://en.oxforddictionaries.com/definition/practice> (last accessed 25 April 2017).

Public Share, *Smoko*, <http://publicshare.co.nz/smoko/> (last accessed 24 April 2017).

Rainer, Yvonne, '"No" to spectacle', in Alexandra Carter (ed.), *The Routledge Dance Studies Reader* (London and New York: Routledge, 1998), p. 35.

Rainer, Yvonne, 'Where's the passion? Where's the politics? Or, how I became interested in impersonating, approximating, and end running around my selves and others', and where do I look when you're looking at me?', *Theatre*, 40.1 (2010), pp. 47–55.

Ravn, Susanne, 'Embodying interaction in Argentinean tango and sports dance', in Thomas F. DeFrantz and Philipa Rothfield (eds), *Choreography and Corporeality: Relay in Motion* (London: Palgrave Macmillan, 2016), pp. 119–34.

Ridley, Aaron, 'Nietzsche on art and freedom', *European Journal of Philosophy*, 15.2 (Oxford: Blackwell Publishing, 2007), pp. 204–24.

Roffe, Jon, 'Exteriority/interiority', in Adrian Parr (ed.), *The Deleuze Dictionary* (Edinburgh: Edinburgh University Press, 2005), pp. 94–6.

Roffe, Jon, *Gilles Deleuze's Empiricism and Subjectivity* (Edinburgh: Edinburgh University Press, 2016).

Rothfield, Philipa, 'Chance encounters, Nietzschean philosophy and the question of improvisation', in Vida Midgelow (ed.), *The Oxford Handbook of Improvisation in Dance* (Oxford: Oxford University Press, forthcoming).

Rothfield, Philipa, 'Differentiating phenomenology and dance', in Alexandra Carter and Janet O'Shea (eds), *The Routledge Dance Studies Reader*, 2nd edn (London and New York: Routledge, 2010), pp. 303–18.

Rothfield, Philipa, 'Philosophy and the bodily arts', *Parallax*, 46 (January–March 2008), pp. 24–35.

Rothfield, Philipa, 'Tinkering away: The untimely art of subtraction', in Thomas F. DeFrantz and Philipa Rothfield (eds), *Choreography and Corporeality: Relay in Motion* (London: Palgrave Macmillan, 2016), pp. 15–30.

Sauvagnargues, Anne, *Deleuze and Art*, trans. Samantha Bankston (London: Bloomsbury, 2013).

Sauvagnargues, Anne, 'Simondon, Deleuze, and the construction of transcendental empiricism', trans. Christopher Cohoon, *Pli: The Warwick Journal of Philosophy*, [2005] 2012, pp. 1–21.

Semper, Gottfried, *The Four Elements of Architecture and Other Writings*, trans. Harry Francis Mallgrave and Wolfgang Herrmann (Cambridge: Cambridge University Press, [1851] 1989).

Shanken, Edward A., 'The house that Jack built: Jack Burnham's concept of "software" as a metaphor for art', *Leonardo Electronic Almanac*, 6.10 (November 1998), <http://www.artexetra.com/House.pdf> (last accessed 24 April 2017).

Shanken, Edward A. (ed.), *Systems* (London: Whitechapel Gallery, 2015).

Shaw, Robert, 'Bringing Deleuze and Guattari down to earth through Gregory Bateson: Plateaus, rhizomes and ecosophical subjectivity', *Theory, Culture & Society*, 32.7/8 (2015), pp. 151–71.

Sheets-Johnstone, Maxine, *The Phenomenology of Dance* (London: Dance Books, 1966).

Simondon, Gilbert, 'The position of the problem of ontogenesis', trans. Gregory Flanders, *Parrhesia*, 7 (2009), pp. 4–16, <http://www.parrhesiajournal.org/parrhesia07/parrhesia07_simondon1.pdf> (last accessed 14 March 2017).

Skinner Releasing Technique, <http://www.skinnerreleasing.com> (last accessed 14 March 2017).

Skrebowski, Luke, 'All systems go: Recovering Hans Haacke's systems art', *Grey Room*, 30 (Winter 2008), pp. 54–83.

Sweigard, Lulu, *Human Movement Potential* (Lanham: Harper & Row, 1974).

Vaan, Michiel de, *Etymological Dictionary of Latin and the Other Italic Languages* (Leiden and Boston: Brill, 2016).

Vācaspatimiśra, *The Yoga System of Patanjali*, trans. J. Haughton Woods (Delhi: Motilal Banarsidass, by arrangement with Harvard University Press, 1914).

Watkins, Calvert, *The American Heritage Dictionary of Indo-European Roots*, 3rd edn (Boston: Houghton Mifflin Harcourt, 2011).

Watson, Janell, *Guattari's Diagrammatic Thought: Writing between Lacan and Deleuze* (London: Continuum, 2009).

Williams, James, *Gilles Deleuze's* Difference and Repetition (Edinburgh: Edinburgh University Press, 2013).

Williams, James, 'Immanence', in Adrian Parr (ed.), *The Deleuze Dictionary* (Edinburgh: Edinburgh University Press, 2005), pp. 125–7.

Williams, Raymond, *Keywords: A Vocabulary of Culture and Society* (New York: Oxford University Press, 1985).

Young, Eugene B., Gary Genosko and Janell Watson (eds), *The Deleuze and Guattari Dictionary* (London and New York: Bloomsbury, 2013).

Index

?interior, 89, 92, 94, 98–9, 101–4, 107, 108; *see also* being; interior

a matter of time, 98–9, 101
act(s), 11, 27, 92, 95, 98, 127, 166, 169, 180, 185–6
 creative, 88–9, 188–90
 power to, 115, 116, 118
action(s), 5, 32, 37–8, 61, 121–4, 127–39, 143, 146–8, 155, 158, 165, 180
 human, 3, 23, 124, 128–30
 and practice (praxis), 3, 9, 11–13, 16–17, 20, 23–4, 41, 50
 and reactions, 108, 121–2, 131
 revolutionary, 2, 6, 8, 12
 see also force(s); intention; *Praxis; praxis*
active destruction, 123, 147–8
active type, 121–2, 131, 134, 139, 140, 147, 148
actual, the, 55, 165; *see also* virtual
actualisation, 100, 102, 187
actuality, 7
affect(s), 13, 20, 52, 24, 122, 138, 162–6, 168, 169, 173, 177–81, 193
 assemblages of, 49, 51, 73
 and percepts, 54, 80, 83, 84, 117, 118, 154
agency, 17, 23, 32, 120–1, 123–4, 127–8, 129–30, 137, 139, 149; *see also* drives; force(s); intention
Alexander Technique, 146
anatomy, experiential, 125, 127; *see also* body, the
Anti-Oedipus, 11, 25, 67
anticipation(s), 36, 132, 144–5, 192
Aristotle, 3, 12, 25–6, 28, 43, 44, 45
art, 97, 117, 118, 155, 191
 encounter, 54, 55, 86, 154, 161, 162–5, 169–71, 174, 177–8, 179–81
 and forces, 26, 48, 49–51, 53–5, 73
 forming, 49–51, 53, 55–6
 framing in, 82, 83, 84, 85, 103–4, 106
 philosophy and, 2, 13–14, 46, 80, 186–7, 189, 190
 practice, 21, 23, 28, 38, 41, 49–50, 63, 70, 163–4, 168–9, 188
 and systems, 62–3, 65–6, 67–8
 world, 56–8
 see also affect(s): and percepts; artworks; framing; habit; painting; viewer
artist(s), 45, 80, 83, 85, 92, 101, 106, 163, 179, 186, 191, 193
 collectives, 70, 167
 and force relations, 50, 118
 and philosophy, 2, 13–14, 46
 and practice, 38, 49, 51, 53, 57, 59, 62–3
 see also art; curatorial practice; forming
artworks, 48, 51–2, 54–5, 56–7, 65, 68, 73, 92, 163, 164, 169, 181
asana, 29–30
assemblages, 19, 105
 and art, 30, 49, 51, 55, 68, 69, 73, 162–3, 166, 179, 181
 and dance, 132, 144
 and philosophy, 189, 193, 196
 social, 50–2, 56, 63, 72
 see also force(s): relations
atmosphere(s), 18, 30, 37, 41, 172, 175–6, 177, 178
Attic Greek, 3–4

Bacon, Francis, 53, 190
Badiou, Alain, 17
ballet, 127
Bateson, Gregory, 63–5, 68

becoming, 19, 20, 21, 23, 32, 39, 54–5, 61–2, 64, 73, 119, 129–31, 135–7, 138, 144
being, 11, 16, 108, 164
?-, 92, 196
and the body, 128, 130, 180
extra-/inter-, 95
and the individual/individuation, 27, 62, 72
modes of, 54, 56, 73
beings, 46, 61, 80, 191
human, 84, 116–17, 188, 194
Benglis, Lynda, 49
Benjamin, Andrew, 164
Bergson, Henri, 35, 100, 103, 155, 197n
Bertalanffy, Ludwig von, 51, 58–9, 62–5
body, the, 33, 39, 81, 115, 166
beyond the, 117, 119, 122–3, 148
and circumstance, 132–3
in culture (training), 139–42
encounter and, 115, 162–3, 165–6, 169, 179–81
as habitual, 134
lived, 29–30, 120, 123, 124, 128
muscular-skeletal system, 125–6, 127
new assemblages of, 143–4, 145–7
as resolution of force, 130–1, 134, 137
and sensations, 87, 99, 138
without organs, 119
see also active type; affect; agency; human: non-; kinaesthetic; movement; Nietzsche
Body Stories: A Guide to Experiential Anatomy, 125
Brown, Trisha, 126, 133, 143
Brown, Wendy, 18–19, 41n
Brunelleschi, Filippo, 174–6
Brunhilde, 49, 50
Burnham, Jack, 62–3, 65, 73

Cache, Bernard, 103–4
capitalism, 19, 66–8
democratic-, 183, 191, 192
capture, 68, 104, 122
forces, 49–51, 53, 54, 56, 73, 147
Cézanne, Paul, 52, 53, 54
Chabot, Pascal, 61–2, 74n
change, 17, 20–1, 23, 24, 33, 35, 36, 37–8, 59, 107, 118, 142, 146, 156, 157
chaos, 86
forces of, 50, 54–5, 68, 73
framing, 83, 104–5, 108
transcendence and, 102, 107
choreography, 127, 141, 143–5
Christov-Bakargiev, Carolyn, 65–6
cinema, 103, 158, 189–9

Cinema 2, 190
circumstance, 4, 10, 13, 32, 64, 132–3, 137, 140–1
cliché, 53, 80, 82, 88–9, 102
and habit, 54, 56, 73, 83, 84, 96, 109, 154
cloud, the, 175–7; *see also* atmosphere(s); Martin, Agnes
colour
in painting, 163, 167–9, 175
and sensation, 53, 104, 106, 170
white, 82, 170–1
see also gallery space; surface: activation
compliance, 17–18, 19, 22, 32, 150n
non-, 20
see also discipline; impatience
composite, 47, 51, 165
composition, 14, 49, 55, 56, 61, 63, 85, 105, 109, 115, 130, 131, 154, 162, 167, 170–2, 179, 181
re, 132
see also framing
conceptual personae, 193–4
Condensation Cube, 60
contemplation, 15n, 36, 38, 101, 171, 183, 196
Cooke, Lynne, 174
creation
and art, 80, 118, 163, 170
of concepts, 1–2, 13, 54, 183, 193, 194
and the philosopher, 190, 192, 195–6
Critique of Practical Reason, 6, 7
Critique of Pure Reason, 7
Crouch, David, 169, 175
crystallisation, 61–2, 72–3
curatorial practice, 89, 90, 92, 94–5, 99, 101, 105, 107
custom, 9, 140–2, 146
customary forces, 139
non-, 142, 145
cybernetics, 62–3, 64–5, 72

Damisch, Hubert, 174, 175–6
dance, 117, 120, 121–7, 132–3, 137–45, 147–9, 150n, 151n
postmodern, 122–3, 125, 132, 139, 142–4, 147–8
see also active type; body, the; experience; force(s); kinaesthetic; Merleau-Ponty; movement; Nietzsche; somatic; subjectivity; virtuosity
dancer/dancing *see* dance
Daybreak, 23, 128
death, 156, 196–7
deframing, 85, 96, 102; *see also* framing

INDEX **215**

Depth is as good as range, 172–3
Depthless Flatness, 172–3, 179
Derrida, Jacques, 196
design
 exhibition, 94–6
 interior, 89–91, 92, 98, 100, 103–8
desire, 16, 29, 41, 163
 flows of, 22, 67–8
deterritorialisation, 67–8, 85–6, 93
Dialogues, 87
difference, 25–8, 30–1, 34–6, 37–8, 40–1, 55, 62, 93, 96–7, 100–1, 107, 122–4, 129, 131, 134, 144, 147–8, 195
 in intensity, 154, 163, 164, 173, 176, 179, 180
 see also repetition
Difference and Repetition, 18, 24–5, 29, 31, 33, 185, 187, 189, 192, 195
difference-in-itself, 27–8, 30–1, 34–5, 37
discipline, 16–18, 21–2, 31–3, 40, 90, 102, 141; *see also* laziness; practice
dispossession, 191–3, 196
'Documenta 13', 65–6
doing, 1, 12, 16, 23–4, 27, 31–3, 38–9, 41, 89, 94, 102, 121, 138–9, 146, 168
 nothing, 38
 see also non-doing
dreams, 29, 129
drives, 121, 128–30; *see also* force(s)
Dumas, Russell, 145, 146, 153n

Economic and Philosophic Manuscripts of 1844, 6, 7
Elkaïm, Mony, 63, 77n
encounter, 27–8, 48, 67, 83, 87–8, 89, 95, 97, 99, 106, 116, 156, 157, 158, 183, 189, 191–2, 193, 195, 196
 affect and, 163–6, 168, 179–81
 with art, 54, 55, 86, 154, 161, 162–5, 169–71, 174, 177–8, 179–81
 and bodies, 115, 134, 138, 162, 165–6, 169, 179–81
 with force, 20, 129, 132
 and the practitioner, 14, 17, 18, 30
 with sensation, 101, 160, 161, 175–6
 spatial, 49, 175–8, 179
 temporal, 49, 100
energy, 113
 and information, 57, 61–3, 65, 73
 spatialising, 52, 53, 68
 transfer of, 59, 60–1, 65
 see also matter-energy-information exchange; sculpture
Eternal Return, 18, 29, 39, 139, 147–8
ethics, 3, 7
 in Deleuze, 39, 40, 119

 in postmodern dance, 148
 Spinoza's, 115, 116
event, 32, 46, 51, 55, 122, 132–3, 152n, 154, 161, 162–6, 169, 171, 174, 177–81, 187–8, 189, 192–3
exchange(s), 33–4, 57–8, 68, 70
 information, 51, 61, 62, 64–5, 73
experience, 7, 10, 23, 99, 112, 113, 117, 148, 155, 156, 157, 162
 of affect, 165, 179–80
 and experiments, 94, 106, 108
 habituated, 48, 83, 188, 192
 and movement, 120, 122, 123, 124, 127, 132, 138, 143
 and reactive apparatus, 134, 135–7, 145
 and the subject, 93, 97–8, 101, 114, 120–2, 123–4, 127–30
experiential anatomy, 125, 127
extension, 103, 156, 164
exterior, 95, 96, 101
 in relation to interior, 60, 81, 91, 98, 99, 102–3, 104, 107–8

false, 19, 187
 hood, 186
feeling(s), 84, 87, 130, 136, 173, 186
 and affect, 162, 165, 180
 through dance, 120–1, 126, 138, 141
 in encounter with art/practice, 83, 86, 99, 101, 117
Fehlleistung, 5
filmmakers, 2, 13, 189, 190
fold, a, 101–2, 143
 as inside outside, 81, 83, 91
 and force, 54
 of materials, 98, 163, 167–8
 un, 187
 see also framing; inside/outside; surface
force(s), 18, 30, 62, 72, 88, 95, 98, 99, 102, 103, 104, 107, 108, 121–2, 129–37, 139, 140, 141, 148, 162, 166, 179, 180–1, 186, 188
 capture of, 49–51, 53, 54, 56, 73, 147
 chaos, 50, 54–5, 68, 73
 -ing, 33
 non-customary, 142, 145
 relations, 26, 50–2, 55, 56, 68, 93, 129–31, 133, 145, 165
 render visible/perceptible, 26, 48, 49
 of sensation, 50, 52–4
 system of, 58, 59, 61
 see also drives
Form, 43
form(s), 7, 25, 49, 61, 67, 72, 75n, 107, 145–6, 164, 169–70, 174
 dance, 122, 124, 137, 141, 143, 150n

form(s) (*cont.*)
 empty, 29–30, 40
 enframing, 104, 105
 forces and, 50–1, 129, 130, 136
 and matter, 27, 44, 45, 47, 48, 51, 52–3, 68
 re-, 129, 133, 134, 144
 of repetition, 36, 40
 of representation, 100, 102
 see also formation(s); transformation
formation(s), 19, 45, 55, 61, 69, 72–3, 121, 123, 129, 135
 corporeal, 133, 141, 144
 of experience, 136–7, 145
forming, 49–51, 53, 55–6, 68, 73; *see also* artworks
Foucault, 90, 189
Foucault, Michael, 11–12, 91, 102–3
framing, 53, 54, 82, 83, 95, 98, 101, 107, 179
 de/re-, 19, 31, 85, 96, 100, 102
 en-, 84, 104, 105
 and interiorisation, 92–4, 99, 102, 103, 104, 106, 108
 see also art
Francis Bacon: the Logic of Sensation, 53, 190
Freud, Sigmund, 5, 67, 136

gallery space, 50, 56, 60, 98–9, 165, 171, 172, 178–9
 Inside the White Cube, 95
 viewers in, 96, 101, 162, 177–9
 as white cube, 94–5, 99, 101
 see also contemplation; event; light; Plato/Platonism
General System Theory, 58
General System Theory, 58–9
generality, 33–4, 36, 37–8
Gourfink, Myriam, 127
Grass Grows, 60, 77n
Grosz, Elizabeth, 91, 100, 103–5, 107, 108
Groys, Boris, 171
Guattari, Félix, 11, 63–4
 Deleuze and, 20, 22, 49, 51–2, 54–5, 59, 64, 67–9, 73, 83, 84, 102, 103, 105, 107, 113, 117, 118, 165, 183, 193–4, 196

Haacke, Hans, 55–7, 59–62, 73
habit, 99, 124, 128, 132, 155, 158, 193
 breaking, 157, 195
 and cliché, 54, 56, 73, 83, 84, 96, 109, 154
 of thought, 31, 53, 54, 56, 73, 103
 and repetition, 37, 40, 101, 195
 and the subject, 18, 101, 114, 118, 140, 145, 147

and time (living present), 27–8, 34, 40
and training, 141
-uated experience, 48, 83, 188, 192
see also art; sensori-motor schema
habitual
 action, 9, 144
 body, 127, 134, 146
 dispositions, 124, 140
 present, 27–8, 34, 36, 40
 ways of making sense, 54, 84, 96, 155, 157, 193
haecceity, 50, 107
Hay, Deborah, 144–5
Hegel (Hegelians), 6
Hughes, Joe, 55
human, 39, 84, 85, 104, 112, 125, 120, 124
 activity, 3, 7
 agency, 23, 121, 139
 anatomy, 125, 127
 being, 84, 97, 112, 116, 117, 128, 183, 188, 194
 experience, 122
 non-, 54, 59, 66, 67, 73, 117, 123, 129, 165, 166
Hume, David, 35, 112, 113, 114, 183
hylomorphic, 44
 model, 50, 52

Idea, 43, 187, 189, 191
idea(s), 2, 5, 9, 16, 33, 87–8, 138, 161, 162, 165, 189–90, 192, 196
identity, 18–19, 30, 39–40, 88, 93, 95, 96, 102, 109, 129, 130, 147, 187
ideokinesis, 32, 134, 146
illusion, 170, 171, 174–5
immanence, 101, 107, 109, 165, 193–4
impatience, 16, 17–18, 20, 22, 23
imperceptible, the, and art, 50, 54, 73, 164
imposition, 44, 46, 50, 52, 104, 131, 134
improvisation, 132
impulses, 85, 129–30, 133
individuation, 19, 27, 50–1, 55, 61–2, 72–3, 164, 179
inhabit/inhabitation, 103, 109, 158, 180
 art, 154, 180
 artistic practice, 29, 39, 41
 an exterior, 102
 an interior, 105, 107
inhuman, 84, 117, 121; *see also* human: non-
inorganic *see* organic: non-
INSIDEOUT, 103–5
inside/outside, 81, 82, 91, 95, 102–3, 105; *see also* fold, a; interior
instinct(s), 121, 134, 152n

intensity, 34, 40, 47, 100, 154, 156, 157, 161, 163–4, 165, 166, 170, 176–9; *see also* intensive: forces; sensation(s)
intensities, 21, 24, 47, 64, 68, 94
and affects, 49, 51, 73, 163
intensive, 160, 163, 169, 171, 173, 180
forces, 51, 74n, 162, 180
space, 168, 174–9, 181
see also light; space: of sensation
intention, 16–17, 24, 29, 32, 41, 124, 127, 133, 163; *see also* motor intentionality
intercessor, 93, 96, 102, 107
interference, 13, 46, 190
interior, 60, 74n, 81, 90–2, 94, 98, 102–8, 136
inhabits, 103, 105
see also ?interior; exterior; interiority
interior design, 89–91, 92, 94, 98, 100, 103–8
interiority, 81, 83, 84, 90–1, 93, 102, 105, 106–7, 135, 137
interiorization, 90, 93, 98, 103, 105, 106, 108, 152n
internal, 85, 90–1, 99, 135, 195
resonance, 61
interpret/ation, 61, 98, 128, 151n
interrupts/interruption, 18, 39, 96, 102, 113, 145, 155
intuition, 7
as method, 100, 197n

joy, 16, 21, 39, 40, 87, 165–6
less, 19, 33

Kant, 5, 6–7, 75n, 191, 197n
kinaesthetic
agency, 120
articulation through circumstance, 132–3, 137
culture, 124, 127, 138–9, 147, 150n
sensibility, 123, 125, 140, 143, 150n
variations, 122, 134, 144
see also dance; movement; subjectivity
Klossowski, Pierre, 130, 147
Krauss, Rosalind, 74n, 163, 174–7, 178, 179

laziness, 22–3, 31, 32–3; *see also* discipline
Leibniz, G. W. F., 193, 195
light, 11, 60, 98, 99, 112, 163, 167, 170, 171–3, 177–9; *see also* shadows
line(s), 52, 68, 163, 174–5, 190
of flight, 67, 88, 93–4
gravitational, 149n
life, 73
sight, 94, 95–6

Linville, Kasha, 174–7
living
moral/ethical, 3, 116
organisms, 58, 59, 66
philosophical practice, 2, 193
present, 27, 29, 34, 35–6, 40
see also habit
Logic of Sense, The, 187, 189, 196–7
lost, 5, 21
love, 43, 112, 157, 162, 185, 192, 194

Martin, Agnes, 163–4, 174–9, 180
Marx/Marxism, 2, 6–8, 11, 12, 67
Massumi, Brian, 87, 91, 180
master, 134–5, 138
activity, 134–5, 137, 138, 145
riposte, 143, 145, 148
material(s), 58, 61, 62, 63, 65, 73, 165, 179
movement, 132, 143, 145
in practice, 49–50, 51–3, 55, 66, 85, 98, 162–3, 170, 173, 174–5, 180–1, 189, 193
materialism, 6–7, 12–13
mathematics, 59, 77n, 189–90
matter-energy-information exchange, 62, 73
Merleau-Ponty, Maurice, 120–1, 123–4, 127, 130
MoMA, 177–8
MoMA Poll (1970), 56
morals/morality, 3, 7, 10, 19, 39, 75n, 116, 135, 148, 150n, 184
motor intentionality, 124, 130, 146
movement, 27, 32, 35, 47, 53, 55, 68, 93, 99, 100, 109, 112, 119, 126, 130, 132, 139, 142, 143–4, 145, 177, 180, 187, 195
active type, 122–3, 124, 131
and change, 23, 24
forces and, 134, 137
obtains, 18, 22, 31, 33
and repetition, 25, 34
subjectivity (and beyond), 125, 127, 140, 141, 146, 147, 148, 150n
see also dance; master
muscular, 30, 131, 134, 138
skeletal system, 125, 127
muscular-skeletal system *see* body, the
music, 48, 80, 105, 190
bodies and, 132
musicians, 10, 13, 190
and dancer, 151n

negation, 17, 40, 92, 135
new, the, 24, 29, 38, 55, 144

Nicomachean Ethics, 3
Nietzsche, Friedrich, 21, 23, 32, 38–9, 74n, 121–3, 128–30, 134–6, 137 139–40, 141, 146, 147, 149, 186, 191
Nietzsche and Philosophy, 51n, 130, 186
nomadic, the, 20, 27
non-doing, 32, 146; *see also* doing

O'Sullivan, Simon, 91, 180
Object, 7
object, 1–2, 7, 12–13, 61, 74n, 106, 129, 160, 193
 in art, 50, 60, 66, 70, 85–6, 94–7, 164, 167, 179
 bodies and, 123, 125
 as container, 60, 94–5, 97, 98, 99
 extra-, 95
 hood, 63
 and space, 91, 92, 93, 94, 98, 103, 108
 unidentified flying, 94–5
 and subjectivity, 108, 176–7
objectivity, 91, 108, 156
Ok-sub, Jin, 141
Olsen, Andrea, 125
On the Genealogy of Morality, 134–5, 191
organic, 58–9, 68, 98, 129
 non-, 47, 130
 soil, 66–7
organisms, 58–9, 65
origami maquettes, 167–8, 170
outside, 44, 60–1, 63, 83, 89, 109
 inside, 81, 82, 91, 95, 102–3, 105
 time, 40
 see also exterior; fold, a
Outside-interior, 102, 103

painters, 1, 2, 13, 82, 163; *see also* Cézanne, Paul; Martin, Agnes; Turner, William
painting, 17, 22, 48, 53–4, 89, 103, 163–81, 190; *see also* surface
parapraxis, 5
Pentecost, Claire, 66–7, 73
perception, and affect, 162, 181
percept(s), 13, 54, 80, 83, 84, 117, 118, 154, 169; *see also* affect(s)
performance, 9, 90, 105, 125, 132, 133, 142–3
Performing Mobilities Assembly, 70, 71
phenomenology, 121, 122
 challenge to, 97, 107, 128, 139
 and experience, 127
 and lived body, 120, 123–4
Phillips, Adam, 16, 17, 20–2, 24, 32

philosophy
 and art, 2, 13–14, 46, 80, 186–7, 189, 190
 and creation of concepts, 1–2, 13, 54, 183, 193, 194
 of difference, 25–6
 as practice/practise, 1–2, 8, 10, 12, 21, 23, 31, 88–9, 183–93, 195–6
 Stoic, 187, 188
plateaus, 64, 68
Platform Contemporary Art Spaces, 166–7, 171
Plato/Platonism, 3, 43, 44, 45, 94, 187, 188
poets, 2, 13
Pompidou, 177–8
Practical Philosophy, 13
practice, 1–13, 27–30, 39, 46, 65–7, 87–9
 art, 21, 23, 28, 38, 41, 49–50, 55, 63–4, 70, 163, 168–9, 188
 dance (and performance), 23, 121–3, 125, 127–8, 139–40, 143, 145, 147
 and discipline, 16–18, 21, 31–3, 102
 identity/identification in, 18–19, 30, 93, 95, 147
 of institutional critique, 56–7
 interior/interiority, 89–94, 98, 100, 101–3, 105–8
 philosophy, 2, 10, 12, 13, 183–93, 195–6
 and repetition, 9, 24, 37, 39–40, 195–6
 see also action(s); creation: of concepts; discipline; *Praxis*; *praxis*
practise/practising, 2, 16–19, 21–4, 27–32, 38, 40–1, 89, 91, 92, 93, 95, 100, 102, 103, 105–7, 127
 etymology, 8–11
 philosophy, 21, 31 191, 195–6
practitioner, 16–21, 24, 25, 28, 29–31, 32–3, 38–9, 40, 88, 93
Praktik, 6, 8 10
Praxis, 4–8, 12; *see also* Marx/Marxism
praxis, 3–5, 7–8, 10–12
Prigogine, Ilya, 59, 64, 77n
problematic, 55, 92, 94, 103
Proust and Signs, 185, 186
Psychopathology of Everyday Life, The, 5
Public Share, 69, 70, 73

Rainer, Yvonne, 142–3
reactive apparatus, 135–8, 145, 148
reactivity, 20, 138–9, 141, 145, 147–8
 and force, 121–2, 131–2, 133–7, 140
 see also action(s)
relation(s), 33, 36, 39, 53–4, 57, 69, 81, 91–3, 95–8, 99, 101–5, 107–8, 121, 127, 132, 138, 139–40, 147, 163, 166, 168–9, 180
 in assemblages, 19, 30, 68, 105

between theory and *praxis*, 11–12
dialectical, 92, 107
and encounter, 162, 179
force, 26, 50–2, 55, 56, 68, 93, 129–31, 133, 145, 165
with the indeterminate, 28–30
information as, 61
subtractive, 17
see also assemblages; system(s)
relaxation, 31, 39, 101
repetition
 -for-itself, 31, 36–8
 and framing, 105
 with movement, 25, 34–5, 145, 151n
 in philosophy, 184, 192, 195–6
 in practice, 9, 24, 37, 39–40
 in time, 98, 99, 100–1
 see also Eternal Return
representation, 11, 26, 28–9, 31, 34, 37, 80, 93, 165, 173
 in art, 53, 83
 curating (framing), 95, 96–7, 99–100, 102
 identification and, 88, 93
resistance, 8, 25, 34, 47, 75n
 in dance, 131, 133, 144, 145–6, 148
 in practice, 18, 38
ressentiment, 130, 135, 148, 152n
reterritorialisation, 68
rhizome, the, 64, 88, 89, 198
rhythm, 20, 28, 29, 52–3, 98, 104–5, 137, 151n
Ridley, Aaron, 21, 38
Ruyer, Raymond, 45

Sauvagnargues, Anne, 50–1, 76n
science, 4, 188–90
sculpture, 17, 45, 49–50, 52, 61, 63, 184; *see also* capture
sensation(s), 97–8, 99, 100, 108, 117, 128, 136, 163, 164, 168, 170
 compounds/blocs of, 49, 52, 54, 80, 85, 104, 106, 154, 180
 encounter in, 160, 161
 force of, 50, 53
 intensive space of, 174, 175, 176–7, 179, 181
 and perceptions, 87, 138–9, 143
sensibility, 49, 137
 kinaesthetic, 123, 125, 140, 143, 150n
sensori-motor schema, 155, 156, 157, 158, 161
sensuousness, 7, 191
Serra, Richard, 49–50, 73
shadows, 163, 167–8, 170, 171; *see also* painting; surface

Simondon, Gilbert, 45, 50–1, 52, 61–2, 72
Skinner Releasing Technique, 127
slave, the, 134–5
slow rendering, 145
slowing, 68, 100, 105, 108, 129, 137, 167, 179
 as practitioners, 29
 rhythms of, 20
Smoko, 70–2, 73
Soil-erg, 66–7, 73
somatic
 approaches, 122, 146
 modes of attention, 124–5
 see also body, the
sovereign
 human subject, 116
 individual, 139–41, 148
space, 156
 craft, 94–5, 96
 as encounter, 163, 166, 169–70, 172
 framing, 104–5
 intensive, 168, 174–9
 interior, 91–4
 and practice, 30, 32, 50, 91–2, 98–9, 103, 108, 132, 168
 of sensation, 53, 104, 174, 175, 176–7, 179, 181
 and time, 7, 20, 55, 68, 94, 100, 103, 104–5, 178, 180
SPACECRAFT, 94–7
spacing, 169–70, 175, 179
Spinoza, Benedict, 13–14, 33, 55, 80, 115, 116, 118, 123, 148, 165
Spinoza: Practical Philosophy, 148
Splash Piece: Casting, 50
stable/stability/stabilisation, 31, 47, 68, 108–9, 114, 156, 157, 163, 168, 196
 meta-, 62, 72
 practice and, 18–20
 un/in/de-, 19, 47, 129, 130, 136, 144
States of Injury, 18
subject, the, 23, 40, 64, 81, 89, 98, 101–2, 108, 112, 115, 116, 118, 119, 129, 140, 145, 147, 154
 agency and, 120, 123, 124, 129–30, 139
 embodied, 120–1
 experiential, 113, 114
 interior and, 91–4, 102, 105–6
 practitioner as, 18–20, 30, 93
 viewer, 95–7, 177, 179
subjectivity, 18, 19, 23, 92, 93, 98, 101, 119, 129, 130, 183, 197n
 and experience, 121, 122–3
 knowing, 143, 144
 movement, 120, 124–5, 127, 140, 141, 144–8, 150n

subjectivity (cont.)
 and object, 108, 176–7
 and objectivity, 91, 156
subtraction(s), 17, 20, 40, 144, 155, 157, 180
surface, 35, 50, 82, 96, 99, 152n, 163, 170, 173, 187
 activation, 165–9, 171–2, 176, 178–81
 beneath the, 38, 128–9, 138
 see also origami maquettes; painting
Surface event, 168, 169, 170, 179
system(s), 12, 14, 72, 104, 136, 175–6, 196
 biological, 57–9, 61, 66–7
 components, 51, 58, 60, 63, 65, 73, 151n
 theory, 63–5
 thinking, 51, 57–61, 62, 65, 73
 of viewing, 175–6
 see also Condensation Cube; Grass Grows; Pentecost, Claire
systems aesthetics, 62, 65, 76n
systems esthetics, 62–3, 73

Taoism, 31–2
taste, 23, 34, 141, 193–5
temporality, 51, 55, 97, 106–7, 132
 of light, 171, 173, 178, 179
 and space, 49, 54, 163, 169
 see also material(s)
territorialisation, 67–8, 89, 104–6
textiles, 98–101
thermodynamics, 34, 59
Thousand Plateaus, A, 25, 52, 64, 68, 87, 89, 90
Three Ecologies, The, 64
time, 33–6, 40, 64, 101, 108
 actualisation, 99, 100, 102
 and practice, 28, 29
 real-, 57, 73
 and space, 7, 20, 55, 68, 94, 100, 103, 104–5, 178, 180
 textiles and, 98–9
training, 125, 132, 140–2, 145–6
transcendence, 102, 107, 165
transcendental, 174
 concept, 2
 principle, 27
 tradition of philosophy, 12
transformation, 18, 24, 31, 40, 46, 55, 64, 131, 163, 165, 197n
Trio A (1966), 142–3

Truth, 46, 183, 187
truth, 128, 184–5, 187–8
Turner, William, 22
type, 33, 43, 123, 130, 138, 152n
 active, 121–2, 134, 139, 140, 147, 148
 proto, 47
 reactive, 122, 136
 workerly, 143, 148
 see also form(s); reactive apparatus

unconscious, 136–7, 138, 148, 153n
 aim, 5
 as habit, 96
 instincts, 134

Verb List (1967–8), 50, 73
viewer, the, 56, 60, 65, 92, 94–7, 162–3, 165, 166, 171, 173, 174–80
virtual, 54–5, 82, 104, 132, 165
virtuosity, 122, 139–42, 144
visual arts see art

Waterview Connection project, 72
weaving, 98, 100–1
What is Philosophy?, 49, 53, 55, 105, 183, 188, 190–1, 193, 196
will, 21, 32, 186
 free, 115
 to power, 129–30, 137, 147, 151n
Williams, James, 40
Williams, Raymond, 5
Wiri, 69, 70, 71
world, the, 37, 39, 48, 51, 57, 62, 67, 80, 91, 105, 108, 124, 129, 187, 192
 being in the, 40, 73
 of experience, 127, 128, 135, 149n, 155, 164
 habit and, 158
 material, 43, 44, 81
 not lived or felt, 50, 54, 56
writers, 13, 51
writing, 115, 190
 and art, 89, 164, 179
 and philosophy, 31, 189
 as spacing, 169
Wu Wei, 32

yoga, 29–30, 127